BLACK & WHITE PHOTOGRAPHY
IN THE DIGITAL AGE

Tony Worobiec and Ray Spence
A DAVID & CHARLES BOOK
Copyright © David & Charles Limited 2007

David & Charles is an F+W Publications Inc. company
4700 East Galbraith Road
Cincinnati, OH 45236

First published in the UK in 2007
First US paperback edition 2007

Text and illustrations copyright
© Tony Worobiec and Ray Spence 2007

A catalogue record for this book is available from the
British Library.

ISBN: 978-0-7153-2561-2 hardback
ISBN: 978-0-7153-2562-9 paperback

Printed in China by Shenzen Donnelly Printing Co Ltd
for David & Charles
Brunel House, Newton Abbot, Devon

Commissioning Editor: Neil Baber
Editors: Ame Verso and Emily Pitcher
Copy Editor: Cathy Joseph
Art Editor: Marieclare Mayne
Indexer: Lisa Footitt
Production Controller: Beverley Richardson

Visit our website at www.davidandcharles.co.uk

David & Charles books are available from all
good bookshops; alternatively you can contact
our Orderline on 0870 9908222 or write to us at
FREEPOST EX2 110, D&C Direct, Newton Abbot,
TQ12 4ZZ (no stamp required UK only);
US customers call 800-289-0963 and
Canadian customers call 800-840-5220.

Thanks to:
Trevor Crone, Stuart Cranstone, Permajet,
Fotospeed, Alan Hayward, John McManus,
Chaudigital, Mike McNamee, Fiona, Kinjal,
Sunny, Paul, Cressida and Sarah.

BLACK & WHITE
PHOTOGRAPHY
IN THE DIGITAL AGE

CREATIVE CAMERA, DARKROOM & PRINTING TECHNIQUES FOR
THE MODERN PHOTOGRAPHER TONY WOROBIEC & RAY SPENCE

D&C
David and Charles

04 / CONTENTS

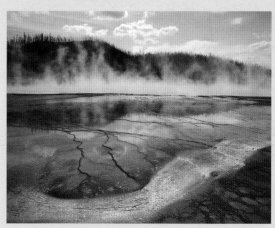

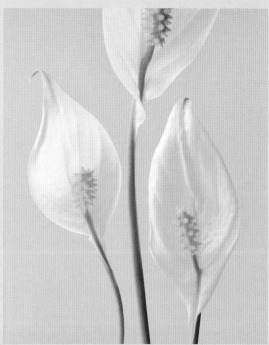

CHAPTER 5:
COMPOSITES AND FURTHER SPECIAL EFFECTS

CHAPTER 6:
THE DIGITAL DARKROOM

CHAPTER 7:
EXTENDING THE BOUNDARIES

CHAPTER 8:
PRINTING AND PRESENTATION

"TO SEE IN COLOUR IS A DELIGHT FOR THE EYE, BUT TO SEE IN BLACK AND WHITE IS A DELIGHT FOR THE SOUL"
ANDRI HERY

The ability to record the world around us by photographic means has been a goal long held by many. The early experimentation with Camera Obscura and photosensitive materials has a chequered history. The achievements of Daguerre, Fox Talbot, Herschel and others in the mid-19th century led to the production of permanent images created directly from nature. One major disappointment of these early processes, however, was that they represented the colourful world as a range of monochromatic tones. Later developments overcame this shortcoming and we now take the colour photograph for granted; indeed the majority of image-making is in full colour. Why then is there still a perverse group of people who deny the existence of colour and insist on producing black and white images? It could be maintaining a link with the beginnings of photography, the abstraction of the image from pure representation, personal taste, or even some snobbishness in the photographic art world.

Both authors have worked in monochrome and colour over a 30-year period, but we have always considered the black and white darkroom and the fine monochrome images we have produced as our major *raison d'être*. Many thousands of hours have been spent in the 'little red womb' coaxing a personal interpretation of an image from a lovingly exposed silver negative. Experiments with film, developers, toners and printing techniques have allowed us to put our own personal signature on every print made. Looking back to past masters and learning the techniques of salt printing, cyanotype and platinum printing have enriched the multitude of ways that a negative can be interpreted. Such a wealth of experience is invaluable to inform new processes when they arise.

There can be no greater change or revolution in photography than the change from film to digital imaging; from the enlarger to the computer. We have embraced the new technology fully and have both been able to use our knowledge of traditional techniques and take these a stage further to achieve what was impossible in the darkroom. The goal of all photographers like ourselves is the fine print and one of the major questions over digital techniques was the quality and permanence of the prints that could be produced. We now firmly believe that the advances in technology, both in digital capture and printing techniques, have caught up with traditional processes and will surpass them. Now it is definitely time to take digital black and white work seriously.

In this book we will endeavour to show you how to get the best from your digital files and produce monochrome and toned images you can be proud of. Though we will be working exclusively in Adobe Photoshop, the basic principles can be transferred to other image-manipulation software. The techniques that we use are selected for their relevance to black and white photography and the toning of monochrome images.

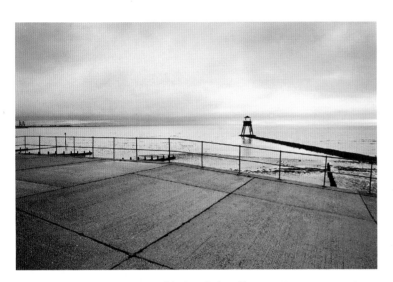

SCANNED NEGATIVE / A 35mm black and white film negative was scanned and manipulated with Photoshop to adjust contrast before printing with an ink-jet printer.

SCANNED OBJECTS / No camera was used here. Every part of the image was created using a flatbed scanner to 'photograph' the objects, which were then combined in Photoshop.

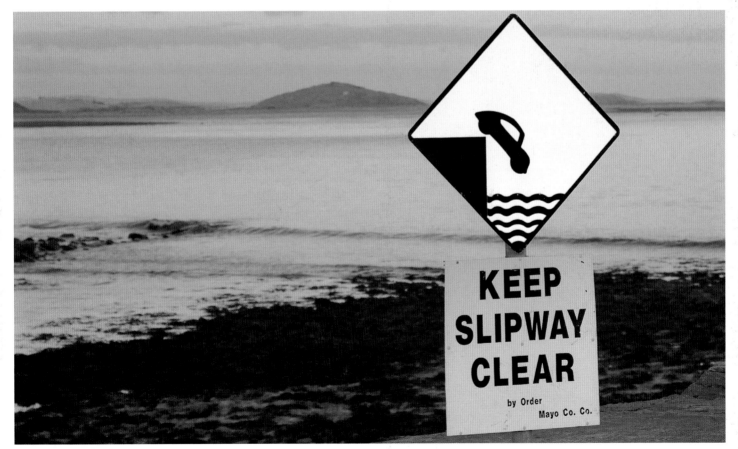

KEEP SLIPWAY CLEAR

by Order
Mayo Co. Co.

DIGITAL CAPTURE / A digital camera was used to produce a full-colour image, which was then converted to monochrome in Photoshop.

CHAPTER 1: CREATING DIGITAL MONOCHROME IMAGES
SCANNING FILM

Most photographers have files full of negatives and transparencies from their years of creative endeavour. Some of you will continue to use film and see no reason to throw away your beloved cameras and lenses. If so, you need to come to terms with scanning film to produce digital files. Scanning is a way of converting the analogue information contained in film into the digital information that computers can understand. This can be left to a professional laboratory or, increasingly, done at home with desktop scanners. The three different types are drum, dedicated film and flatbed scanners.

Drum Scanners are usually used by professional labs, producing high-quality scans for ultimate performance. Of course this is not cheap and may be too expensive for the majority of amateur photographers. A more affordable alternative, if you are regularly scanning film, is to buy a dedicated film scanner. These are usually designed for 35mm film but medium- and large-format scanners are available. They will produce high-quality results that are perfectly adequate for most people's needs.

At one time flatbed scanners were seen as no more than slightly sophisticated photocopiers. Not any more. As we will see, they are not only creative tools in their own right, but they can also serve a dual purpose (see pages 120–125). Apart from scanning by reflected light, many scanners now have built-in light sources in the lids. These transparency units (TPUs) allow all types of film to be scanned. Many of the features of the more expensive dedicated film scanners are now being incorporated into flatbed scanners, making them a viable alternative.

SCANNER FEATURES
It is risky to describe the features of a piece of digital technology in a book, as by the time it is published some features may have become obsolete. However, if we understand the salient features of the equipment, informed decisions can be made. It's important to recognize that there is no single best piece of equipment. We have to decide what is the most suitable for our own particular needs. So what are the features to look out for?

FLATBED SCANNER / Epson flatbed scanner with a built in TPU (transparency unit).

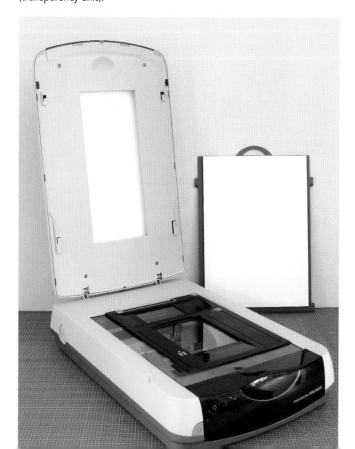

FILM SCANNER / Nikon 35mm film scanner. Capable of scanning black and white negatives, colour negatives and transparencies up to 4,000 dpi.

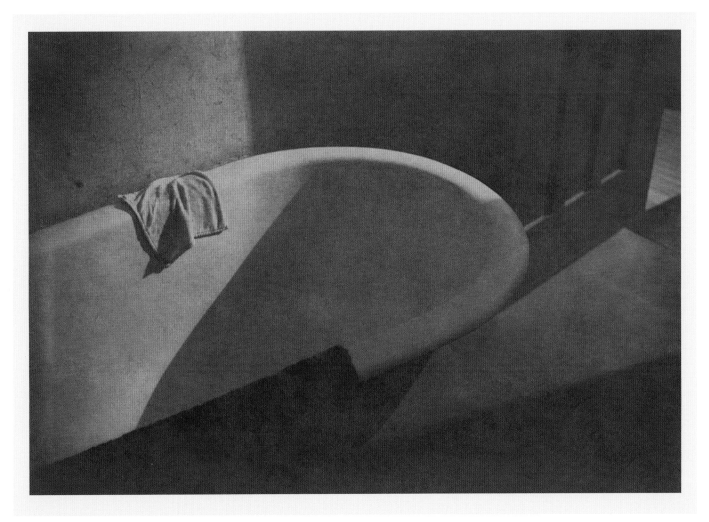

GLASS NEGATIVE / An old glass negative has been scanned with the TPU of a flatbed and the resulting image treated to a digital salt-printing technique.

FORMAT

The choice is yours – 35mm, 6 x 6cm, 5 x 4in or 10 x 8in. Most dedicated film scanners are designed for 35mm, but medium- and large-format scanners, though more expensive, are coming down in price. TPUs on flatbed scanners also come in varying sizes from 35mm upwards. Obviously you will pay more for larger sizes, but also think about how you are going to use them. Even if you only use 35mm, an A4 (29.7 x 21cm/11½ x 8¼in) TPU will enable you to scan a whole film and produce a digital contact sheet. How about scanning old glass plate negatives or lantern slides? This can be done easily using a TPU on a flatbed scanner.

RESOLUTION

Scanners analyse and sample the image from a piece of film. Every sample is converted to a pixel, which is the basic unit of a digital image. The more pixels, the more information and the larger the image can be printed. This is called the 'resolution' and is measured in the amount of pixels produced per inch (ppi). The resolution required depends on the size of the original negative and the ultimate size

of print produced. Most dedicated film scanners will scan at about 4,000–5,000 dpi (this means dots per inch. Unfortunately dpi is a slight misnomer that has now stuck – more accurately it should be samples per inch). Until recently, flatbed scanners had a lower scanning resolution, but those with TPUs can now scan up to at least 6,400 dpi (and probably higher by the time you are reading this).

The higher resolution is important if you are working entirely from 35mm film stock, but is probably overkill with medium- or large-format negatives. In fact, beyond 4,800 dpi you are probably just enlarging the grain of the film.

One word of warning: many scanners claim to have much higher resolutions, up to 12,800 dpi. These claims are nonsense. Such vast numbers are the result of a process called interpolation. This is where the software installed with the scanner creates new pixels artificially. A scanner will always have a maximum optical resolution, for example a 4,800 dpi scanner will be able to sample a maximum of 4,800 samples per inch. If you use the scanner at a higher resolution, say 9,600 dpi, it will still sample at 4,800 dpi, but the inbuilt software will then create an additional 4,800 pixels. By doubling the resolution size, in this case,

SCANNING FILM

75 per cent of the resulting image will contain pixels that have been artificially created by the software. The success of interpolation depends on the quality of the software installed, but generally it is not a good idea to do this at the scanning stage. The images are rather soft and may also have tonal irregularities.

MODE
It might seem fairly obvious that if you want to produce black and white images from your film stock, then you would select to scan in monochrome rather than colour. If your film stock is black and white, then that would be recommended. However, if you are starting with a colour negative or transparency, it is always best to scan in colour mode from the outset. This will allow far more control over the images' tonality when the scans are worked on in Photoshop, as we shall see later. In fact, arguably the best way to work in

black and white digitally from film is to start from a colour negative, scan in colour mode and use monochrome conversion techniques in Photoshop to control tonal qualities and range.

BIT DEPTH
Computers have a very simple language – they use a binary system of numbering. This means that they really do see things in terms of black and white. An image is recorded by using this binary system and the basic unit is called a bit. A 1-bit sample (2^1) is reproduced as either totally black or totally white. This means an image produced would only contain pure blacks or pure whites. To achieve a full-tone image, cameras, scanners and computers generally use an 8-bit sample (2^8), which can provide 256 shades from white to black. Therefore scanning film as 8-bit grayscale will produce a full tone black and white image.

NIKON SCAN / Kodak T-Max 3200 film, scanned in a Nikon scanner, retains all of the grit and grain of the original film image.

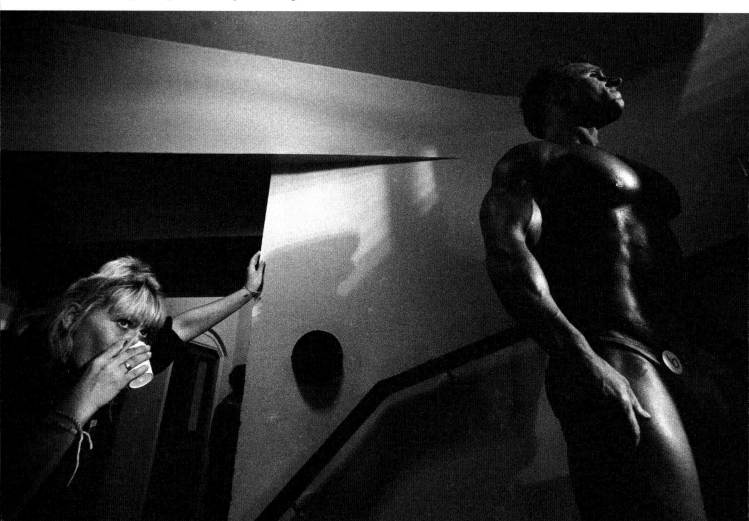

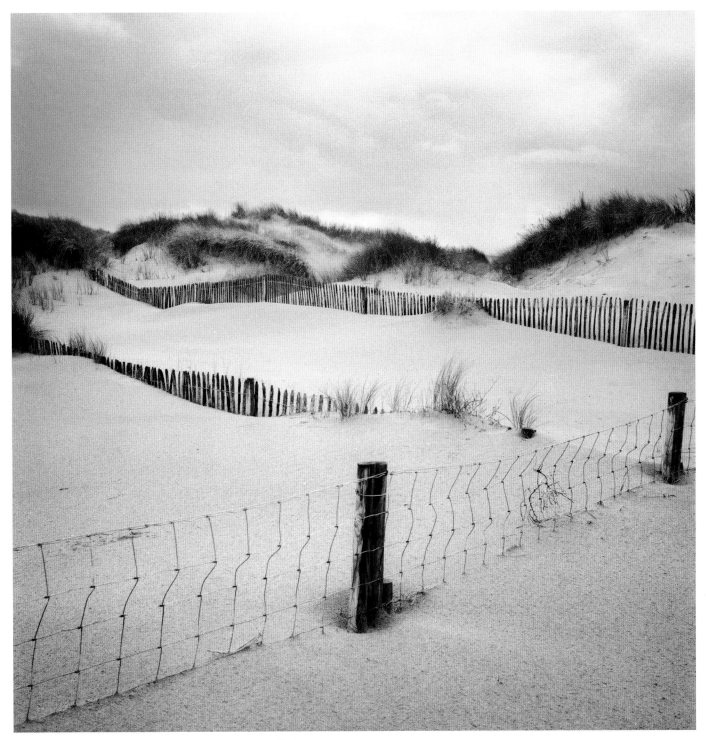

EPSON SCAN / Harlech Dunes photographed on 6 x 6cm Ilford FP4.
The film has been scanned using the TPU of an Epson flatbed scanner.

However, as we will see later, many scanners have the ability to scan in 16-bit (21^6) grayscale mode (work out the maths), which produces many more shades that are indistinguishable to the eye. The file size of your scan will also double. You might ask yourself, why bother with this level of information overload? To find the answer, refer to the section on 8-bit versus 16-bit images on pages 20–21. At this stage, believe us when we say that you will get better quality prints using the higher bit depth.

This is all very well when we are scanning black and white negatives but what happens when our source is a colour negative or transparency? Scanners still work in 8-bit or 16-bit mode, but when you scan in a colour mode, the image produced consists of three colour channels – Red, Green and Blue – an RGB image. Each channel is either 8-bit or 16-bit. For this reason, an RGB image is often referred to as 24-bit (3×2^8) or 48-bit (3×21^6). Again it would be best to scan in 16-bit colour mode.

SCANNING FILM

DYNAMIC RANGE

This is a measure of the scanner's ability to collect information from both highlight and shadow areas of a negative or transparency. The higher the dynamic range the better. This is particularly important if you scan mainly from transparencies, which have a greater tonal range than negatives. Generally speaking, dedicated film scanners have a higher dynamic range than flatbeds, though, again, the difference is narrowing.

TRANSPARENCY / 35mm slide film has been scanned using the flatbed TPU to retain the characteristic film rebate, which forms a natural frame.

DEDICATED SOFTWARE

All scanners are provided with dedicated software that allows some basic manipulation of the scanned image. Sometimes this is best left to more powerful applications such as Photoshop, but some basic manipulation at the scanning stage can certainly improve your scans.

PINHOLE NEGATIVE / OPPOSITE / Pinhole photography is an enormously creative process. In this case, a 35mm film canister was used as a pinhole camera. The small piece of film inside was then processed and scanned on a flatbed TPU and the resulting image could then be manipulated and toned.

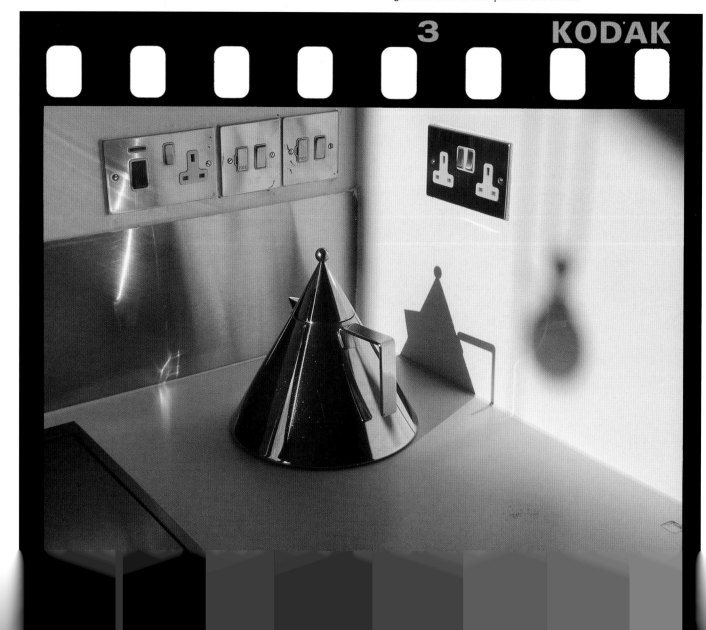

SETTINGS / Dialog box for a Nikon film scanner showing basic adjustments and resolution settings.

HISTOGRAM / The ability to view and adjust the histogram is one of the most useful features in the Nikon scanning software.

UNSHARP MASK: This will increase edge contrast between different areas of tone and give the impression of increasing sharpness. Unfortunately, in most cases this is not controllable and is best left to the more sophisticated controls in Photoshop. Therefore turn it off.

COLOUR CONTROL: This can fine tune the colour of the scan, which can be affected by such things as the colour of the film base or colour casts at the time of exposure. For the monochrome worker, this is not a major concern.

HISTOGRAM: Measures the range of tones available in the negative and is worth using to extract the maximum quality and prevent 'clipping' of highlights or shadows. Make sure that the black and white points are moved to the extremes of the histogram.

CONTRAST CONTROL: This allows a series of preset curves to be applied to increase or decrease contrast. The curves can usually be further modified by manual adjustment. In most cases it is better to produce a full-tone scan that looks slightly flat and then use Photoshop to modify contrast.

DUST AND SCRATCHES FILTER: Software such as Digital ICE is able to distinguish between the image layer in film and any dust or markings on the surface layer. It then magically removes the dust and scratches saving a lot of cloning later. It tends to work best with colour originals and problems may arise using it with black and white negatives.

CONVERSION TO MONOCHROME

All digital cameras will produce a full-colour RGB image, though some use internal software to create a black and white or sepia-toned photograph directly. It might seem that this would be the best way to use a digital camera for black and white photography. Instead of loading up with black and white film, just switch over to black and white mode. The trouble is, this will give the camera control over the way colour is converted to tones of black and white and, once stored to the memory card, is irreversible. The best way to produce a black and white image from a digital camera is to start with a full-colour RGB file. Once in Photoshop there are various ways of converting the image to mono, each with slightly different results. The skill then is to determine which method works best for a particular image.

GRAYSCALE CONVERSION

Probably the simplest way to start is to use the straightforward conversion to grayscale. The example here shows an RGB image produced by a digital camera. By opening the Channels palette, you will see that it consists of three channels, Red, Green and Blue (see Channels, below). Open the colour image and, from the Photoshop menu, access Image > Mode > Grayscale. A warning will appear on the screen to ask if you want to discard the colour information. Click OK and the image will be converted to black and white. What we have now is a single

channel image with tones ranging from black to white (see Grayscale, below). In some cases, the image produced may look a little flat and need some contrast adjustment, but if the original has a good contrast range this will produce excellent results (see Final Image, opposite). You may notice that the file size has been reduced by two thirds, so a 15MB RGB image will become a 5MB grayscale image.

Grayscale conversion is also the necessary route to take if you wish to tone your image using Duotones or Tritones. However, you will find that other toning procedures such as Hue/Saturation and Color Control are not available. As this image now contains no colour information, we cannot adjust colour. If you have produced a black and white image this way, it can be converted back to RGB mode (Image > Mode > RGB Color). This will seemingly have no effect to the image on screen. It will still look like a black and white grayscale image, but it now consists of three channels, Red, Green and Blue. This can be confirmed by looking at the Channels palette (Window > Channels). Photoshop can allocate the appropriate colour information to each channel, though they are identical, and colour toning is now possible.

An almost identical result can be achieved using the Desaturate command (Image > Adjustments > Desaturate) although this way the three colour channels are retained.

FINAL IMAGE / OPPOSITE / Portrait of Fiona after conversion to grayscale.

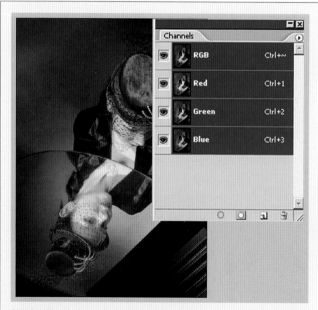

CHANNELS / This palette shows that a colour image is composed of three channels, Red, Green and Blue.

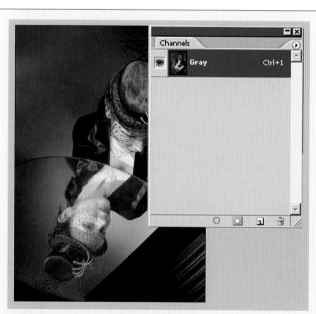

GRAYSCALE / Converting to grayscale discards the colour information, resulting in a single grayscale channel.

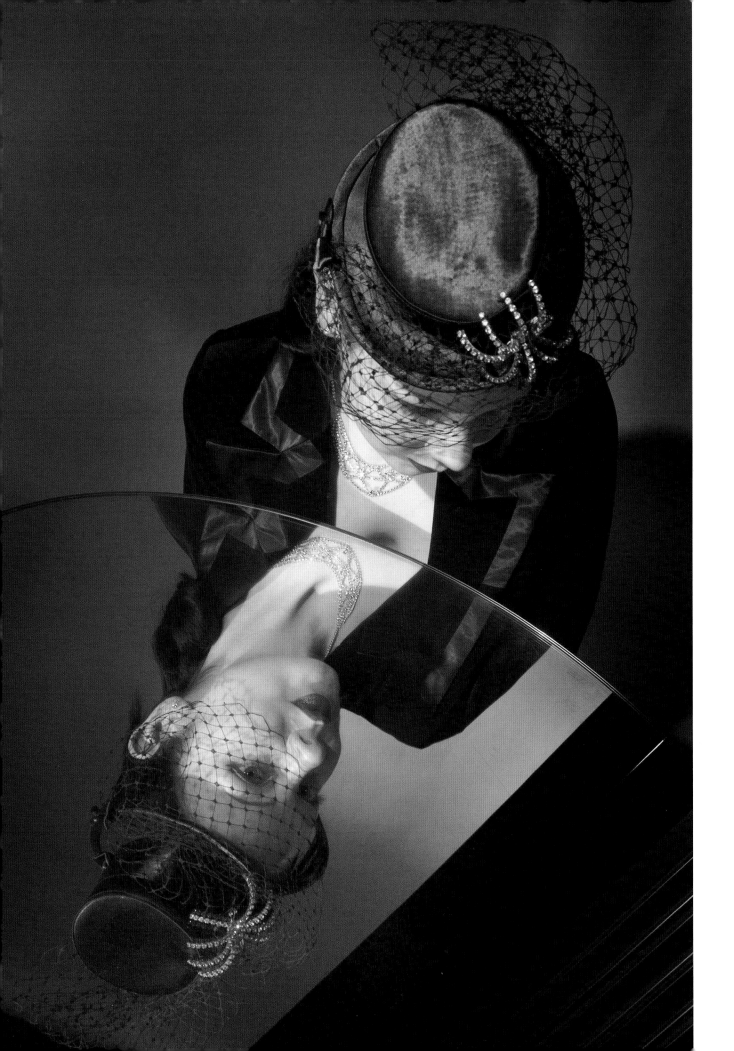

CHAPTER 1: CREATING DIGITAL MONOCHROME IMAGES
CONVERSION TO MONOCHROME

USING LAB COLOR

A technique favoured by many photographers is the conversion to monochrome using Lab Color. A normal colour image is usually composed of three channels of information – Red, Green and Blue. Open a colour image along with the Channels palette to see this. With the palette still open, now access the menu and go to Image > Mode > Lab Color. On converting the image to Lab Color, you will see that the Channels palette has changed. The information is now presented as a Lightness channel, which holds the luminosity data, and two channels, 'a' and 'b' which hold the colour information, green to red, and yellow to blue. Highlight the Lightness channel and your image will be shown as black and white only. Now got to Image > Mode > Grayscale and discard the colour information. The black and white image produced is now a single Grayscale channel but tends to have more contrast than a straightforward grayscale conversion.

ORIGINAL IMAGE / The colour image before conversion.

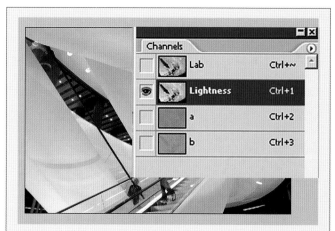

LIGHTNESS CHANNEL / Channels palette showing selection of Lightness channel after converting the image to Lab Color.

LAB COLOR CONVERSION / Black and white version using Lab Color.

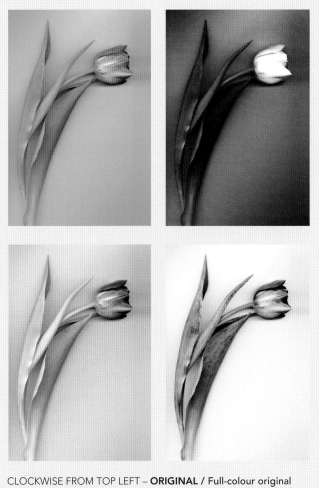

CLOCKWISE FROM TOP LEFT – **ORIGINAL** / Full-colour original image created by scanning a tulip on a flatbed scanner with a blue background. **RED CHANNEL** / This shows the darkening of blues and lightening of reds. **GREEN CHANNEL** / This gives a pleasant tonal arrangement and is the one that I will select. **BLUE CHANNEL** / This lightens the blue background and darkens the red and green colours.

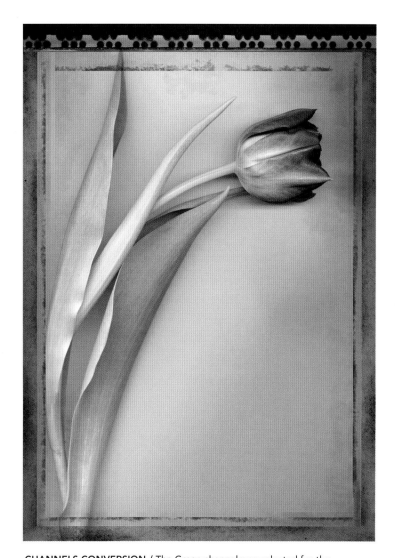

CHANNELS CONVERSION / The Green channel was selected for the final image as it produced the tones that best fitted the subject. The edges were darkened slightly using Levels and a Polaroid edge was added to complete the image.

USING CHANNELS

A colour image from a digital camera or scanned colour negative is normally composed of three channels, Red, Green and Blue. If we explore the Channels palette, we will see that each of these channels is actually monochrome and the colour is then assigned to each channel at the capture stage (camera or scanner). The effect is similar to taking a black and white photograph using red, green or blue filters on the lens. Remembering that colour filters tend to lighten their own colour and darken their complimentary colour, the appearance of each channel can be predicted.

RED CHANNEL: Red, orange and yellow tones will become lighter, and blues and cyans will darken. Blue skies and water will darken while red flowers, lips and even blemishes on faces will lighten.

GREEN CHANNEL: Leaves and grass will lighten. Anything containing the complimentary magenta will darken.

BLUE CHANNEL: Blue skies will lighten, red lips and brick buildings will darken.

If you were using film, a separate exposure would need to be taken with each of the three filters to achieve these effects. A digital colour image has the advantage here as the ability to 'select the filter' after exposure is a possibility. If the camera is used in black and white mode to shoot, this useful feature is lost. That is why it is best to shoot in full-colour mode.

The effect of each channel can be seen more clearly by 'splitting' the channels into their individual components. To do this, go to the Channels palette and click on the right facing arrow at the top right of the palette. Select Split Channels from the drop-down menu. The image will now divide into three separate windows, Red, Green and Blue. In the menu, select Window > Arrange > Tile Horizontally to view the three alternatives. The tonal range of each image can now be compared and the best one selected and saved.

CHAPTER 1: CREATING DIGITAL MONOCHROME IMAGES
CONVERSION TO MONOCHROME

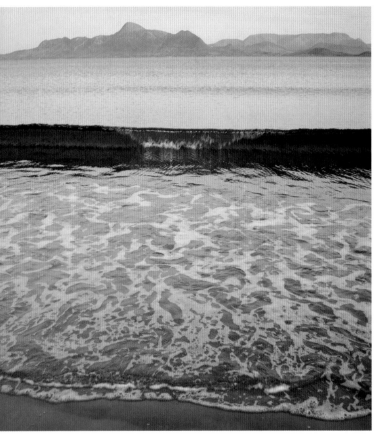

ORIGINAL IMAGE / The colour image before conversion.

USING CHANNEL MIXER

Now we understand how the three channels in an RGB image convey different tonal information, we don't have to be content with just one of the three alternatives. We can mix channels by various means and produce the best hybrid image from each of the three channels. A successful way to do this is to use the Channel Mixer. From the menu select Image > Adjustments > Channel Mixer. A dialog box will appear with three sliders, one for each channel (see Channel Mixer, below). Check the Monochrome box at the bottom left of the palette and the image will be converted to black and white. By default, the image produced is the same as the Red channel. If you look at the sliders you will see that Red is 100% and Green and Blue are 0%. Any of these sliders can now be adjusted to alter the tonal relationship between the colours in the image. A general guideline (but not an absolute rule) is to keep the total percentage between the three channels adding up to 100%. Less than this and you will lose shadow detail, more than this and you are in danger of clipping highlights. Another slider, the Constant, can increase or decrease the overall exposure, but it is fairly crude and is best avoided.

If you have found a good combination of channel mixing that suits your images, it can be saved and used again.

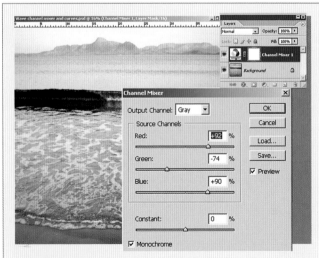

CHANNEL MIXER / In this palette, check the Monochrome box and use the channel sliders to adjust the tonality. Try to keep the total percentage to about 100%.

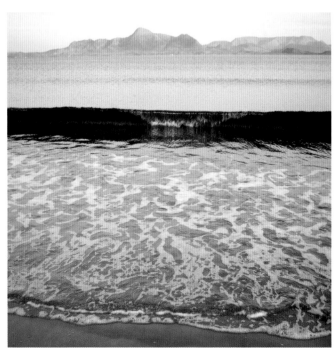

CHANNEL MIXER CONVERSION / The black and white version after using the Channel Mixer.

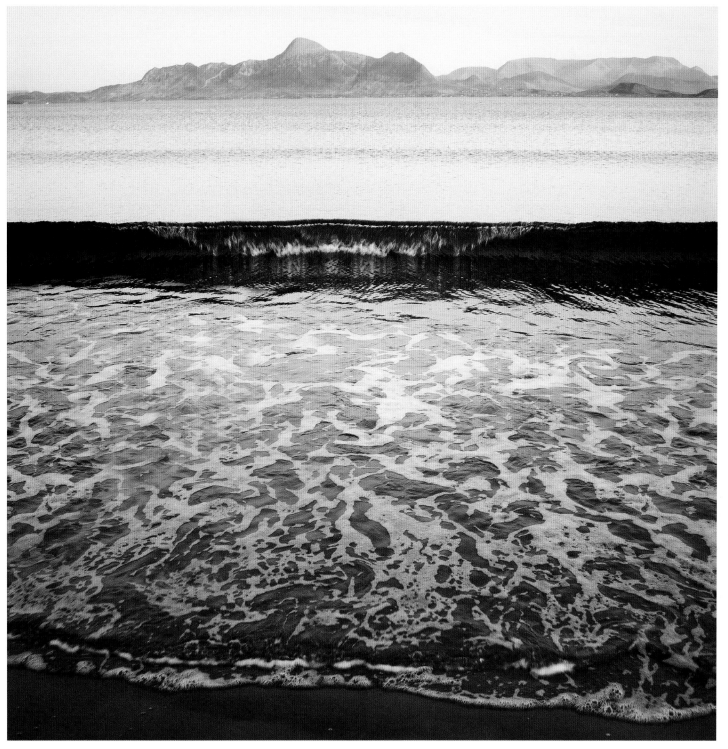

ADJUSTMENTS / Some local manipulation has been done to increase contrast and alter the shape of the wave.

Click on Save and a .cha file can be created that can be named and saved into a Channel Mixer folder for loading to any future images. Whether you choose to save or not, it is probably a good idea to use the Channel Mixer via the Adjustment Layers route. Open up the Layers palette and, rather than applying the Channel Mixer via the menu, click on the New Fill or Adjustment Layer icon at the bottom of the palette. Select Channel Mixer and this will then create a new Adjustment layer. The advantage of doing this is that you can always return to this layer and adjust the mix at a later stage.

HUE AND SATURATION

Another way of controlling tonal translations using channels is via the Hue/Saturation command. Open up an RGB original with the Channels palette on screen. Make sure all channels in the palette are highlighted in blue. Then turn off the eye icon on the Blue and Green channels, leaving only the Red channel with the eye turned on.

Now select Hue/Saturation from the menu (Image > Adjustments > Hue/Saturation). By adjusting the Hue slider to the left or right, you will affect the tonal relationship between all three channels.

8-BIT VERSUS 16-BIT

We discussed the meaning of bit depth earlier when considering the scanning of film (see pages 10–11). An 8-bit black and white image will produce a full-tone monochrome print with 256 shades of tonal information. However, the adjustments that are routinely made in Photoshop have a habit of damaging the tonal range and producing unwanted artefacts such as posterization and stepped tonal gradation. Using a starting image of 12-, 14- or 16-bit will allow such discrepancies to be masked, resulting in higher

quality prints. As we have seen, dedicated film scanners and TPUs on flatbed scanners allow us to produce 16-bit images from film. Digital cameras when used in JPEG mode usually produce 8-bit images. To produce a higher bit resolution, it is necessary to use a RAW file and software such as Photoshop CS2. The RAW image from a digital camera is usually 12-bit or more, which provides 4,096 tones in each colour channel. When such an image is opened in Photoshop's Camera RAW plug-in, it can be opened either as an 8-bit or a 16-bit image.

To illustrate the point, I have selected a 16-bit image that needs a small amount of tonal correction using Levels. A copy of the image has been made at 8-bit. As you can see from the original histogram (see Levels Adjustment, left), the levels needed adjusting to achieve a full tonal range. The black and white sliders were moved in slightly and a minor adjustment was made to the mid grey slider.

The same adjustment was made to both images and, on screen, they both look acceptable. However, if we look at the histogram again after the Levels adjustment, we will see a difference. The 16-bit image has a smooth transition throughout the complete tonal range (see 16-Bit Histogram, below left). The 8-bit image has a series of gaps (see 8-Bit Histogram, below). These are what the late photographer, Barry Thornton, referred to as the 'spikes of doom'. What they represent are missing pieces of information. The tonal range has been interrupted, producing steps between one tone and the next. Though this may not be too obvious on screen, the final print will show poorer tonal gradation

LEVELS ADJUSTMENT / The Highlight and Shadow sliders in the Levels palette have been moved inwards to achieve a full tonal range.

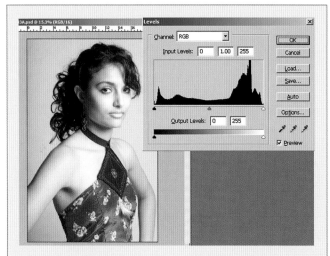

16-BIT HISTOGRAM /After Levels adjustment, the 16-bit image still shows a full range of tones with no gaps in the range.

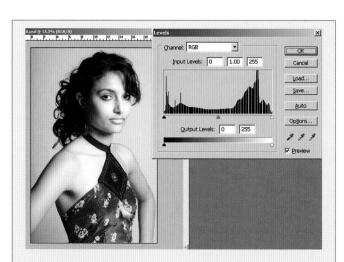

8-BIT HISTOGRAM / After Levels adjustment, the 8-bit image is exhibiting gaps in the histogram. These so-called 'spikes of doom' are missing information and can lead to posterization within the image.

(see 8-Bit Image, below). This is usually evident in areas such as the skin in portraits or skies in landscapes, in fact anywhere that should show subtle changes in tone. If extreme changes in Levels are necessary, these areas will look posterized.

A possible problem with producing a 16-bit image is the software you use for image manipulation. Older versions of Photoshop are not able to cope with 16-bit files and even Photoshop CS has some features that are not available when working in 16-bit. However, most of the important features such as Levels, Curves, Adjustment Layers and many filters are now fully compatible with CS2. All of these corrections should be made in 16-bit, only converting to 8-bit (Image > Mode > 8 Bits/Channel) as a last resort to access the extra features.

Working in 16 bit will double your file sizes but you should see an immediate improvement in the quality of your images, especially if you regularly use levels and curves. If you have to save copies of your work as JPEGs you will have to convert them to 8 bit first.

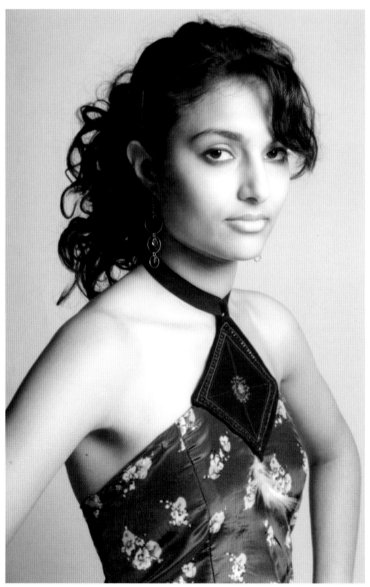

8-BIT IMAGE / Portrait of Kinjal in 8-bit grayscale.

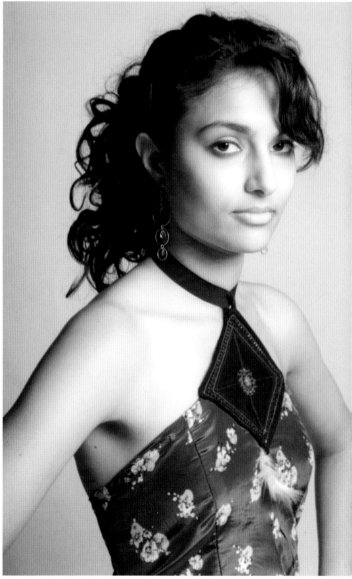

16-BIT IMAGE / Portrait of Kinjal in 16-bit grayscale.

CHAPTER 1: CREATING DIGITAL MONOCHROME IMAGES
USING RAW FILES

With both JPEG and TIFF files, in-camera processing usually occurs between capturing information on the sensor and recording to a memory card. The way information is processed can be set through the camera's menu. For example, contrast adjustment, white balance and sharpening are usually applied by the camera and such changes are permanent. Control has been relinquished

to the machine. To regain control we have to consider using another format – RAW.

As the name suggests, this format is as close as possible to the original information that is captured by the sensor. It allows us to make our own decisions as to how we process that information at a later stage. It also enables us to use the camera at its highest bit resolution, which means that images will contain more information, have a higher dynamic range and therefore be capable of higher quality. There's no doubt that the software available for converting RAW files will continue to improve in the future, so even better results from original RAW exposures will be possible.

FORMATS
Unfortunately, at the moment, there is not a single type of RAW file – several formats exist, depending upon the camera used. Most camera manufacturers provide software for converting their RAW files into TIFF files. Once the conversion is complete, most image-manipulation software can process the files. However, this is not the best approach to take. It is far better to work from the original RAW file and apply any changes directly. This can be done using either Photoshop CS2, Elements 4 or other third-party software such as Pixmantec RawShooter Essentials 2006.

Adobe has also introduced the DNG (Digital Negative) format. This is an attempt at producing a universal format, which is now supported by many software manufacturers such as Extensis and Apple, as well as camera manufacturers including Hasselblad and Leica. Adobe produces DNG converter software, which can be downloaded free from its website. We will be working with Photoshop CS2 to explain the general workflow.

SAVING
The initial step in my workflow is to save the original RAW images. I save the day's work to a named folder on my hard drive, then browse through the images in Adobe Bridge. At this stage I can delete, name, tag and add keywords or metadata. Being paranoid, I then copy the folder to a CD or DVD and make a back-up on an external hard drive. For most of my day-to-day work, I access files from the external hard drive. In this way, I can always return to my original RAW files no matter what I do to my images.

THE CAMERA RAW DIALOG BOX
Even if the intention is to produce a high-quality black and white image, we would normally start with a colour original, for reasons that have been explained. The way we manipulate this in the Camera RAW converter can

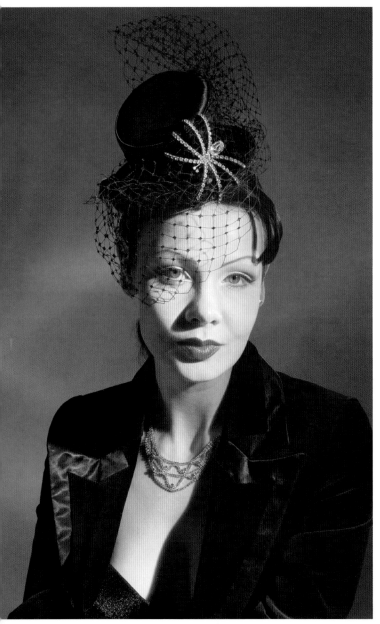

ORIGINAL IMAGE / The original colour image taken on Fuji S2 Pro digital SLR camera set to Raw shooting mode.

ADJUST PALETTE / The Camera Raw dialogue box in Photoshop CS2. The initial stage is to deselect all Auto settings in the Adjust menu and take manual control.

CHECK BOXES / Check the highlight and shadow clipping boxes before you adjust exposure. Any clipping will be seen as red in the highlights and blue in the shadows.

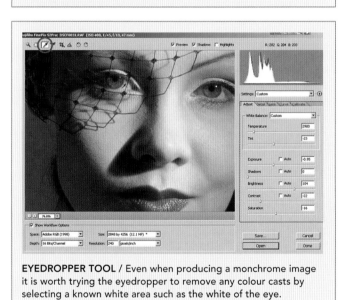

EYEDROPPER TOOL / Even when producing a monchrome image it is worth trying the eyedropper to remove any colour casts by selecting a known white area such as the white of the eye.

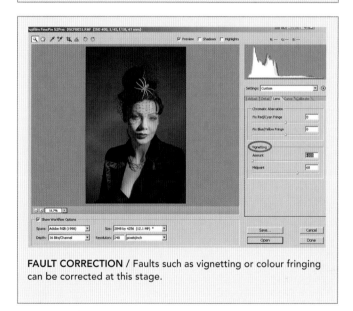

FAULT CORRECTION / Faults such as vignetting or colour fringing can be corrected at this stage.

have a significant effect on the subsequent conversion to monochrome. Opening an image in the Camera RAW plug-in produces a rather complex-looking dialog box. However, the procedure is fairly straightforward if a logical approach is taken. The image will appear in a large Preview area with a toolbar for basic manipulation above. On the right-hand side of the box is a histogram and below that a series of nested adjustment palettes.

INITIAL ADJUSTMENTS

Ensure that the Preview box is checked. This will allow you to see your changes in the large preview image. By default, the Adjust palette will be visible and the various controls checked to Auto. They can be unchecked to take full manual control.

WHITE BALANCE

This may not seem important for monochrome workers, but overall colour casts can affect the way colours are converted to tones of black and white later. In the White Balance drop-down menu there are a number of options. Choose the one that most closely matches the shooting conditions. In the toolbar at the top left of the screen is an eyedropper tool that can be used if there are neutral areas in your image. Click around the whites or greys to correct any colour cast.

EXPOSURE

We now need to extract the maximum range of tones from the digital negative. A familiar histogram is shown at the top right of the screen, which displays each of the three colour channels. As the Exposure slider is moved to the right, the histogram moves to the right. Move this as far as possible without clipping important highlights. Now move the Shadow slider to the left to expand the shadow range. Check the Highlight and Shadow boxes in the View Options at the top of the screen. Warning colours will now appear on your preview image if detail is being clipped. Highlights will show as a red colour and shadows as blue.

The image can be further adjusted for brightness, contrast and saturation if required, though you may feel that Curves is a better option when the image is opened in Photoshop. It is possible to reduce saturation to zero to produce a black and white image but, again, I would probably use one of the many alternative methods found in Photoshop.

WORKFLOW OPTIONS

Below the Preview window can be found the workflow options where the image colour space and size can be set.

SOURCE: This is the colour space you will be assigning to the image. The most useful to use is Adobe RGB (1998).

DEPTH: Here you have the choice of working in 8-bit or 16-bit. For highest quality use 16-bit.

SIZE: The number of pixels can be changed here. Generally, I would select the size indicated by the accompanying star, which is usually as the camera recorded the image. If you wish to interpolate later, you can.

RESOLUTION: No need to change this as it is set to a default printing resolution of 240 dots per inch. The image is now ready to open in Photoshop.

ZOOM TOOL / The tool bar has rudimentary tools such as the zoom tool, so the effect of any changes can be more easily seen.

FINAL IMAGE / OPPOSITE / The final monochrome image after using the Camera Raw adjustments in Photoshop CS2. This allowed me complete control over the positioning of highlight and shadow detail. The conversion to monochrome was via the Channel Mixer.

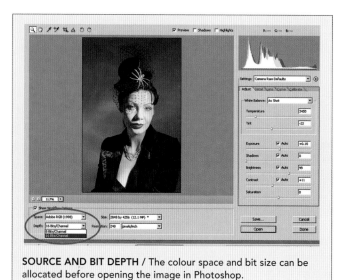

SOURCE AND BIT DEPTH / The colour space and bit size can be allocated before opening the image in Photoshop.

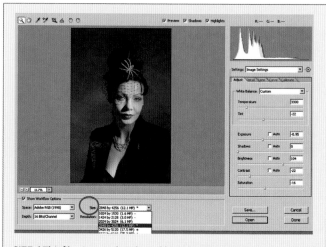

SIZE / The file size can be altered here by interpolating. I suggest leaving it at the default size shown by the asterisk.

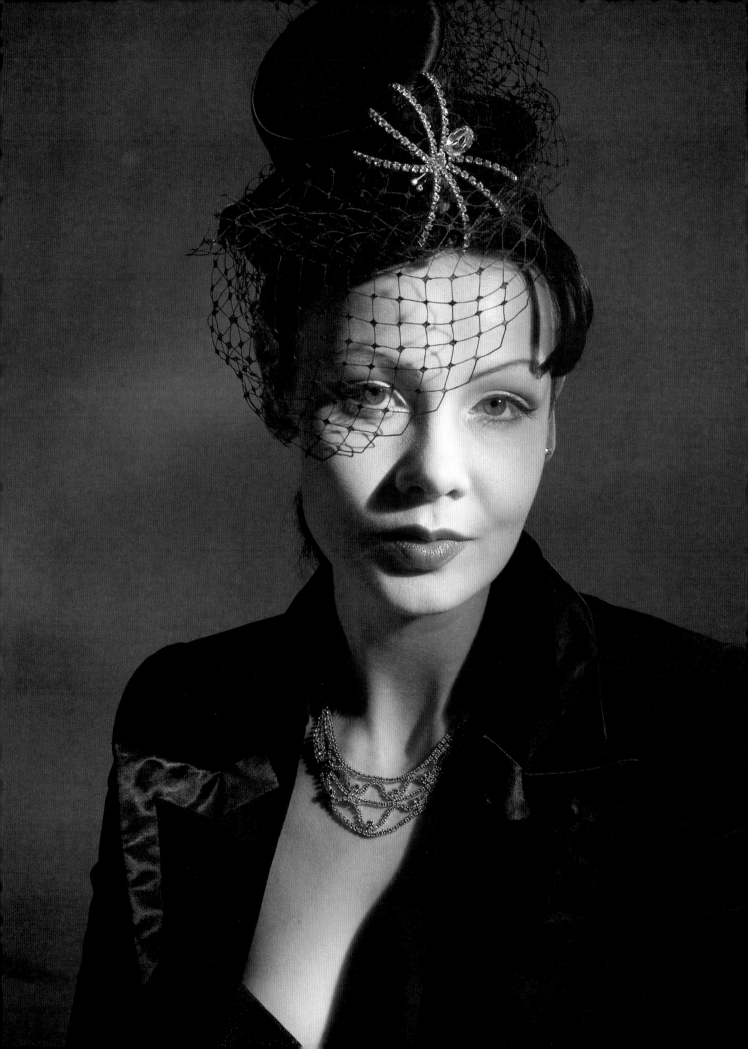

CHAPTER 2: TONAL CONTROL
CONTROLLING CONTRAST

Contrast is possibly the single most important consideration when producing a fine art black and white photograph; if an image lacks contrast, it will appear flat and uninteresting, but if it has too much then important highlight and shadow detail will be lost. Contrast can also contribute to the mood of the image so controlling it has obvious benefits.

Traditionally, photographers would use different grades of paper in the darkroom; a soft, low-contrast image could be achieved by printing on grade 1 paper, while a much punchier one could be created by printing on grade 5. There are several methods for adjusting contrast digitally, but the most flexible of these are Levels and Curves. Some newcomers to Photoshop might be tempted to use the Brightness/Contrast command, but this is a fairly crude way of making changes.

ORIGINAL IMAGE / As this image was unintentionally underexposed at the capture stage, the tones lack contrast.

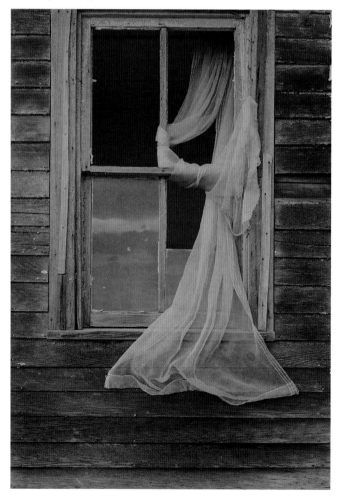

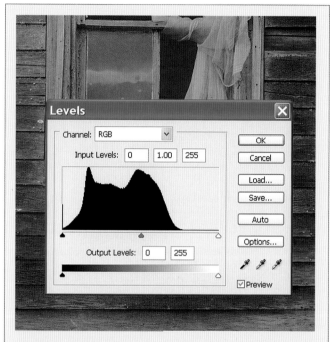

THE HISTOGRAM / When you call up Levels, a histogram automatically appears showing the tonal distribution of the image. The range of tones is set out horizontally, while the height of each column illustrates how much each tonal value appears within the image. In this example, the distribution is heavily weighted towards the mid and darker tones. The lack of information on the right of the histogram suggests that there are no highlights.

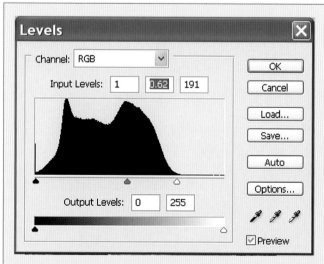

ADJUSTING HIGHLIGHTS / By dragging the highlight slider inwards, the contrast of the image will increase. In this case it is necessary to drag the slider to the value of 191 before highlights begin to appear.

ADJUSTING CONTRAST USING LEVELS

If you come from a darkroom background, then Levels is easy to understand. It allows you to make adjustments to the highlights, shadows and midtones. But whether you opt to use either Levels or Curves, it is always a good idea to set up an Adjustment layer first; if you are dissatisfied with the result, then this can be discarded without affecting the pixels in the Background layer.

Levels maps out the full tonal range of the image, from zero to 255. When using Levels, a histogram appears that allows you to see how the tones are distributed throughout the image. To darken an image, drag the solid black slider to the right; alternatively, to lighten the image, drag the solid white slider to the left. By dragging these two sliders closer together, contrast increases. By clipping the pixels at the extreme ends of the tonal range the areas of pure white and pure black are extended. Rather than aim for the full gamut of tonal values, it is possible to ensure that all pixels between 0 and 15 are black whilst all pixels between 245 and 255 are white. From a printing standpoint, this is not necessarily a problem as it is virtually impossible to detect these tonal variations at the extreme ends of the tonal spectrum, so very little is lost. The Gamma slider (the grey triangle in the middle) determines whether the midtones are lighter or darker, depending whether it is pushed towards the highlights or shadows.

A simple method for reducing contrast requires using the Output Levels. This is the bar at the bottom of the Levels Dialog box. This normally serves as a tonal overview of the image, however if you drag the black Output Levels slider to the right whilst dragging the white Output Levels slider to the left, the contrast of the image will be reduced.

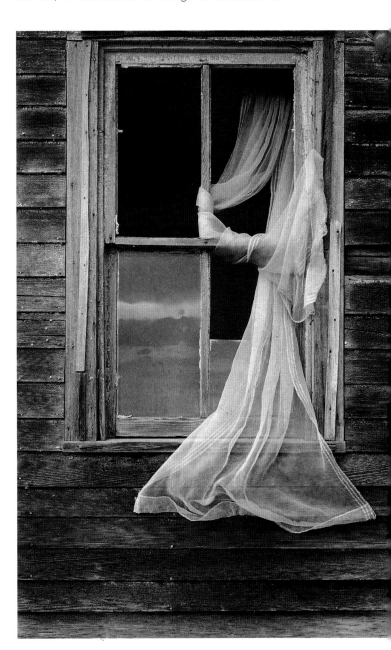

AFTER ADJUSTMENTS / This new histogram shows a more even distribution of tones throughout the image. But more importantly, by dragging the highlight slider inwards, contrast has been substantially increased.

FINAL IMAGE / As the range of tones has been compressed, the previously dull tones in the curtain now appear much brighter. Also, as the Gamma slider is pushed toward the highlights, the image appears to darken, which helps to further increase the overall contrast.

ADJUSTING CONTRAST USING CURVES

Curves offers the most versatile set of controls for making tonal adjustments in Photoshop. When you call up Curves, the graph will default to a straight diagonal line indicating 0 (black) to 255 (white). The horizontal axis of the graph represents the input values, while the vertical represents the output or adjusted values. Contrast is controlled by the incline of the curve; the steeper it is, the greater the contrast, the shallower it is, the lower the contrast. In order to increase contrast, place the cursor a quarter way up the curve and drag this downwards to darken the shadows. Next, place the cursor on a point three-quarters up the curve, but this time drag the curve upwards in order to lighten the highlights. Conversely, to reduce contrast, place the cursor a quarter way up the curve, but this time drag it upwards to lighten the shadows, then place the cursor three-quarters up the curve and drag downwards in order to dull the highlights.

USING BLENDING MODES

There are other less obvious but equally effective methods for increasing contrast; one of these involves applying Blending Modes. Call up the Layers palette (Window > Show Layers) then make a Duplicate layer. This gives you access to the various Blending options, although not all of these increase contrast. Those that do include:

OVERLAY: increases both the contrast and the saturation of the image and is an excellent first step.

HARD LIGHT: darkens the pixels but increases contrast at the same time. When using Hard Light, the changes may prove too excessive, but these can be easily countered using the Opacity slider.

SCREEN LIGHT: lightens the pixels and increases the contrast of images that appear rather dark.

SOFT LIGHT: lightens tones that are lighter than 50% grey and darkens tones that are darker than 50% grey; consequently it has the effect of only gently increasing contrast.

ALTERING TONES WITH THE CHANNEL MIXER

Providing your image remains in RGB mode then, as we have seen in Chapter 1 (pages 18–19), the Channel Mixer is another useful method of controlling contrast and altering tones. Make an Adjustment layer and select Channel Mixer. It is important that the Monochrome option at the bottom of the dialog box is selected. As the channel sliders are moved, considerable changes can be made to the overall contrast and tonality of the image, although this change is best made while the image is still a RAW file. Once again, you have the option of modifying the effects using the Opacity slider.

ORIGINAL IMAGE / While all areas show good highlight and shadow detail, this image lacks the contrast one would expect to see in a fine art monochrome print.

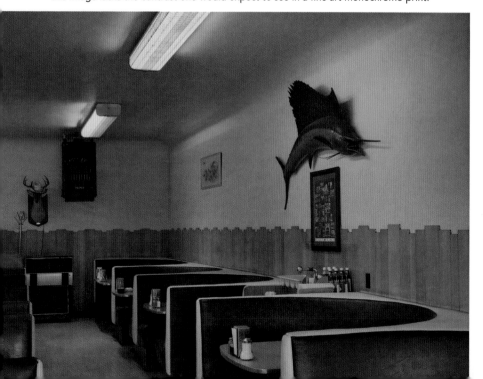

INCREASE THE CURVE / Contrast is improved by increasing the incline of the curve. Pegging it helps to ensure that the shadow and highlight detail is retained.

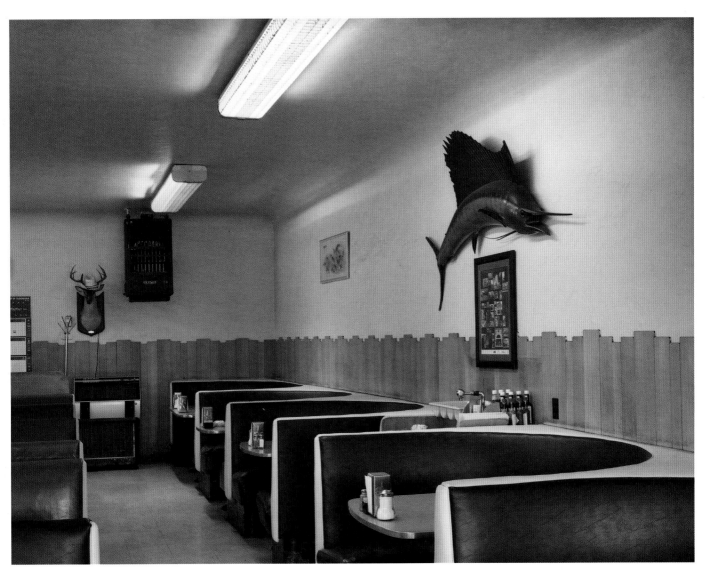

FINAL IMAGE / Curves are unquestionably the most versatile method for increasing contrast, but it is important that the curve is applied gently in order to retain smooth tones. The increased contrast has added drama to this image.

ORIGINAL IMAGE / A desaturated image in RGB mode. While care was taken to ensure good highlight and shadow detail, this has been achieved at the expense of the foreground, which appears dull.

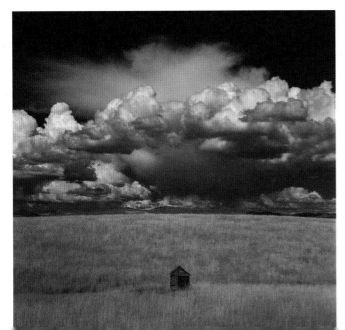

OVERLAY / Making a Duplicate layer and then applying Overlay is an excellent way of increasing contrast. In this example, the effects were slightly countered by decreasing the Opacity.

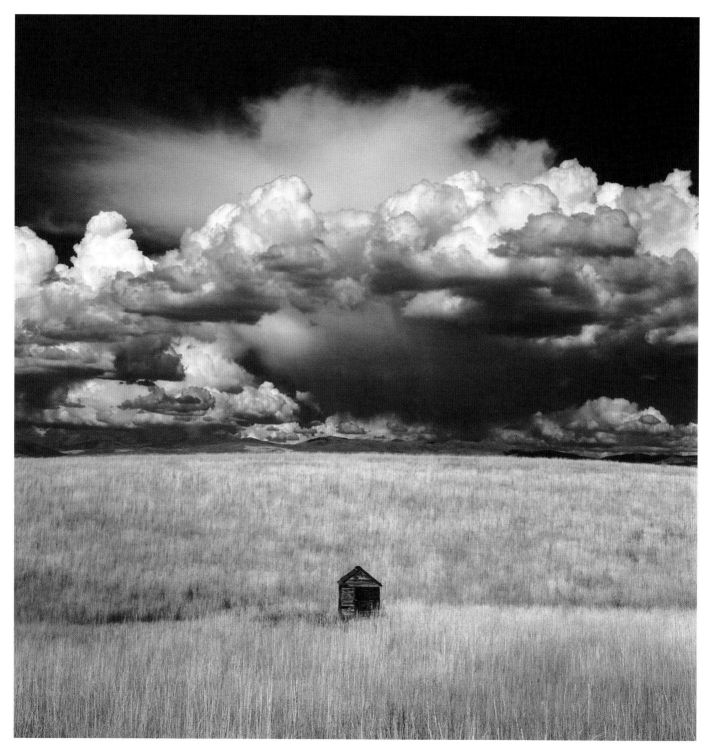

FINAL IMAGE / By lightening the tones and increasing contrast using Overlay, greater emphasis is made of the dramatic cloud formations. Using the Blending Mode sometimes offers a worthwhile alternative for introducing contrast.

FLAT LIGHTING / This is a classic example of a monochrome image that has been taken in subdued lighting. Although there is clear detail throughout the image, the tones appear dull and lack contrast. This could be remedied using either Levels or Curves, but a more subtle outcome can be achieved by blending Duplicate layers.

SPLIT-GRADING

This is a principle well understood by most darkroom printers that involves making a separate high and low contrast exposure on to a single sheet of variable contrast paper using filters. To achieve very high contrast, a grade 5 filter would be used, while a very low grade filter (grade 00), would be used to print low contrast. Individually, each of these exposures offers both advantages and disadvantages; printing high contrast, the tonal separation is greatly increased, but this is achieved by losing highlight and shadow detail. Printing low contrast undoubtedly retains all the subtle tonality of the image, but the contrast

is often significantly compromised. The thinking behind split-grading is that it is possible to harness the advantage of both exposures. As a result, contrast is increased but without having to sacrifice important highlight and shadow detail in the image.

Similar principles also apply to split-grading digitally, but it is a lot quicker to achieve and the effect can be as subtle or pronounced as you see fit. To do this, call up the image in Photoshop and desaturate it. Make two Duplicate layers and name them Low Contrast and High Contrast respectively (see Duplicate Layers, below left). Select the Low Contrast layer and, using the Brightness/Contrast command, reduce the contrast by -50 (or at least until there is visible detail in both the highlights and shadows). Remember, this is just the beginning. If you need to reduce contrast further, providing you do not flatten the layers, further adjustments can always be made later.

Next, activate the High Contrast layer and, once again using the Brightness/Contrast command, increase the contrast by 50%. Now comes the balancing act. Firstly, select Overlay from the Blending Mode (which increases contrast), then drag the Opacity slider until there is visible detail throughout all the highlights, while still retaining the contrast. As the Low Contrast layer shows through the High Contrast layer, the overall contrast will be incrementally reduced.

DUPLICATE LAYERS / Making two Duplicate layers, one which shows low contrast and another showing high contrast, then using a combination of the Blending Mode and the Opacity slider, it is possible to achieve an image that shows high contrast, yet retains excellent shadow and highlight detail.

ADJUSTED TONES / The sky and the foreground have been lightened, but this has been achieved without compromising highlight detail. By way of contrast, the darker areas appear punchier. By adjusting the tones in this way, the inherent graphic qualities of the image have become much more apparent. Using Layers has allowed more control over the tonality of the final image.

CHAPTER 2: TONAL CONTROL
SELECTIVE TONAL CONTROLS: DODGE AND BURN

Often, particularly when taking photographs in contrasty lighting conditions, the exposure we use is an unwelcome compromise, seeking to balance excessively bright highlights with impenetrable shadows. The results are rarely satisfactory but this can be overcome by dodging and burning, which involve making localized tonal changes.

It should also be noted that fine art printing is very much an interpretative process. Often, the balance and aesthetics of an image, even without obvious exposure problems, can be greatly improved by lightening the tones in one key area or darkening them in another. Working digitally, you can experiment until you have the effects you find most personally pleasing.

ORIGINAL SCAN / When an image is scanned, certain parts often appear too dark or too light. In this example, while most of the sky seems to work well, the rising steam in the background appears dull. Most of the highlights in the foreground also need to be lightened.

USING THE DODGE AND BURN TOOLS

These are modelled on the traditional dodging and burning darkroom techniques for lightening and darkening. In order to lighten parts of the image, the darkroom printer would use a small piece of card attached to a thin piece of wire, which would be used to shield parts of the image during the exposure. This was known as the dodge tool. Similarly, in order to darken parts of the image, a small hole would be cut into a piece of card, the burn tool, which could be used to give additional exposure to certain areas. By balancing these two techniques, a more satisfactory print could be produced. The Photoshop Dodge and Burn tools work on much the same principle as the darkroom method, except they offer considerably more control.

It is not recommended that you use the Dodge and Burn tools to change large areas. Levels and Curves are

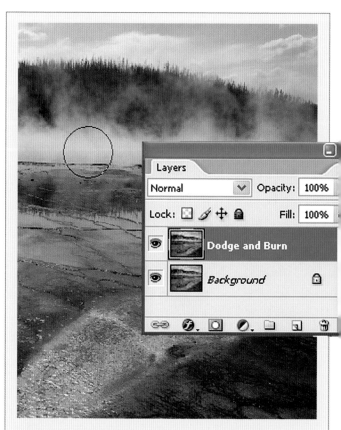

LOCALIZED CHANGES / Apply a large, soft Brush set to a low Exposure setting. Used in conjunction with the Navigator, it is possible to make very accurate localized changes.

TOOL OPTIONS / The Dodge and Burn tools offer various options including Brush Size, Range and Exposure. This allows you to make accurate adjustments.

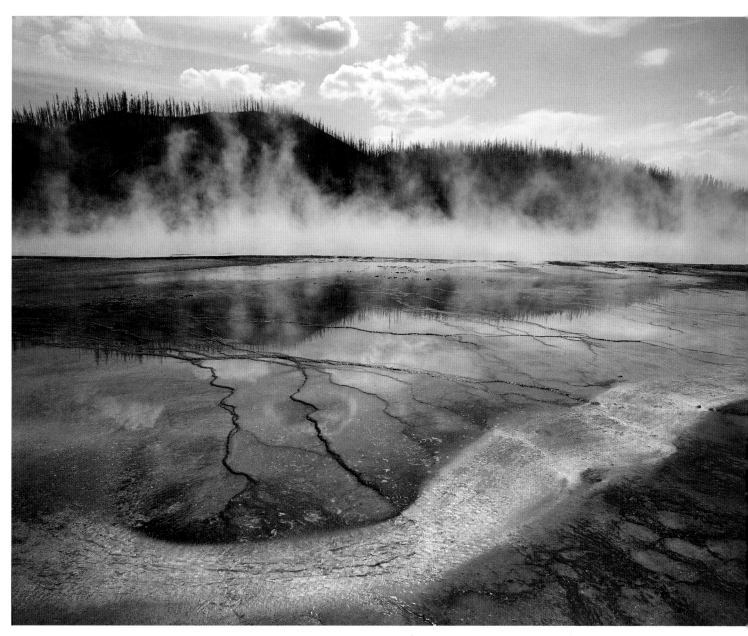

FINAL IMAGE / There is a great advantage in being able to selectively lighten and darken parts of the image. The Dodge and Burn tools have been used to lighten the rising steam and darken selected areas in the foreground.

capable of doing a much better job; they are, rather like their darkroom antecedents, an excellent way of making localized changes.

DODGING

To lighten the image, use the Dodge tool. Firstly, select an appropriate Brush Size. Newcomers to Photoshop often opt for one that is too small for the task. A larger Brush will allow you to complete the job with fewer brushstrokes and if it is soft edged, the results will be smoother. The next task is to choose a suitable range. Unlike in the darkroom, using these Photoshop tools allows you to specify the tones you wish to change. Finally, set Exposure to control the intensity of the tool. I rarely use one higher than 15%; it is far simpler to use a low exposure setting and build up the effects gradually.

It is very easy to overdo this, so make one sweep and then assess the effects.

BURNING

Use the Burn tool to darken pixels in your image. In most respects it operates exactly like the Dodge tool although, when burning-in detail, try using an exposure higher than you would for dodging.

Remember, using these tools is not an exact science, so it is a good idea to start with a Duplicate layer. If you make a mess of the dodging and burning, discard that layer and start again. The Dodge and Burn tools work well when used to make localized changes, but if more complex tonal alterations are required, it helps to use a Gray Fill Adjustment Layer (see pages 40–41).

LOCAL TONAL CONTROL USING SELECTIONS

In the traditional darkroom, highlight areas could be burnt-in and shadow areas dodged to balance extremes of contrast. In black and white work particularly, the brightest area of an image immediately draws the attention. If this happens to be a secondary part of the picture, it will draw the eye away from the primary subject. Therefore we need to tone down these unwanted highlights.

In this image of two statues, the main subject is the standing male but the lighting in the museum has highlighted the seated figure. We need to darken down this area so that the viewer's attention is transferred to the main subject. To do this we firstly make what is known as a 'loose selection'. There are many ways of making selections in Photoshop. Some are very precise and require a great deal of work but in this case there is no need to be too accurate as the burning-in will be blended gradually with the surrounding area.

Using the Freehand Lasso tool, roughly draw around the figure. Press Q on the keyboard and you will see the area selected surrounded by a red mask. This red area is protected from any changes that are now performed. However, you will notice that the edge of the selection is very precise and hard (press Q again to come out of Quick Mask mode). In the darkroom this would be the equivalent of cutting a hole in a piece of card and laying it on to the surface of a piece of photographic paper. The card would

mask and the hole would allow an area to be burnt-in. The result would inevitably be a sharp change in tonality, which would be very noticeable in the print. To overcome this in the darkroom, the card would be raised above the surface of the paper and moved gently during an exposure to soften this transition. The digital equivalent of softening the selection uses a process called Feathering.

FEATHER / The selection has been made with the Lasso tool and a Feather Radius of 150 pixels selected.

ORIGINAL IMAGE / The initial image requires the seated figure to be darkened, to bring our attention back to the main subject.

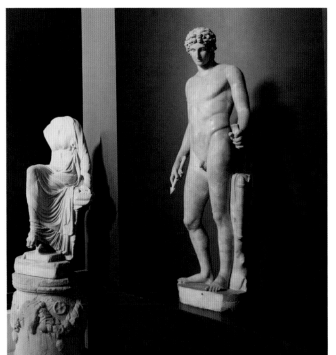

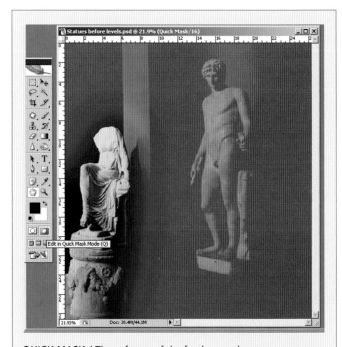

QUICK MASK / The softness of the feather can be seen by activating Quick Mask mode.

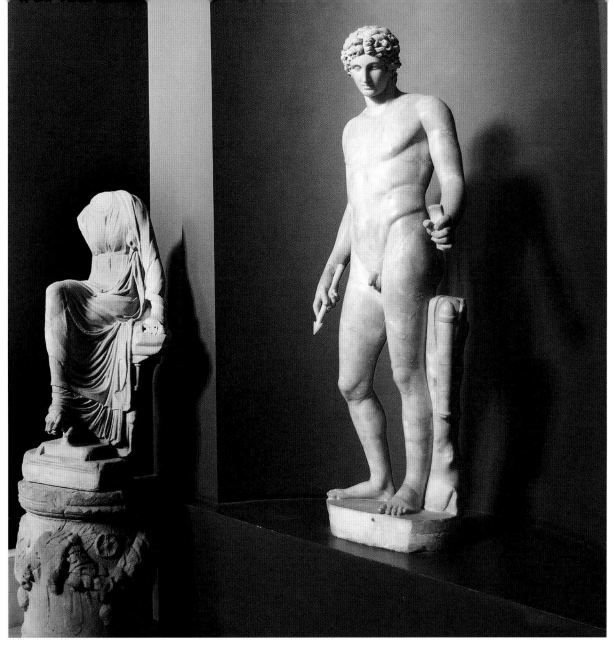

FINAL IMAGE / The final image shows a much improved balance of tonality and now the standing figure takes prominence.

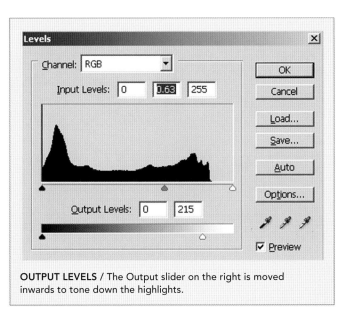

OUTPUT LEVELS / The Output slider on the right is moved inwards to tone down the highlights.

FEATHERING

After making the selection, go to the menu and Select > Feather. A dialog box will appear that allows you to set the degree of feathering in pixels (see Feather, above left). The larger the number, the softer the selection will be. The number you choose will be determined by the size of the image and how soft you want the transition. To check, press Q again and you will see the effect of the feathering on the mask (see Quick Mask, left).

When you are satisfied with your selection you can alter the tonality within it by calling up Levels. The histogram now refers only to the area inside the selection. To tone down the highlight areas, I moved the highlight Output slider to the left. Initially it is set at 255, which means that any pure whites in the selection will be output as pure white. By reducing the Output to 215, these highlight areas will be toned down (see Output Levels, left). With the selection still active, the tonality of the rest of the image can be adjusted by inversing the selection (Select > Inverse).

COPY AND PASTE

There are times when dodging and burning techniques just don't work. In particular, areas of an image that are totally burnt-out or have very little detail are a problem. Using normal burn methods only produces featureless grey areas, which look less than convincing. The original scan of the nude shot, shown opposite, is a case in point. The strong backlight has produced a very light patch in the top left-hand corner, which looks wrong when the Burn tool is used. In this situation a better approach is to fill the burnt-out area with appropriate detail from another part of the image. The lower left detail is ideal. It would be relatively easy to use

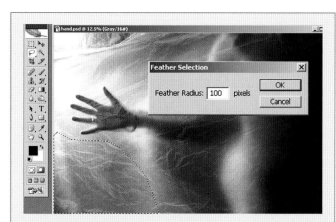

SELECTION / A rough selection using a 100 pixel Feather has been made of the area to be copied.

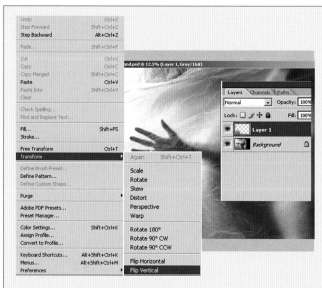

FLIP COPY LAYER / The selected area has been copied to a new layer, which is then flipped vertically and moved into place.

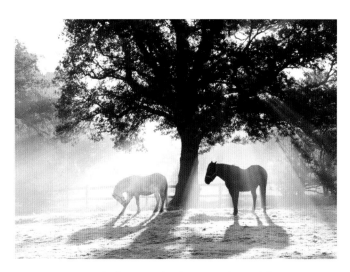

ORIGINAL IMAGE / A burnt-out bright area in the top left corner spoils the overall effect.

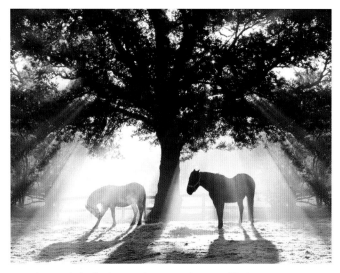

SYMMETRY / The final image has a good sense of balance and symmetry and we have gained a few extra rays of sunshine.

the Clone tool to clone detail into this area, but a better approach would be to copy and paste.

To begin, the lower left area is roughly selected using the Lasso tool and heavily feathered by 100 pixels (see Selection, above top). When we copy and paste the selection, the Feather will ensure a smooth join. To copy, use control C, and to paste control V. This will put the copied selection into a new layer. Alternatively, use control J, which copies and pastes in one action. The copied selection could now be moved over the burnt-out area, but the

tonality would be wrong. A more natural look is achieved by flipping the selection vertically (Edit > Transform > Flip Vertically). Now use the Move tool to take the selection to the top of the image. The image can then be flattened and adjustments to tonality achieved by using Selections and Levels. If the copying has produced a too obvious duplication, some minor cloning can be used.

In the image of the horses opposite, again there is strong backlight that has picked out some very pictorial rays of sunshine. However, the left-hand side of the image is bright and uninteresting. This can be remedied by using the same copy and paste technique. In this case, the right-hand side of the image has been roughly selected and copied on to a new layer. Then the copied section has been flipped horizontally and moved across to the left-hand side. Minor adjustments can then be made to this area using the Eraser tool set to a large, soft-edge brush. After flattening the image, any obvious repetition can be cloned over. In this case, the symmetry that has been created adds to the image.

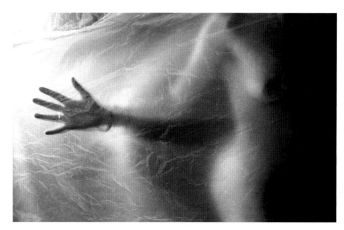

ORIGINAL IMAGE / The top left area of this image is messy and distracting.

AFTER COPY AND PASTE / The copied section has filled the original bright area and Selection and Levels have been used to darken this area slightly, drawing attention to the hand and figure.

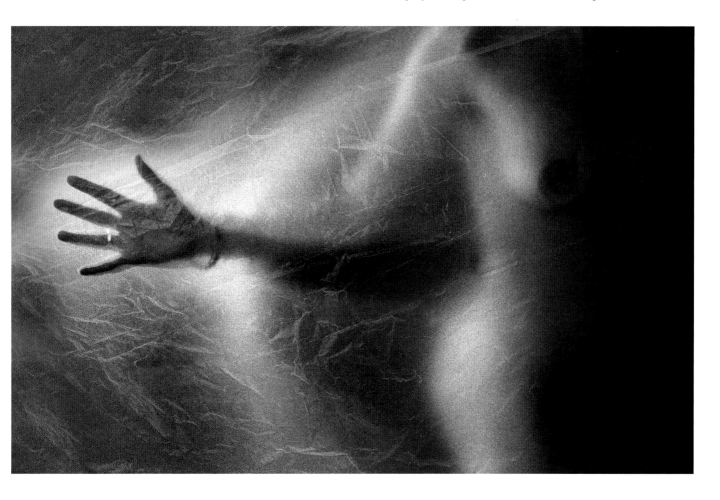

GRADIENTS AND QUICK MASK

Bereft of colour, a black and white image is highly dependent on tones for its impact and being able to make seamless adjustments is part of the skill. In the darkroom, the printer would often use customized pieces of card to make these important changes and quickly learned to keep the card moving in order to disguise the process. Obviously working digitally, we need to think of another way of achieving this.

Often, in order to create a tonal balance, a photograph needs to be lightened or darkened incrementally. For example, when photographing an image that is illuminated by strong side-lighting, it will appear lighter on the side nearest the source of the illumination. Visually this can appear unsettling. A common problem occurs when photographing landscapes as, unless corrective filters are used, the sky will appear much brighter than the landscape. Accurately exposing for a landscape is always difficult, if only because the sky can be several stops lighter than the ground. Remedying this by selecting then darkening the sky usually proves unsatisfactory because this can look false around the horizon.

The ideal solution is to darken the upper parts of the sky without affecting the areas immediately above the horizon; only in this way can a true sense of aerial perspective be suggested. Using Curves or Levels, even if the selection has been substantially feathered, is not sufficient to achieve this. However, by applying the Quick Mask allied to the Gradient tool, it is possible to make a selection that gently graduates for a much more subtle effect.

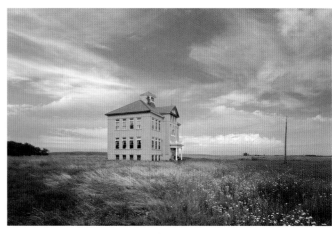

THE SKY BEFORE / Sometimes it helps to darken down the sky in order to add impact. Being able to do this incrementally helps enormously.

APPLYING GRADUATED CHANGES

Select the Quick Mask mode, and then select the Gradient tool. Position the cursor where you want the gradient to start – in this example, at the top of the image. Click and drag the cursor downwards. It is not necessary to drag the cursor the full way, merely drag it double the length of the area you wish to affect. The cursor can be dragged in any direction and any length, therefore it is possible to apply graduated changes to virtually any part of the image. On releasing the cursor, a graduated ruby lith will appear over the area that you do not wish to change (see Quick Mask, below left). Click the Standard mode, and the 'marching

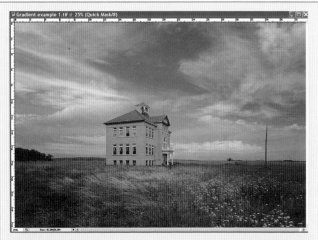

QUICK MASK / When a Quick Mask is applied, only the area not covered by the mask becomes the selection.

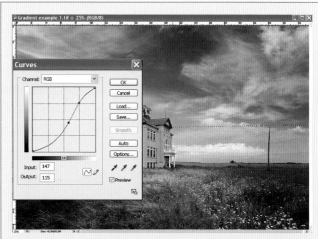

DARKEN WITH CURVES / Using Curves, the selected area has been darkened. The highlights were pegged to retain contrast.

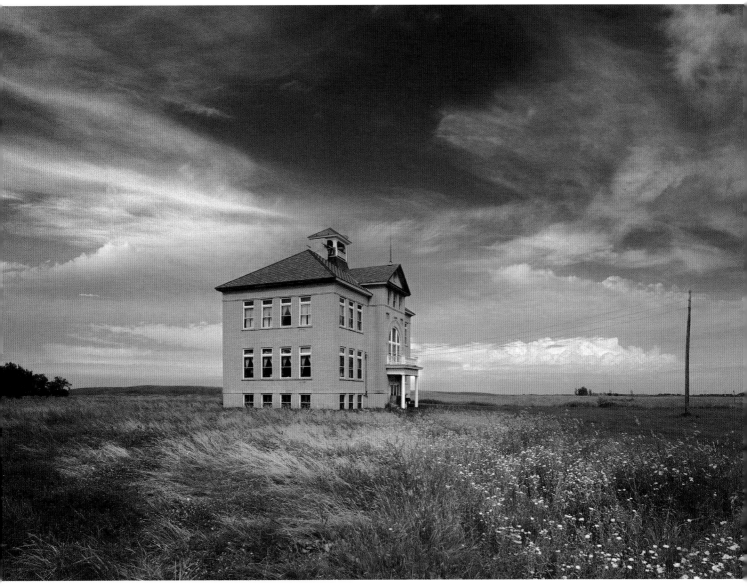

AFTER TONAL CHANGES / Burning in the sky is a time-honoured monochrome technique that helps to introduce a certain gravitas to the image. By using Quick Mask and the Gradient tool, these tonal changes can be applied incrementally.

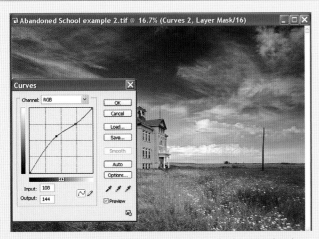

LIGHTEN WITH CURVES / To counterbalance the heavier sky, the foreground has been selected and incrementally lightened.

ants' denoting a selection will appear in the upper section of the image. Initially this selection may appear the same as any other but once you begin to apply a tonal change the effects will appear incremental.

At this point, any of the standard methods for making tonal changes can be applied. In this example, Curves was used to darken the shadows and midtones in the upper part of the image, without altering the highlight detail. This has been achieved by pegging the final quarter (to ensure that the highlights remain unaffected), then pulling the curve towards the darker tones. Thus, a more pleasing tonal balance has been introduced. Having achieved this, further tonal adjustments were made to the landscape by simply inversing the selection (Select > Inverse). This does, of course, remain a graduated selection so as the landscape is lightened, the effects will be far less noticeable at the horizon point.

DODGING AND BURNING USING A GRAY FILL LAYER

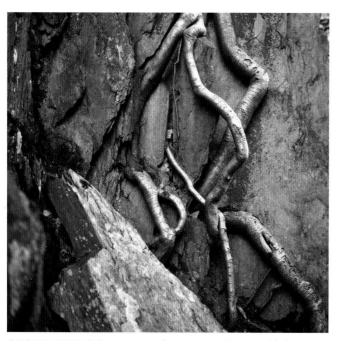

ORIGINAL SCAN / This was a scan from an original 6 x 7cm black and white negative in 16-bit grayscale, using the histogram control in the scanner software to ensure a full range of tones. The image was then cropped and any dust marks cloned out. The intention was to emphasize the tree roots and tone down the rock wall and rock to the lower left. A simple global Levels or Curves control was not appropriate, so local dodging and burning was necessary.

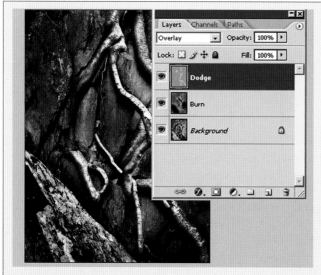

GRAY FILL LAYERS / Two layers were created, one for dodging and one for burning. With the Blending Mode on Overlay, a soft-edged Brush was used to add black or white to dodge or burn.

Using the normal Dodge and Burn tools in Photoshop will produce very acceptable results if handled carefully, but the disadvantage is that any changes to the image are permanent. Using Adjustment layers means that the image can be changed and returned to as many times as required without affecting the background image.

We will return to the preset Adjustment layers throughout this book, but for the effect shown here, you simply create a new layer above a background layer. Click on the Add New Layer icon at the bottom of the Layers palette or Layer > New Layer from the menu. This will produce a transparent layer, which you fill with a 50% grey by going to the menu, selecting Edit > Fill and then selecting 50% Gray from the contents list. Applying this will completely obliterate your background image with a uniform grey tone. Don't worry, as you now select a Blending Mode for this layer. You can use Soft Light or Hard Light, but I prefer Overlay. Select this and the image returns to normal (any pixels lighter or darker than 50% grey are now visible, i.e. all of them). Now you can selectively dodge or burn the grey layer and this will darken or lighten the image.

BURNING
To do this, set the Foreground and Background colours to the default black and white. Now select the Brush tool with a soft edge and paint on the grey layer with foreground black. This will darken the image and, with the default brush settings of 100% Opacity, it will probably be very severe. To be more subtle, reduce the Opacity of the brush and work gradually to build up the amount of burning necessary. The Opacity setting will be determined by the underlying tonality of the image so you will have to experiment.

DODGING
To lighten an area, change the Foreground colour to white. Now the brush will lighten areas of tone. Again start with a relatively low Opacity setting – try about 10% to begin with. If you wish, you can create separate Fill layers for dodging and burning to make things simpler to assess (see Gray Fill Layers, left). By using the eye icon next to the Fill layers you can switch them on and off to see the effect of your dodging and burning.

FINAL IMAGE / OPPOSITE / After dodging and burning, the shape and form of the tree roots now stand out strongly against the surrounding rocks and seem to glow with light.

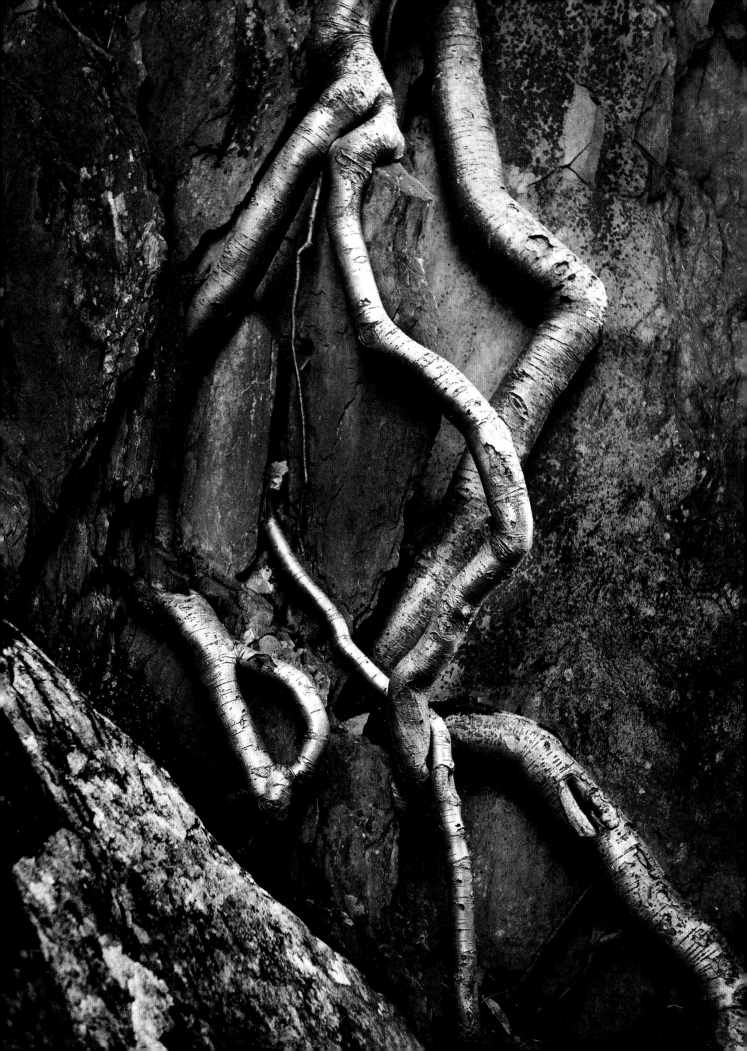

THE SHADOW/HIGHLIGHT COMMAND

The Shadow/Highlight command is an excellent feature of Photoshop that allows you to counter the effects of backlighting. It should be noted that this excellent facility only features in Photoshop CS1, CS2 and Elements 4. To access this, go to Image > Adjustments > Shadow/Highlight. Initially, a simple dialog box appears showing just a Shadow and Highlight slider; by clicking in the Show More Options box, additional controls are offered (see Further Controls, below right).

The Shadows Amount immediately defaults to 50%, but this should serve as no more than a guide. To lighten the darker tones, drag the Shadows Amount slider to the right, or enter a value from 0–100 in the percentage entry field. Further subtle adjustments can be made by altering the Tonal Width. This governs how many of the tonal values will be included. The third control is the Radius slider, which sets the scale size of the pixel selection. It has the effect

of increasing or decreasing contrast, but in my experience is generally best left alone. In common with many of the Photoshop commands, this needs to be applied with caution. Blocked-in shadows are often the bane of many black and white workers, but by excessively lightening the darker tones the image can appear flat and bleached out. I would rarely ever wish to use more than 20% of amount, unless the Tonal Width is greatly reduced. In our experience, it is impressive how well the newer generation of papers and printers now deal with shadow detail, therefore excessive use of this facility is unnecessary.

To increase highlight detail, drag the Highlights Amount slider to the right. Like the Shadow facility, the tonal range of the highlights can also be changed. With monochrome, the Midtone Contrast slider is a particularly useful feature. Use the highlight command with caution, however – it can't put in highlight detail that does not exist in the image.

LIFTING SHADOW DETAIL / OPPOSITE / While there was little need to change the highlights, the shadow detail has been greatly increased by adjusting the Shadow Amount slider.

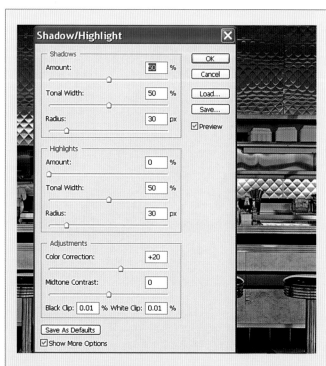

UNDEREXPOSED / This is the classic situation where the camera has been fooled into giving a false reading. The centre-weighted light meter has been influenced by the highlights, consequently much of this interior has been underexposed.

FURTHER CONTROLS / By clicking Show More Options, further controls become available. It is worth experimenting with these to see what can be achieved.

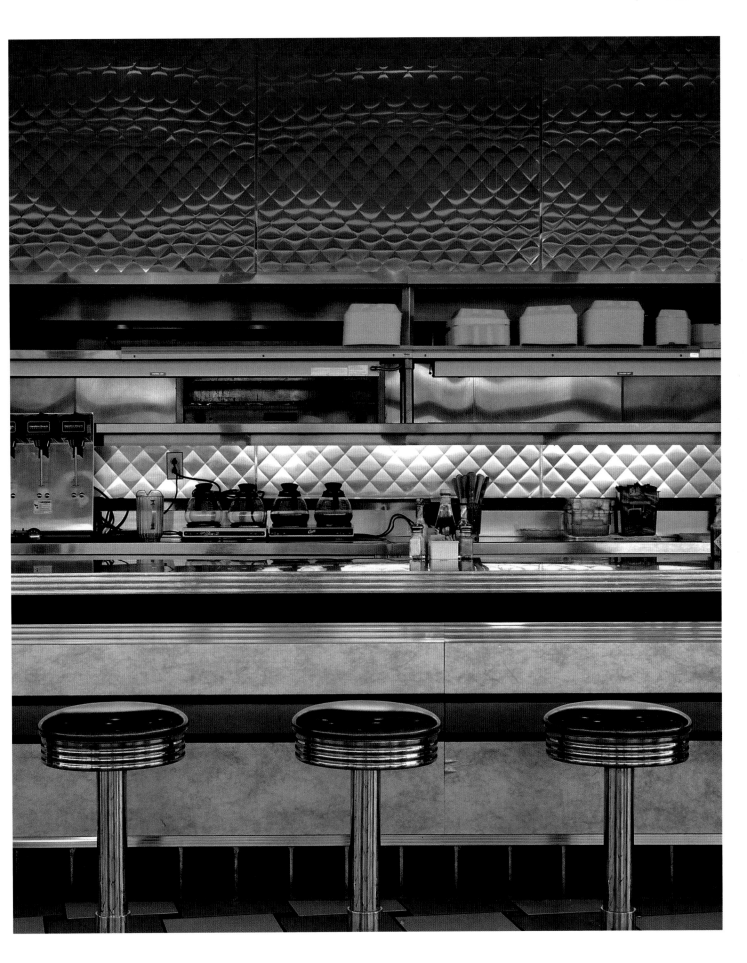

TONAL CONTROL USING RAW FILES

The Camera RAW plug-in in Photoshop is a powerful piece of software, as we have seen. The ability to adjust highlights, shadows and colour balance of an original 'digital negative' is an essential part of your workflow. There are times, however, when a single conversion cannot achieve everything. In particular, very high-contrast subjects are best dealt with in two or more stages.

In the original image shown here, we have a scene that is lit by a single candle bulb. Increasing the exposure to get detail in the shadows invariably leads to the highlights

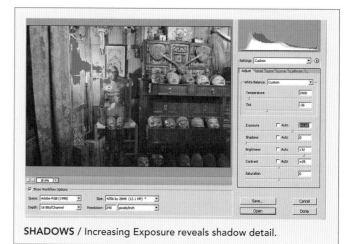

SHADOWS / Increasing Exposure reveals shadow detail.

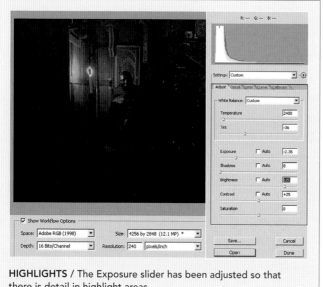

ORIGINAL IMAGE / The original RAW file was photographed in a room lit only by a single candle bulb.

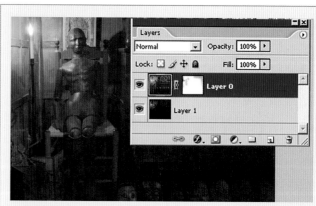

LAYER MASK / The shadow and highlight layers are combined and a Layer Mask used to combine the two.

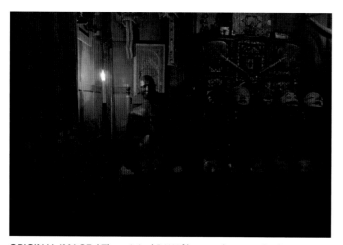

HIGHLIGHTS / The Exposure slider has been adjusted so that there is detail in highlight areas.

MONOCHROME / Adjustment layers are used to convert to monochrome, adjust contrast and tone the final image.

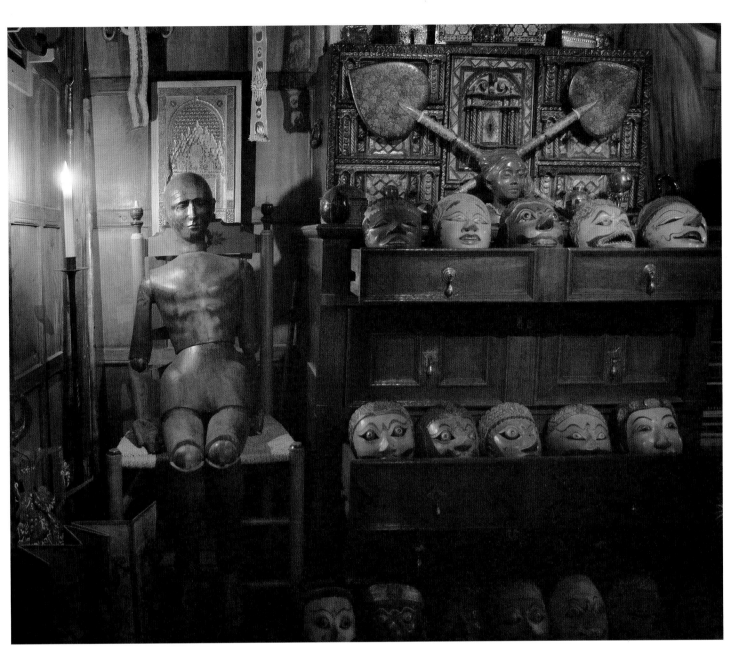

burning-out. To solve this problem, the RAW file is first opened and adjustments made so that the highlight detail is retained using Exposure, Shadows and Brightness sliders. Ignore the shadow areas at this stage. Keeping the Preview, Highlights and Shadows boxes checked allows you to determine where information is either lost or kept. The only area that has been allowed to burn-out is the candle flame, which shows as a red warning colour. This image is then saved. The same RAW file is opened once again and adjustments made to open up the shadow areas (see Shadows, left top). This causes highlights to burn out, but this will not be a problem. This version is also saved.

Both saved versions are then opened and combined as separate layers. To do this, drag the brighter image showing the shadow detail on to the darker image using the Move tool while the shift key is depressed. In this way, the two versions of the image will correspond, pixel for pixel. A Layer Mask is then created for the upper layer, and

FINAL IMAGE / There is now visible detail in both shadows and highlights and the tonal range has been compressed.

the Paint tool is used to reveal highlight detail from the lower layer (see Layer Mask, left centre). Use a soft-edged Brush at about 20% Opacity. Default the Foreground and Background colours to black and white (D on the keyboard). By painting with black on the mask, the underlying image will show through and this can be built up gradually because of the low Opacity selected. If you go too far, switch the Foreground colour to white (X on the keyboard) and paint back again.

In this case, reflections on the mannequin's face and highlights on the wall are restored with their original detail. Once the overall balance of highlight and shadow detail is corrected, further contrast controls, conversion to monochrome and toning can be achieved using Adjustment layers (see Monochrome, left bottom).

HIGH KEY/LOW KEY

Having examined a variety of methods for making tonal contrast adjustments, high key and low key represent the ultimate in tonal control. My fascination with monochrome stems from its capacity to evoke a mood that simply cannot be matched when shooting in colour. Images that are devoid of colour assume certain abstract qualities, which is part of their appeal; none more so than when presented as either high key or low key.

DEALING WITH HIGH KEY

High-key images concentrate on the lightest tones in the spectrum and use subject matter that is pastel or white. The technique creates a feeling of optimism, lightness and delicacy but it is notoriously difficult to achieve. It is a matter of ensuring that the tones are extremely pale, while making sure that they do not burn-out into bald white. It is often suggested that there ought to be a very small element of dark or black within the image so as to prevent it appearing too bleached out. A classic example of this would be a portrait of a blond, pale-skinned model set against a white background, with only the subject's eyes giving any hint of darkness.

ORIGINAL IMAGE / This is a classic example of where the camera has been fooled into giving a false reading. While the lilies reveal delicate high-key tones, the background remains too heavy. If we examine the first histogram, we will see that the tonal range peaks in the midtones.

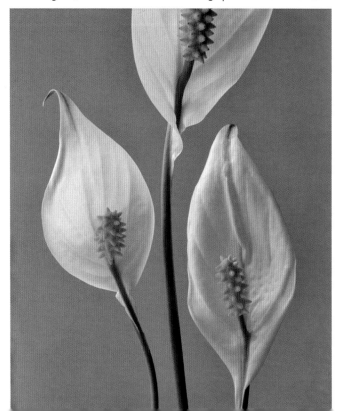

Part of the difficulty with creating high-key images comes at the capture stage. Not only must we ensure that the lighting is as flat as possible in order to eradicate shadows, but we also need to make very accurate exposures. Most light meters default to 18% grey, but that is still too dark for high key. Snow, for example, can make an excellent high-key subject, but if it is photographed with strong side-lighting or, even worse, backlighting, the high-key element will be

FIRST HISTOGRAM / This histogram reading shows the tonal values peaking in the middle.

GAMMA SLIDER / Sliding the Gamma slider to the left has significantly lightened the selected background.

CURVES / The curve is gently pulled upwards to lighten the overall image.

FINAL HISTOGRAM / This last reading shows that it now peaks at the lighter end of the tonal spectrum.

lost. Getting the exposure right initially clearly is important, but if this is inaccurate, the situation can easily be remedied using Photoshop.

LILIES

Accurately selecting and lightening the background is the best way to improve the original image of the lilies. The problem is that there are too many adjacent tones, making an automated selection more difficult. I decided to apply the Polygonal Lasso tool (feathered by 1 pixel) instead. Having saved this selection as a Layer Mask, it was possible to apply it again on various occasions, which allowed further subtle tonal adjustments to be made. A better balance between the background and lilies was achieved using Levels. A second histogram reading shows that the tonal balance has shifted towards the highlights (see Final Histogram, above right).

The entire image can still be lightened further. The important principle of creating high key is that you should aim to lighten most of the tones without sacrificing highlight detail. It is best achieved using Curves. Having firstly applied an Adjustment layer, the lightest quarter was pegged to ensure that the detail in the lightest tones was not lost, while the remaining part of the curve was pulled upwards. In order to retain an even tonality, this needs to be done with care.

FINAL IMAGE / RIGHT / Making careful and considered tonal changes has resulted in a lighter and more aesthetically pleasing image, much more in keeping with the subject.

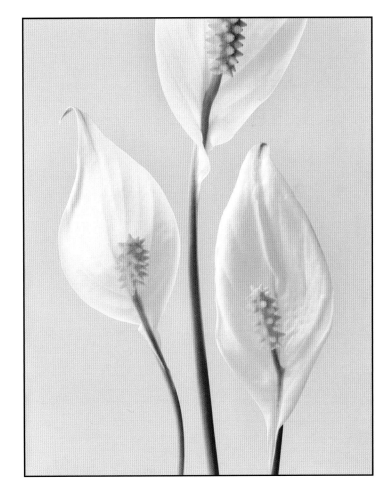

LOW-KEY IMAGES

Where the majority of tones are very dark, with just a suggestion of lighter tones, this is a low-key image. It often suggests an entirely different mood in the mind of the viewer, introducing a certain gravitas. It is important not to confuse a low-key image with one that has been underexposed. When that is the case, the full tonal range is affected and even the highlights appear weak and insubstantial.

In common with high key, shooting low key takes great skill and achieving that critical balance between underexposure and overexposure can often defeat many photographers. Without doubt, Curves offer the best

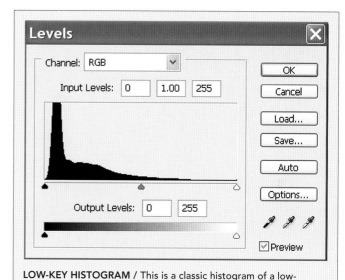

LOW-KEY HISTOGRAM / This is a classic histogram of a low-key image, with the tonal range peaking in the darkest tones. Retaining some detail, no matter how small, throughout the full tonal range is important.

method for making the required tonal adjustments. Having made an Adjustment layer, use the Info palette to measure the K values. There is little point in increasing the image density beyond 94%, as most printers fail to show detail in areas darker than this.

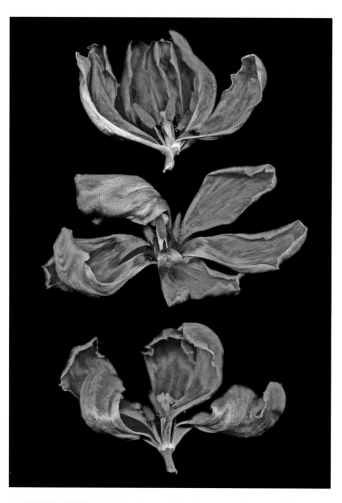

SCANNED TULIPS / This has been digitally captured using a flatbed scanner (see pages 120–125). While this is an excellent way of capturing very small subject matter, the lighting cannot be controlled in the same way as more conventional photographic methods. The tulips appear fully illuminated over a featureless black background.

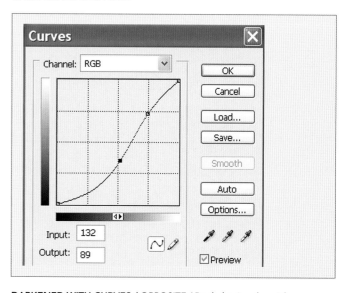

DARKENED WITH CURVES / OPPOSITE / By darkening the mid greys, an entirely different mood is created whereby the tulips appear to emerge from the background in an almost sculptural manner. The predominantly dark tones create a sense of mystery, which defies the ordinary nature of the subject matter. Curves is an excellent way of making these adjustments.

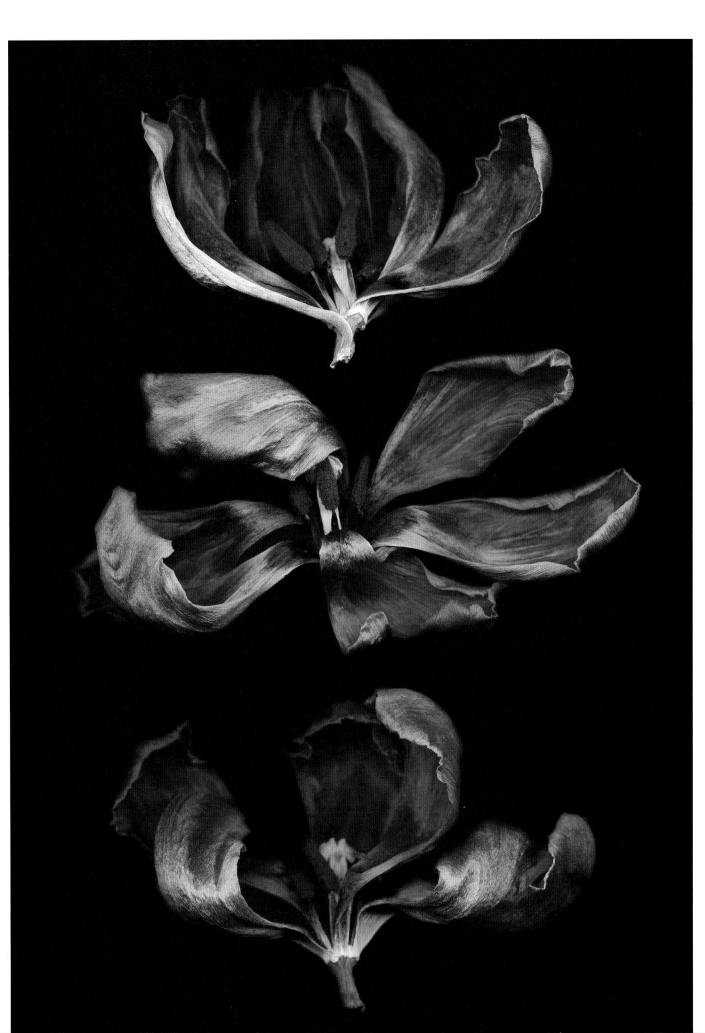

CHAPTER 3: FURTHER IMAGE MANIPULATION
CROPPING FOR PERSPECTIVE

It is always best to strive to get as much right in the image as it is taken, but there are some situations that inevitably cause problems, among them perspective control and converging verticals. A normal SLR has a fixed lens and back, which means that when photographing buildings or other structures with parallel vertical sides, the camera must not be tilted up or down. If it is, the sides of the building will seem to lean in or out. In the past, the only way to get over this problem would have been to use an expensive tilt and shift lens or a large-format camera with rising lens panels. Now, correction for converging verticals is easily achieved using Photoshop.

TRANSFORM TOOL
The church interior here is typical of the problem. To photograph the altar from the ground, the camera had to be tilted upwards, resulting in converging verticals (see Original Image, left). To rectify this we first have to make a selection (control A), then this can be distorted using the Transform tool (Edit > Transform). There are now several alternatives, starting with the Perspective tool. This will make handles appear around the selection. Pull out the handle in the top left corner and the left side is straightened. At the same time, the handle on the top right corner will move out an equal amount, straightening the right-hand side. This is fine if both sides need to be corrected by equal amounts. If not, select the Distort tool and then each side can be moved independently. To help judge whether everything is straight, a non-printing grid can be laid over the image as a guide (View > Show > Grid).

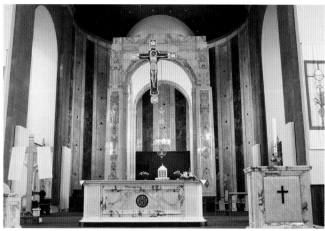

ORIGINAL IMAGE / The verticals in this image are clearly converging due to pointing the camera upwards.

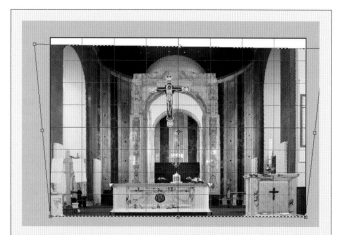

TRANSFORM MENU / The Distort tool from the Transform menu has been used to pull the image outwards at the top. A non-printing grid has been used as a reference.

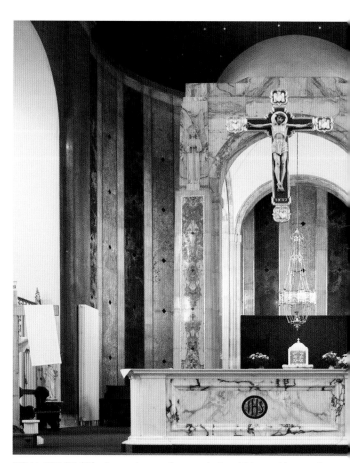

FINAL IMAGE / The image has perfect verticals, which would normally only be achieved using a rising front on a large-format camera.

CROP TOOL

Another way to control perspective is to use the Crop tool. The example here is a glass display case in a museum. The picture was taken from one side to prevent my own reflection appearing in the glass. To straighten the distorted result, the Crop tool is selected and the cursor dragged across the image to make a selection. Normally, pulling in and out on the selection anchor points will change the selection size and shape, but the selection remains a rectangle with 90-degree corners. However, if you now check the Perspective box in the Options bar, the shape of the selection can be changed. In this case, the corners of the selection have been moved to the corners of the glass display case (see Crop Tool, right). The shape is now irregular. However, if you OK the crop, the selection is automatically converted to a perfect rectangle and all the sides are parallel.

CROP TOOL / This image had to be taken from the left-hand side to avoid including my own reflection. The Crop tool has been used in Perspective mode to select the edges of the case.

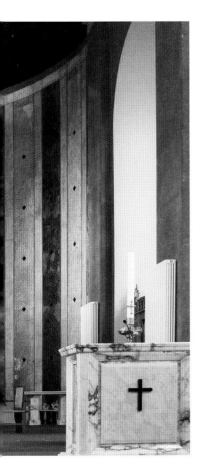

PARALLEL VIEW / The edges of the case are now perfectly parallel, as though the image was taken with the camera directly in front of the case.

DIFFERENTIAL FOCUSING

As a young photographer working with 35mm cameras, I learnt that critical focusing was most important; the subject had to be sharp. My first camera was not an SLR and had no range finder. The distance had to be estimated and the lens set accordingly. Amazingly, the ability to judge distance didn't take long and now seems innate. With SLR cameras, of course, this should not be a problem and now, with autofocus, there is no excuse for not getting the subject

sharp. As I learnt more, the link between aperture and depth of field became apparent and I used wider apertures to create out-of-focus backgrounds and allow more emphasis to be placed on the main subject. Moving on to 5 x 4in studio cameras, I then discovered that the plane of focus does not have to be parallel to the camera and depth of field can be extremely limited. This opened a whole new world of creativity. Now I work with digital SLRs I find one of the main problems is that too much of my image is sharp and the depth of field is much greater than with my film cameras, even using wide apertures. However, as usual, Photoshop comes to the rescue.

In the menu under Filters is a range of really interesting filters that will defocus or blur the image. Go to Filter > Blur and a list will be presented. It might seem obvious to select the one simply called Blur, however this is not controllable and probably of least use. The most commonly used filter is Gaussian Blur because it allows the degree of blur to be finely tuned.

GAUSSIAN BLUR
The simplest way to produce an out-of-focus background is to make use of one of the many Selection tools and apply a Gaussian Blur. The key to success is making a good selection of the background, helped by a little bit of forethought. In the original image here, the two girls have been photographed in the studio against a fairly neutral background with a slight separation between the heads. A selection of the girl in the background has been made with the Polygonal Lasso tool (see Pixel Choice, below left), which has been feathered by 2–3 pixels. Gaussian Blur has then been applied to the selection (Filter > Blur > Gaussian Blur) at a radius of 15 pixels. The amount will be determined by the size of the image and the amount of blur needed, but it is best not to go over the top as it will appear unnatural.

GRADIENT MASKS AND GAUSSIAN BLUR
Another technique that works well with landscapes is to use the Linear Gradient tool in Quick Mask mode to provide a graduated selection to the distant background. By adding Gaussian Blur, the change from sharpness in the foreground to out of focus in the background will be gradual and seem more natural.

LENS BLUR
Though Gaussian Blur is undoubtedly a very good technique to use, Photoshop CS has introduced a new way to blur an image, which is much more like true lens blur. Not surprisingly, this new method is called Lens Blur and is found

ORIGINAL IMAGE / The original image of the girls was sharp back to front and did not give a sense of separation or depth.

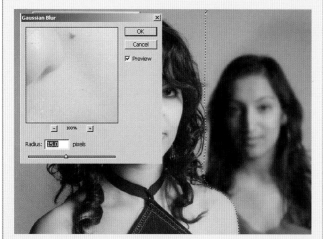

PIXEL CHOICE / The girl in the background has been selected and Gaussian Blur of 15 pixels applied.

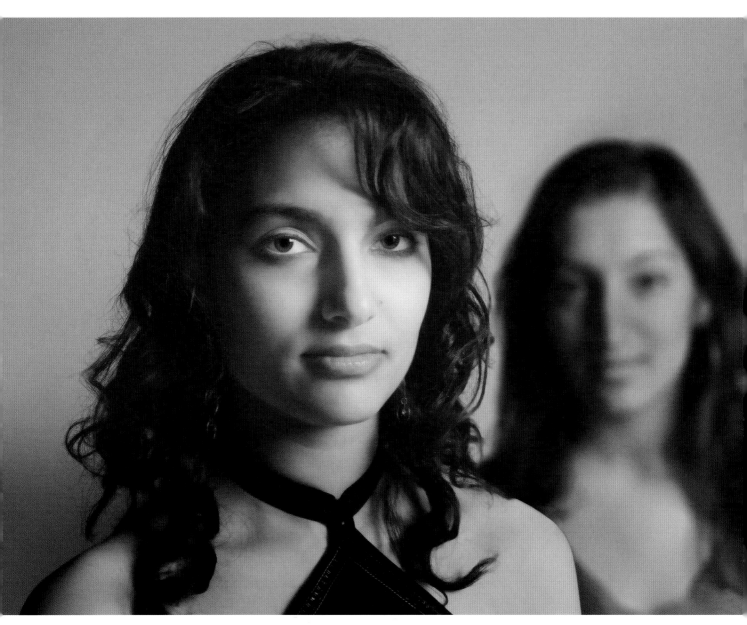

WITH GAUSSIAN BLUR / The finished image has a much greater sense of depth due to the differential focusing effect.

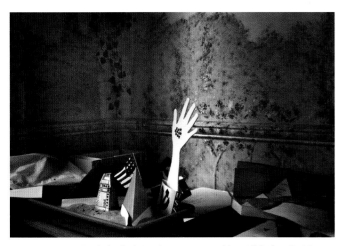

ORIGINAL IMAGE / The lighting here was good but I felt that limiting the area of focus would add extra emphasis and impact.

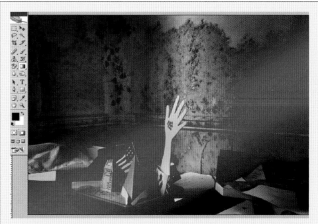

ZONE OF FOCUS / A Quick Mask has been applied using the Reflected Gradient tool.

DIFFERENTIAL FOCUSING

under the same Filter menu. When you open Lens Blur you will find many more ways of defocusing your image (see Filter, below).

The image is viewed in a preview window and, as this filter takes longer to be applied than Gaussian Blur, it is as well to select Faster from the Preview options. Choose an iris from the Shape pop-up menu. There are settings that represent an iris anywhere from 3 to 8 blades. Dragging the Blade Curvature slider smooths the edges of the iris, and dragging the Rotation slider rotates it. The Radius slider is then used to introduce blur. It will probably take a few seconds for the image to regenerate before you see the effect. If you are happy with the amount of blur, you can select More Accurate in the Preview options.

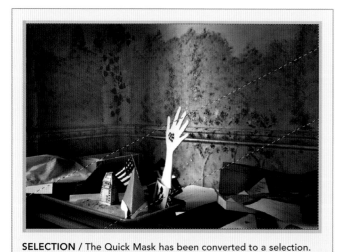

SELECTION / The Quick Mask has been converted to a selection.

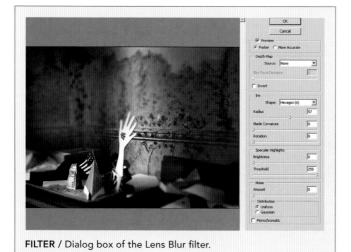

FILTER / Dialog box of the Lens Blur filter.

If your image contains points of light in the background then the Specular Highlight control can give very realistic out-of-focus effects. For Specular Highlight, drag the Threshold slider to select a brightness cutoff; all pixels brighter than the cutoff value are treated as specular highlights. To increase the brightness of the highlights, drag the Brightness slider.

Blurring removes film grain and noise from the original image. This can be a good thing if it was taken at a high ISO but, should you wish to retain it, the grain effect can be

FINAL IMAGE / Lens Blur has focused attention on the main subject and some digital toning has added to the aged appearance of the subject.

returned using the Noise slider. It works in the same way as the normal Noise filter, but does not have any choices of the type of noise. Be careful if you are only applying this to a selection, however, or you will end up with an image that only has noise in certain areas.

In this image, I aimed for a rather special effect that can normally only be produced by large-format cameras with lens tilts. To give the main subject added emphasis and impact, I wanted to have a very narrow zone of focus running diagonally across the image with the plane of focus

at a 45-degree angle from the camera back. A selection was made using the Reflected Gradient tool in Quick Mask mode (see Zone of Focus on page 53). To do this, select the Reflected Gradient tool and click on the Quick Mask button at the bottom of the toolbox. Then click and drag from a central point outwards at the desired angle. The mask can now be converted to a selection by hitting Q on the keyboard. The outer selected area can now be blurred using the Lens Blur filter, leaving the unselected area in sharp focus.

SHARPENING TECHNIQUES

Digital sharpening of images can be both a blessing and a curse. An image that is not sharp due to poor focusing, camera shake or even over-enthusiastic digital manipulation can be really irritating so the ability to enhance sharpness digitally can be a boon. However, one of the most common faults with digital images is over-sharpening, which makes them look unrealistic, and so it is a technique that needs to be approached with care.

Sharpening is the digital enhancement of edge contrast. This means that the contrast between light and dark pixels is increased, resulting in an illusion of sharpness. You cannot realistically make a blurred image sharp. If possible, you should strive for optical sharpness as you take the picture, which can only come from a combination of equipment and technique. In the real world, however, a certain amount of digital sharpening will lead to a noticeable improvement in most images.

Sharpening can occur at many stages in the process from capture to print. Most digital cameras will apply sharpening unless this is manually switched off. Similarly, film scanners will sharpen unless told not to. My advice would be to take control and switch off any automatic sharpening at this initial stage. The images produced may look a little soft to begin with but it is better to be in charge of subsequent sharpening rather than let a machine take over.

The amount an image needs to be sharpened depends upon several factors, such as how it is to be viewed, the size it will eventually be printed at and the quality of the surface it will be printed on to. For this reason, it is wise to apply sharpening only as the last stage of the digital process and consider applying it to a copy layer so that the original image is still intact and can be returned to for resharpening at any time.

DETAIL BEFORE / Close up of Paul before sharpening.

DETAIL AFTER / Close up of Paul after sharpening with Unsharp Mask. An Amount of 124%, Radius of 1.1 pixels and a Threshold of 0 has been applied.

ORIGINAL IMAGE / Though technically sharp, this image can be improved by emphasizing the edge contrast using the Unsharp Mask filter.

FINAL IMAGE / The sharpening has emphasized the jewellery and facial hair in this portrait. By raising the Threshold, I could have made the skin tone smoother but felt that this was not appropriate in this case.

There are many tools in Photoshop for sharpening an image. The first set is found in the Filter menu. Here you will find Sharpen, Sharpen Edges, Sharpen More, Smart Sharpen and Unsharp Mask. They all have their place, but only Unsharp Mask and Smart Sharpen allow a degree of control so we will concentrate on those, as well as an additional useful sharpening tool, the High Pass Filter.

UNSHARP MASK

This is probably the easiest method of applying a controlled amount of sharpness to your images. When you open the Unsharp Mask dialog box you will be confronted with three sliders – Amount, Radius and Threshold.

RADIUS: This determines the number of pixels surrounding an edge that are affected by the sharpening. This is usually kept low to prevent noticeable lines appearing around edges. A good starting point is 1–2 pixels radius.

THRESHOLD: This is a measure of how different the pixels must be from each other before they are considered to be

edge pixels and sharpened by the filter. Again, this is usually kept low. A setting of 0 will include all the pixels in an image. A slightly higher setting (between 2 and 20) is often used to prevent unwanted noise occurring in flesh tones.

AMOUNT: Once the Radius and Threshold are determined, the Amount slider is used to increase the pixel contrast and thus apparent sharpness. If the Preview option is selected, then the effect can be seen clearly. Alternatively, click inside the preview window and hold down the mouse to see how the image looks without sharpening. It is best to view the changes with the image at 100% magnification. Moving the Amount slider to somewhere in the region of 100–150% is usually sufficient.

Sharpening can only be applied to one layer at a time so it is usual to flatten the layers before sharpening. Selections and Layer Masks can also be used to selectively sharpen areas of the image, for example the eyes in a portrait. If sharpening has been overdone, choose Edit > Fade Unsharp Mask immediately after applying sharpening to reduce the effect.

SMART SHARPEN FILTER

The Smart Sharpen filter works in a similar way to Unsharp Mask except that it allows more control over selective sharpening of highlight and shadow areas. To work with this filter it is best to zoom in to your image at 100%. From the menu select Filter > Sharpen > Smart Sharpen. A large

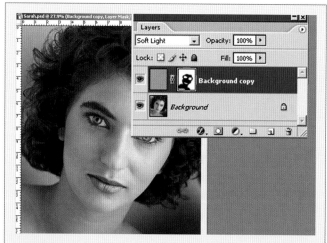

LAYERS / The Layers palette showing the application of the High Pass filter to a copy layer and use of a Layer Mask to modify the areas affected.

SHARPENED WITH HIGH PASS / This filter allows plenty of control, used here to emphasize the model's hair and features.

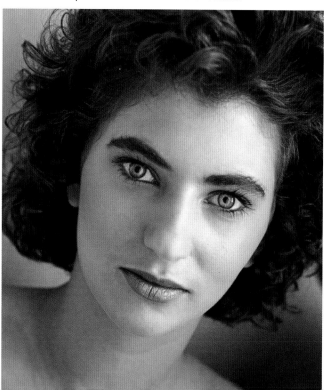

dialog box will appear, which, in its default Basic mode, has two sliders, Amount and Radius. These are used in exactly the same way as if you were working with Unsharp Mask (see previous page). Below these is a box called Remove. This gives three options, which affect the way the image is sharpened:

GAUSSIAN BLUR: Works the same as Unsharp Mask.

LENS BLUR: This is very useful for sharpening edges and detail. It tends to give a finer sharpening of edges and detail and reduces the 'halo' effect that is sometimes seen when images are over-sharpened.

MOTION BLUR: If there has been some camera movement then this can effectively sharpen the image. You will need to adjust the angle of the movement with the Angle control.

FURTHER CONTROL

More refined effects are available by selecting the Advanced option. This will bring up the sliders that allow sharpening to be applied selectively to either highlight or shadow areas of the image. There are three controls:

FADE AMOUNT: As with Unsharp Mask, this controls the amount of sharpening.

TONAL WIDTH: This allows you to select the range of tones that can be sharpened. If you only want the adjustment to be applied to either highlight or shadow, keep the values low for Highlight and Shadow.

RADIUS: This effects the size of the area around each pixel to determine whether it is in shadow or highlight. Moving the slider further to the right increases the effect by specifying a larger area.

HIGH PASS FILTER

This is a technique that works particularly well with grayscale images and allows a high degree of control. To use it, first make a copy layer. Then apply a High Pass Filter to this layer via Filter > Other > High Pass. Set a radius of between 4 and 8 and use a Blending Mode of Soft Light or Hard Light to blend with the background layer. The effect can be modified by using the Opacity slider on the High Pass layer or by creating a Layer Mask and painting with black, white or grey. For this close-up portrait, the mask was used to maintain softness in the skin but allowing the sharpening effect to emphasize the eyes, lips and hair.

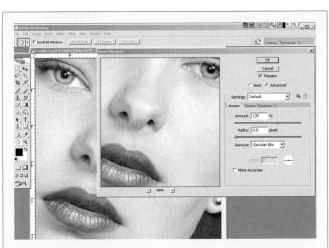

SMART SHARPEN / Like Unsharp Mask, the dialog box has sliders for Amount and Radius.

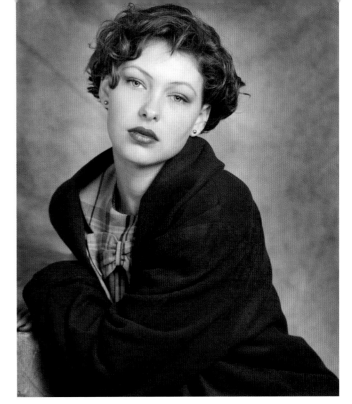

ORIGINAL IMAGE / Portrait before sharpening.

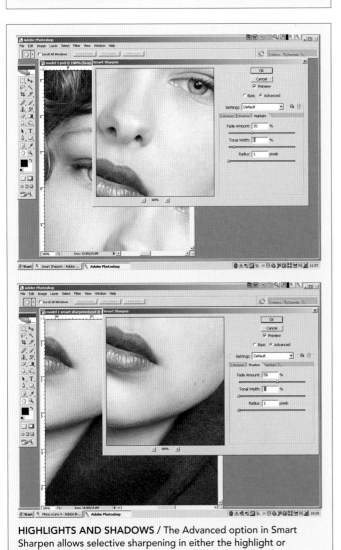

HIGHLIGHTS AND SHADOWS / The Advanced option in Smart Sharpen allows selective sharpening in either the highlight or shadow areas of the image.

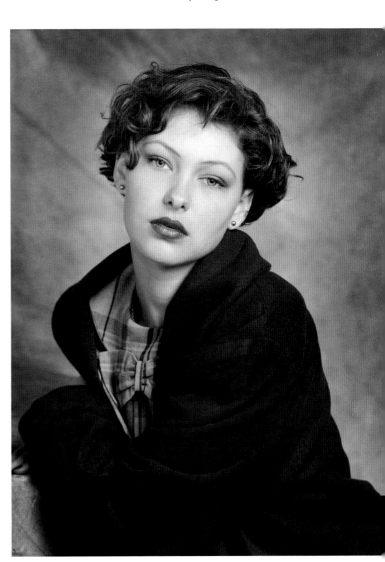

FINAL IMAGE / Portrait after use of Smart Sharpen filter.

CHAPTER 4: TONING AND COLOURING
SEPIA TONING

While black and white images continue to have an allure, toned monochrome images have become particularly fashionable in recent years because, by introducing a subtle hint of colour, an indefinable mood is suggested. It is important to match the right image with the appropriate toning technique; toning a winter scene sepia clearly would not work, although toning it blue will. Toning is largely an aesthetic issue and should not be considered unless it positively improves the image.

When one considers toning a black and white image, one automatically thinks of sepia. It conjures up a warmth and nostalgia that is associated with a bygone era. However, increasing numbers of contemporary photographers have come to recognize its unique visual qualities, applying the technique in interesting and unusual ways. Its light brown, earthy hues can be successfully applied to a range of subject matter including portraiture and landscapes. This effect can be achieved in a number of ways, but let us consider two.

METHOD 1: USING CHANNELS
Start with the image in RGB mode. Click the New Adjustment Layer button at the bottom of the Layers

WITH SPLIT-TONE / Some sepia toning techniques can appear overdone. By preventing the sepia changing the highlights, an interesting split-tone effect is created.

BEFORE TONING / A desaturated image in RGB mode. Not all images suit being sepia toned and careful thought should to be given to the subject being used.

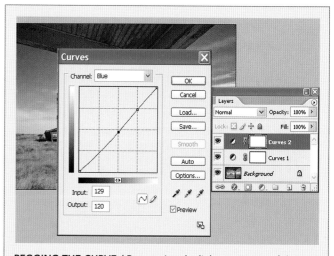

PEGGING THE CURVE / By pegging the lightest quarter of the Curve, the sepia toning is restricted just to the midtones and shadows for a subtle effect.

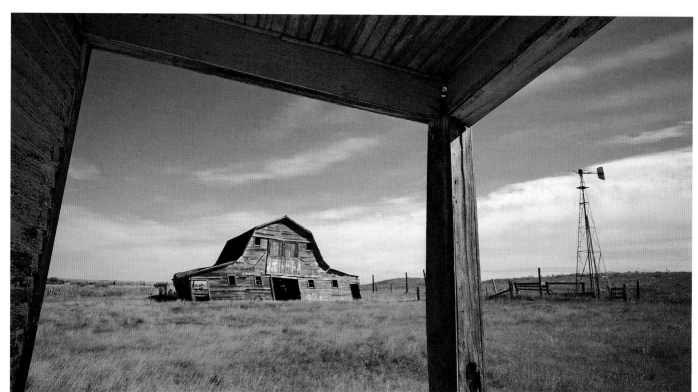

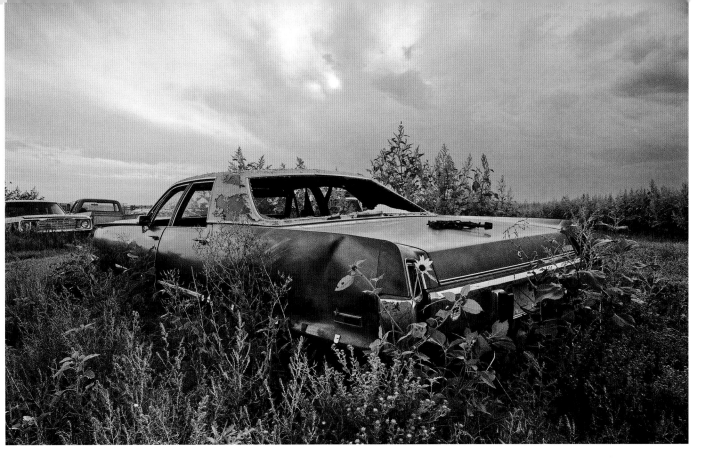

FINAL IMAGE / These wonderful old vehicles were discovered abandoned near a farm in Nebraska. While some sepia toning effects produce strong brown hues, it is also possible to create a much lighter effect. Using Color Fill, this is very easy to control.

palette, and select Curves. Now select the Blue channel and carefully pull the curve towards yellow. This needs to be done with care, otherwise you risk overwhelming the image with colour. Create a second Adjustment layer, select Curves, but this time choose the Red channel and pull the curve towards the red. If the result is too orange, make a final Adjustment layer, select the Green channel and make a very gentle pull towards green. This should produce a light overall sepia colour.

Applying Curves can be wonderfully subtle; by pegging either the lightest or darkest quarter, an interesting and aesthetically pleasing split can be achieved, whereby the toning is restricted to just part of the tonal range. This is known as split-toning. In the darkroom this effect is created by only partially bleaching the print. Providing this technique is not too severely applied, it can add a greater sense of depth. If your first attempts do not quite work, then 'bin' the Adjustment layers and start again – remember no change of pixels have occurred at this stage. Introducing colour to a monochrome image often appears to lighten it. This can be countered by making further adjustments using either Levels or Curves. Once you are happy with the final result, flatten and save.

METHOD 2: USING COLOR FILL

This is also a quick and easy way of achieving a sepia effect. Start with an image in RGB mode. Make an Adjustment layer and select Solid Color. Using the Color Picker, aim to select a colour that most closely parallels a sepia hue; try

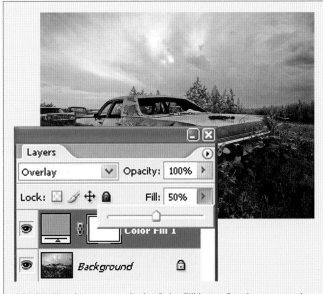

COLOR FILL / Having applied a Color Fill layer, Overlay was used to blend it with the Background layer. Fill was set to 50% to make the effect more subtle.

Red 210, Green 165, and Blue 90 as a starting point. A solid colour will appear over the entire image, but by selecting Overlay from the Blending Mode, the image will reappear through the Color Fill layer.

To some, the effect can appear a little overwhelming but moving the Fill slider to 50%, which restricts the toning to the darkest tones, can reduce this. Alternatively, it is possible to lessen the strength of the toning by reducing the Opacity; this decreases the tones incrementally across the full tonal range.

HUE/SATURATION TO ACHIEVE BLUE AND COPPER

Toning a black and white image blue can dramatically alter the mood conveyed, but trying to achieve this in the darkroom is fraught with technical difficulties. Also, the iron blue toners commonly used have a poor reputation for archival permanence and do not compare to the better pigmented inks currently available to digital workers.

Start with a desaturated image in RGB mode and apply an Adjustment layer. Make sure that both the Colorize and Preview boxes are ticked. Drag the Hue slider to achieve the colour that you want; clearly it is important that your monitor and printer are accurately profiled. Blue is a particularly difficult colour to judge; push it one direction and it becomes too green, but pull it in another and it begins to look purple. Working in an area between 210–215 usually delivers an acceptably neutral blue.

One of the drawbacks of blue toning with chemicals is that it is difficult to assess the intensity of the toner. The general mistake is leaving it in the toner for too long resulting in a rather garish blue. Working digitally, the intensity of the colour can be modified merely by adjusting the Saturation slider. Photoshop offers other options, too. For a more delicate blue, try blending your Background layer with the Adjustment layer using Soft Light. The result is not dissimilar to an image that has been toned in gold.

COPPER TONING

Copper is a much warmer colour and, as with blue, care should be taken with the choice of subject matter. It works well with portraiture and certain landscapes. When using the Hue/Saturation command, the Hue slider defaults to an almost perfect copper colour; only move the slider very slightly towards sepia. Unlike blue, a copper-toned image can sustain much heavier saturation.

COPPER TONE / OPPOSITE TOP / Toning often introduces a mood that is not apparent in the desaturated black and white alternative.

BLUE TONE / OPPOSITE BELOW / In common with most toning processes, it is important to consider the suitability of the subject matter. In this example, the wintry feel of the image is positively enhanced by toning it blue.

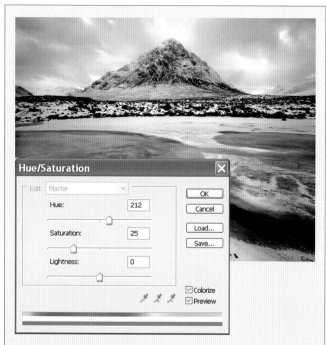

ORIGINAL IMAGE / A desaturated image in RGB mode. Blue is a cold colour, which restricts the choice of subject matter.

SATURATION SLIDER / Hue/Saturation is a simple and direct way of toning a monochrome image. Often the colour can appear too strong but this can be tempered by reducing Saturation.

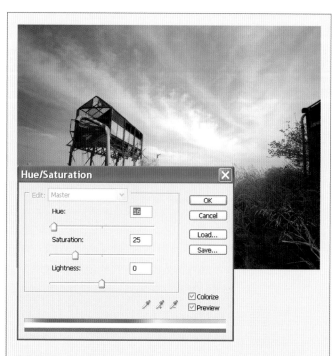

ORIGINAL IMAGE / An abandoned elevator, photographed under a hot Texan sun, makes this an ideal subject to tone copper.

ADJUSTING COPPER TONE / Once the Colorize box is ticked, Hue defaults almost to a perfect copper tone. Use the Saturation slider to slightly reduce its impact.

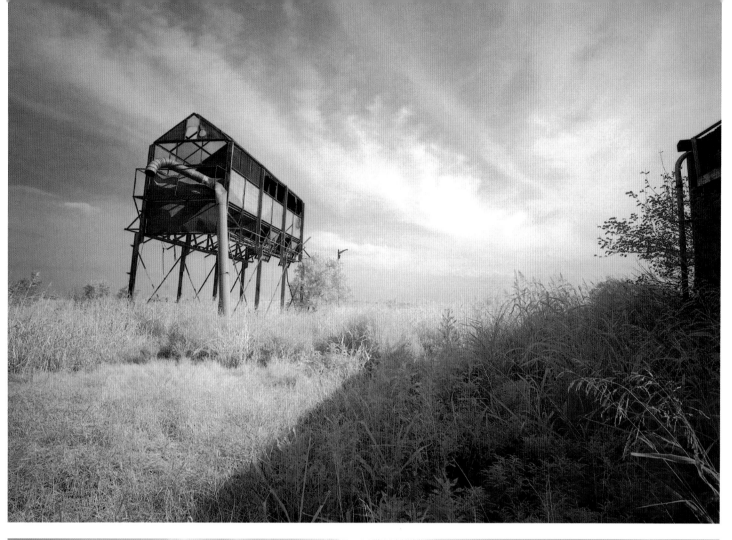

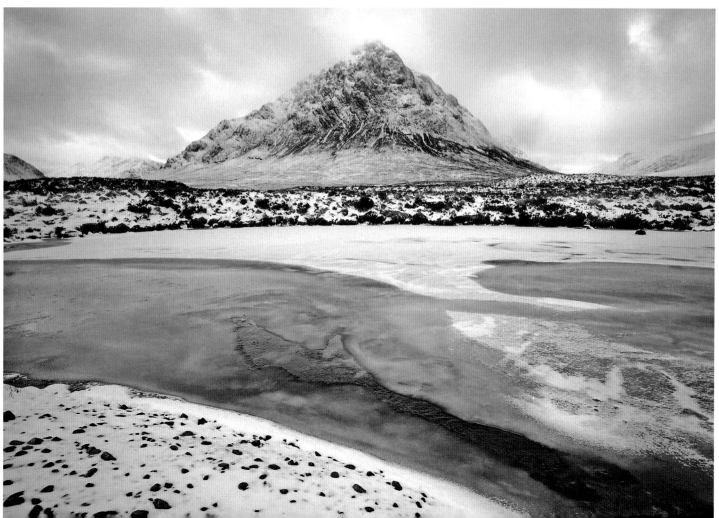

MIMICKING SELENIUM USING DUOTONE

Achieving the perfect split-tone selenium print is one of the holy grails amongst the darkroom fraternity. It is characterized by deep brown in the shadows countered by delicate highlights. With the right image, the results can look stunning.

When aiming to simulate any darkroom technique in Photoshop, it helps to understand why certain processes respond in the way that they do. Split-toning works because the selenium affects the darkest tones first, and then progressively starts working on the mid and light tones. The secret is to snatch the print away early. But getting the timing right is difficult, as the toning process continues long after the print has been removed. By using Duotone, not only are you able to mimic this technique, but you are also able to determine precisely where within the tonal range the split should occur.

Although we are illustrating a split-toning technique that mimics selenium, it can just as easily be applied to other toning techniques including gold, copper or blue. And while some traditionalists will argue that selenium toning is an archival process, the new generation of pigmented inks can boast similar archival qualities. If your image is then printed on to a high-quality digital paper (two to consider would be Fotospeed Platinum Gloss and PermaJet Delta Matt Fibre, see pages 134–135), it will be difficult to distinguish it from the Real McCoy.

If you are accustomed to working only in colour, Duotone may be a bit of a mystery. It is designed with monochrome workers in mind, but it is a truly excellent facility. The word 'duotone' originates from the printing industry and describes a process of separating tones in order to give a monochrome image greater depth. This was achieved by

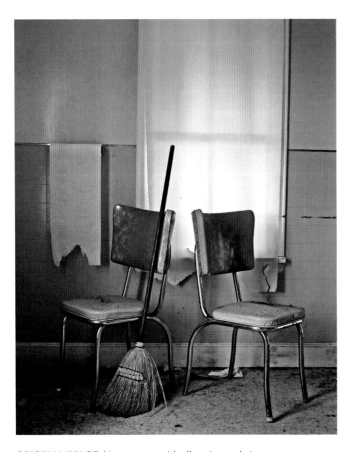

ORIGINAL IMAGE / In common with all toning techniques, some images work better than others. In this example, the dark tones of the interior contrast well with the window and blind, which means that controlling the split will be easier to achieve.

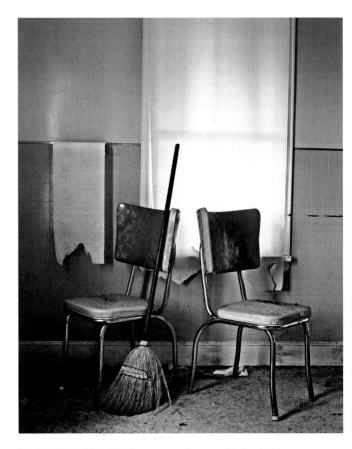

SELENIUM TONED / Without so much as a sniff of a darkroom chemical, it is possible to selenium tone this moody interior using Duotone Options. Note that the digital toning has affected the full tonal range of the image.

Duotone Options

Type: Monotone ▾
- Monotone
- Duotone
- Tritone
- Quadtone

Ink 1: Black

Ink 2:

Ink 3:

Ink 4:

Overprint Colors...

OK
Cancel
Load...
Save...
☑ Preview

DUOTONE OPTIONS / Duotone offers four options: Monotone (one ink), Duotone (two inks), Tritone (three inks) and Quadtone (four inks). For a toned single colour, opt for Duotone. Scroll through the Type drop-down menu to find this option.

Duotone Options

Type: Duotone ▾

Ink 1: Black

Ink 2: TRUMATCH 8-e

Ink 3:

Ink 4:

Overprint Colors...

OK
Cancel
Load...
Save...
☑ Preview

SECOND COLOUR / Ink 1 will always default to black. To choose a second colour, click the Ink 2 colour box (just below the black box) and the Custom Color dialog box appears. Select the colour you consider most appropriate; for selenium try TRUMATCH 8-e.

Duotone Curve

0:	0	%	60:		%
5:		%	70:		%
10:		%	80:		%
20:		%	90:		%
30:	0	%	95:		%
40:		%	100:	100	%
50:		%			

OK
Cancel
Load...
Save...

DUOTONE CURVE / It is possible to restrict the effects of the toning to a particular part of the tonal range, which creates an interesting split-tone effect. Don't touch the curve in Ink Box 1. Select Ink box 2, click the box to the left of the Ink 2 colour box, and the Duotone curve will appear. Carefully pull the curve so that it only covers the darker tones.

using different coloured inks. Photoshop's Duotone option largely does the same thing. First, you need to convert your image to grayscale by going to Image > Mode > Grayscale. Next go to Image > Mode > Duotone and select Duotone from the Type drop-down menu. Ink 1 will default to black; to select a second colour, click the Ink 2 colour box and choose your preferred colour from the menu.

To create a selenium split effect digitally, it is necessary to use the curves in order to only restrict the toning to a selected part of the tonal range. Click the box to the left of ink 2 Colour box and the Duotone curve will appear. By pegging the lighter part of the curve, the second ink will appear only to affect the mid and darker tones.

If you wish to convert the image back to RGB, go to Image> Mode, but this will increase the file size.

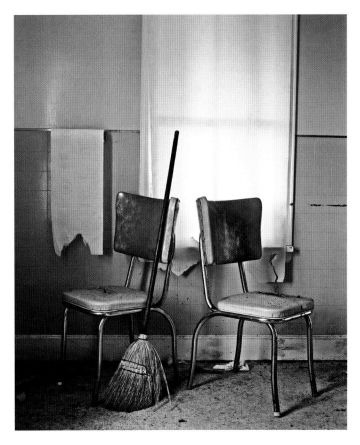

SPLIT-TONED WITH DUOTONE / Split-toned selenium prints are visually appealing, but difficult to achieve in the darkroom. Determining precisely where on the tonal spectrum the split will occur is particularly difficult to gauge. Using Duotone, this is a much easier task.

DUAL TONING

DESATURATED IMAGE / A desaturated image in RGB mode. For dual toning purposes, it is usually best to start with a fairly contrasty image.

COPPER AND BLUE / This is the classic copper/blue split, much revered by generations of darkroom printers.

SELECTIVE TONING / When working in the darkroom, restricting the effects of a toner to a limited part of the tonal range demands great timing. Working digitally, it is a much easier task. This particular technique highlights the graphic qualities of the image.

This valued darkroom technique aims to place colours at opposite ends of the tonal scale. It works on the principle that while some toners begin working on the lighter tones first, others start on the darkest. This, of course, means that you are restricted to using only a combination of toners that work from the opposite extremes. While there is virtue in trying to simulate these wonderful darkroom dual toning techniques, working digitally also allows us to explore entirely new possibilities.

COPPER AND BLUE USING COLOR BALANCE
This has been a popular technique with darkroom workers over the years, but it is difficult to do, largely because deciding when the first toner should end and the second should begin requires precise timing – not an issue when working digitally. It is usually best to start with a fairly contrasty image. As we intend using Color Balance, begin with a desaturated image in RGB mode. The big advantage of using Color Balance is that you have the option of restricting the toning just to the highlights or shadows.

Make an Adjustment layer, apply Color Balance and select Shadows in Tonal Balance. To achieve a positive blue, dial in 30 Blue and 30 Cyan. This may appear to overwhelm the image but a balance will be restored once other colours are added. Select Highlights, dial in 30 Yellow and 40 Red and you should have achieved a satisfactory split, although this will be governed by the overall tonality of the image.

You may wish to take this further. For example, it is possible to retain the copper hues, yet knock out the blues. Once you are satisfied with the blue/copper split, apply Multiply as the Blending Mode. The image will appear darker. Flatten, then save this as a file. Call up the original monochrome image, Select > All > Edit > Copy, then call up the dual-toned image and Edit > Paste. Blend these two layers in Lighten mode and reduce the Opacity in order to lighten the sky.

SEPIA AND GOLD
Start with a relatively dense, desaturated image in RGB mode. Call up Curves (see Curves, far right) select the Blue channel and pull the curve towards yellow. As a rough guide, try an Input of 140 and an Output of 105. Now select the Green channel and pull the curve towards magenta; try an Input of 126 and an Output of 117. Finally select the Red channel, and pull the curve towards red giving an input of 120 and an output of 131. At this stage you should have achieved a rather dark, flat sepia image. Call up the RGB curve; peg down the highlights, thus encouraging a steeper curve throughout the midtones, then peg the blacks a little in order to increase the D-Max.

RGB MODE / A sequence of four images, illustrating the edge of a forest of poplars. They were desaturated, but retained in RGB mode.

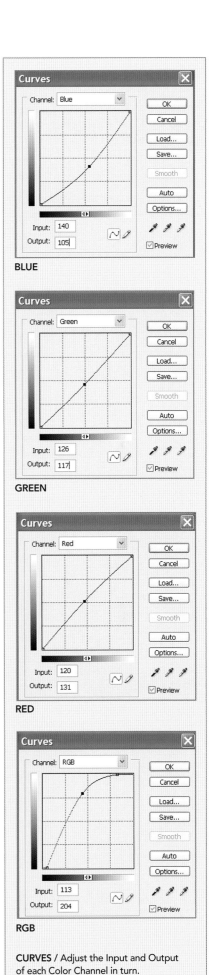

BLUE

GREEN

RED

RGB

CURVES / Adjust the Input and Output of each Color Channel in turn.

SEPIA AND GOLD / A sepia/gold toning effect. Achieving this in the darkroom is both costly and time-consuming; mimicking the technique digitally is a plausible alternative.

DUAL TONING WITH DUOTONE

Duotone is a superb facility for producing split tones, but it is important that the image is converted to grayscale beforehand. To create an effective split-tone, two inks plus black will be required. Start by selecting Tritone from the Type drop-down menu and then select two further colours for Inks 2 and 3. Duotone offers a stunning variety of colours to experiment with, but in the first instance it is reassuring to be able to recreate well-loved darkroom combinations. One of my personal favourites is the selenium/gold split that can be achieved with a lith print. This limits the chocolate brown to the shadows, while rendering the highlights a beautiful pale blue.

To achieve this in Duotone, retain Ink 1 as black. For the second or third colour, click inside the white box and the Custom Color dialog box will appear, offering a multitude of colour options. First, scroll the vertical colour spectrum to determine the area of colour required. By clicking this, a more specific range of hues will appear as bars. Select the hue you want and click OK. This becomes the second colour. Repeat this process to establish Ink 3. For the sand dunes image here, I used TRUMATCH 8-C (brown) for Ink 2 and TRUMATCH 31-b1 (pale blue) for Ink 3.

DUAL TONING USING SELECTIVE COLOR

Another interesting facility for changing colours and tones is the Selective Color command. Again, start with a desaturated image in RGB mode; then go to Image > Adjustments > Selective Color. While this facility is designed for changing the main colours, it can also be used to alter black, white and grey, referred to as 'neutrals'. Select the tones you wish to alter from the options in the Color box. Refer to the desaturated example and try to establish which tones require changing. For example, if you have a large area of light sky contrasting with a heavy foreground, you may wish to add just a hint of colour to the lighter tones. The effects can be beautifully subtle. If a delicate change is required, select Relative at the bottom of the dialog box.

FINAL IMAGE / OPPOSITE TOP / One of the interesting features of dual toning is that it can help to introduce unrealistic combinations of colour, which can enhance the visual appeal of a monochrome image.

SELENIUM/GOLD SPLIT / OPPOSITE BELOW / One of my favourite darkroom techniques is to dual tone a lith print, first in selenium, then in gold toner. Unfortunately it does not always go to plan. Working digitally is not just a much simpler procedure, it also guarantees success every time.

GRAYSCALE CONVERSION / Desaturate the image and convert to Grayscale. **INK OPTIONS** / It is important to appreciate that while a pale sand colour has been chosen for Ink 2, this does not mean that all the tones will appear pale; Ink 1 (which is black) largely governs the tonality of the image. Look to the strip at the bottom, which offers a good overview.

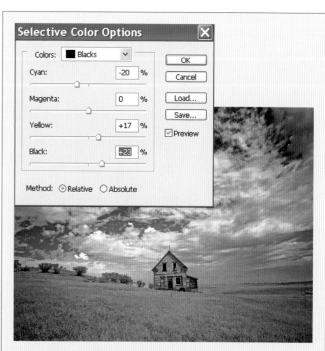

RGB MODE / A desaturated image in RGB mode.
SELECTIVE COLOR / While this facility is more commonly used for changing colours, it can also be used for dual toning monochrome images.

COLOURING MONOCHROME IMAGES

One of the possible drawbacks of abandoning the darkroom is that there is a danger that some of the more quirky techniques risk being lost; hand colouring black and white photographs is a good case in point. Before the advent of colour film, if a photographer wanted to present his work in colour, he was required to apply subtle dyes to a silver gelatin print. Although this is a technique that has enjoyed a revival in recent years, it is a time-consuming exercise requiring a fair measure of skill. In order to recreate the delicate colours one associates with this technique, the pigments need to be applied using thin washes. To achieve this digitally, a similar degree of restraint is required.

There are two ways of recreating this hand-colouring effect: firstly, by incrementally desaturating an image, and, secondly, by desaturating the image completely and then reconstructing the hues using various Photoshop techniques. Whichever method is used, it is important that the intensity of the colour is subdued.

With most of the techniques considered so far, it does help to understand how they are achieved in the darkroom before trying to copy them digitally. Unquestionably, the most popular method for hand colouring involved using Marshall's Oils. Similar to traditional oil paints, these translucent pigments were designed specifically for the

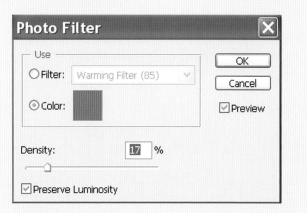

PHOTO FILTER / I do not normally use Photo Filter, as it applies a universal colour over the entire image, but if used subtly, it can increase the sense of oils being applied over a black and white print.

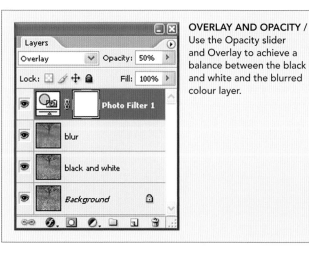

OVERLAY AND OPACITY / Use the Opacity slider and Overlay to achieve a balance between the black and white and the blurred colour layer.

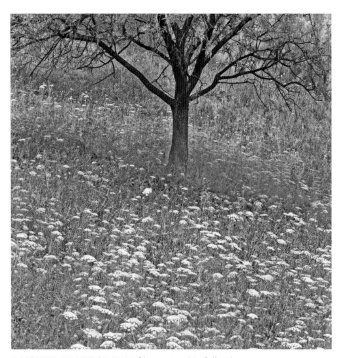

ORIGINAL IMAGE / A RAW file retained in full colour.

purpose and were applied directly on to the print using wads of cotton wool. The intensity of the colour was determined by how thickly these pigments were used, but the emphasis was generally to keep the outcome subtle. The results were extremely appealing, illustrating the advantages of both colour and black and white. It was also possible to be selective about which areas should be coloured.

WORKING FROM A RAW FILE

Call up the image retained in full colour. This becomes the Background layer. Make two Duplicate layers, which become Layer 1 and Layer 2. Activate Layer 1 and desaturate it using the Channel Mixer (Image > Adjustments > Channel Mixer),

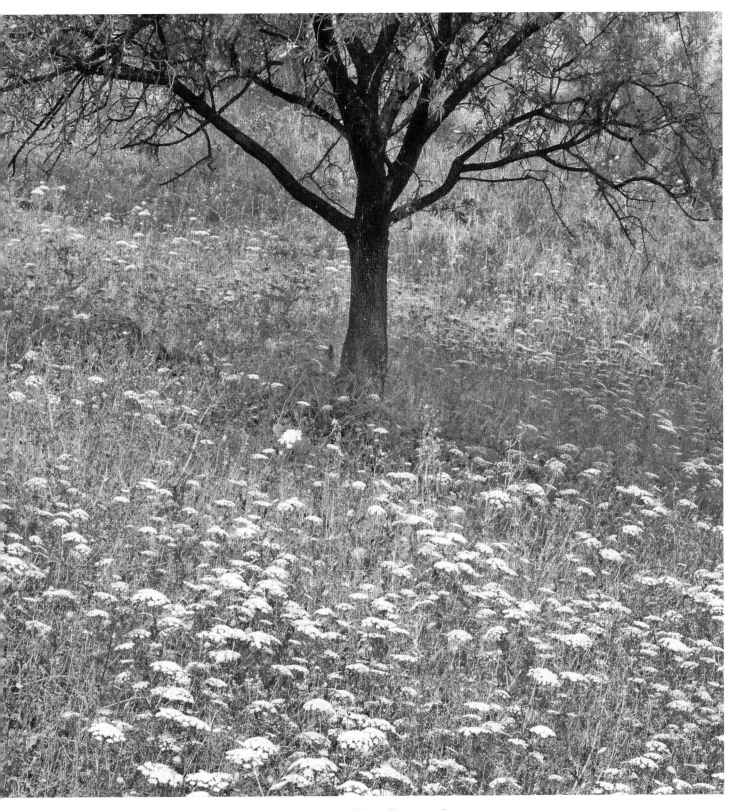

HAND-COLOURED EFFECT / By carefully balancing the black and white and blurred layers, an almost hand-crafted quality is introduced, which is the defining characteristic of a hand-coloured print.

making sure that the Monochrome box is ticked. Then rename this layer 'black and white'. It is a matter of choice, but I prefer to increase the contrast of this layer at this stage. Activate Layer 2, which is retained in colour, apply a Gaussian Blur using a radius of 18 pixels and then rename it 'blur'. Finally, blend the two layers using Overlay; if required subdue the colour slightly using the Opacity slider. One of

the great advantages of hand tinting is that you can apply or remove colours at will. A simple method for adding further colours is to make an Adjustment layer and apply a Photo Filter. This gives the impression that the black and white image has been subtly toned prior to hand colouring. Select Color in the dialog box, and then use the Density slider to determine the strength of the required hue.

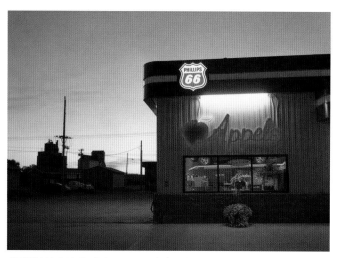

ORIGINAL IMAGE / The surrounding colours detract attention from the red illumination.

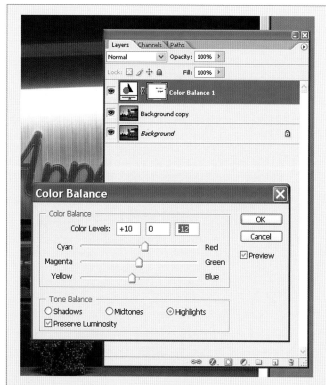

TONING THE IMAGE / It is a matter of personal choice, but hand colouring often works best on a toned monochrome image. Traditionally, many colourists would sepia tone the image first. To do this digitally, make an Adjustment layer, select Color Balance, choose Highlights from the Tone Balance and then dial in a small amount of red and yellow. Once you are satisfied that a visual balance between the selected red areas and the background has been achieved, click OK.

ISOLATING RED

The eye is capable of being far more selective than the camera and this is a classic case in point. When photographing this gas station, I was drawn to the red illumination and was largely unaware of all the other surrounding colours. Once I was able to see what I had captured, however, I was disappointed. In order to recreate what had initially caught my attention, I wanted to remove all colour with the exception of the reds. The major task was to make an accurate selection.

Firstly, a Background copy was made and then, using the Magic Wand tool set to a Tolerance of 50, all the larger areas of red were picked out. Remember, to add to a selection, hold down the shift key and then click on the areas you still wish to include in the selection. In this image, some of the areas to be selected are diffused, particularly around the neon lighting. This meant that this part of the selection needed to be feathered, in this example by 40 pixels, to keep the effect soft rather than hard-edged. Once all the red areas were successfully selected, the selection was inversed (Select > Inverse) and the background desaturated. Saving the selection at this stage helps, as further local adjustments can still be made later on. To complete the image, a subtle sepia tone was added (see Toning the Image, below left).

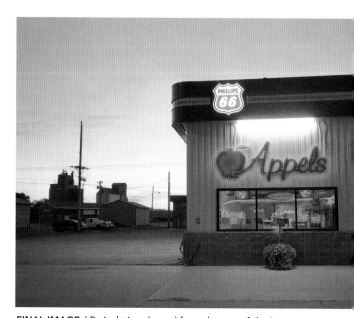

FINAL IMAGE / By isolating the red from the rest of the image, a strong graphic element is introduced. There are other smaller areas of red dispersed throughout the original image (particularly inside the window), but including these would have compromised the simplicity of the design. Adding just a hint of sepia has helped to introduce a slightly warmer feel to the background. If the red appears too bright it can easily be reselected and slightly desaturated.

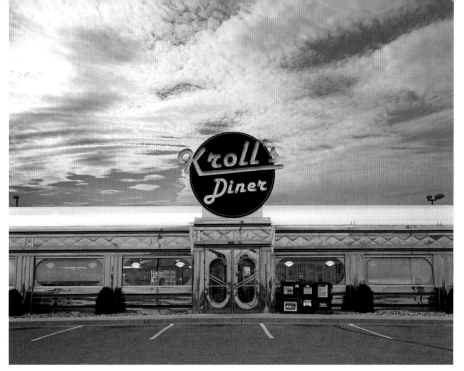

ORIGINAL IMAGE / This wonderful old diner, dating back to the mid-1950s makes an excellent subject for hand colouring.

BRUSH SIZE / Selecting a large Brush set on Overlay is the key to airbrushing colour over monochrome. Reduce Opacity and Flow to apply the colour slowly.

TONING THE BUILDING / Having inverted the selection, Adjustment layers were applied and Color Balance selected. The building was split-toned using copper and blue. The neon lighting was also selected and coloured individually using Hue/Saturation.

RECONSTRUCTING A BLACK AND WHITE IMAGE

While to some this might appear a laborious task, there is great value in being able to desaturate an image and then reconstruct the colours precisely as you would wish to see them. There are, of course, various Photoshop facilities for changing colours within an image, but the results lack that

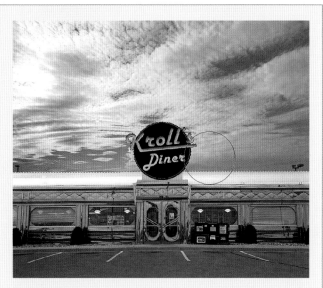

COLOURING SKY / Once the sky has been accurately selected, large sweeping brushstrokes can be applied without affecting the diner.

quality that distinguishes a hand-tinted image from a colour photograph. If you wish to recreate the subtle hues that characterize early 20th-century postcards, it is best to start with a monochrome image.

Having applied colour to just a small area, try using a full palette of colours throughout the entire image, very much in the manner of those early hand-tinted postcards. Once again, start with a desaturated image in RGB Mode. It helps to first give the entire image a gentle tint, using either blue or sepia depending on the mood you wish to suggest.

Selection is the key to successful hand tinting, and be prepared to use the full gamut of selection tools. Save all selections, as it may be necessary to make changes further down the line. To recreate the sense that the colour has been applied by hand, feather all selections, but not by more than by 5 pixels. It also helps to make Duplicate layers at each stage so that mistakes can easily be binned.

The Airbrush is the tool that most closely mimics how colour was applied on traditional hand-coloured images. Set a large Brush size (if I am doing a sky area, it is not uncommon to set it at 500 or more), then set the Blending Mode to Overlay. Choose the required colour from the Color Picker palette. The Opacity and Flow will determine how quickly it will be applied, but if you are not too experienced using this tool, reduce both, as it is far better to apply washes, and build up the colours gradually. By using the Airbrush set on Overlay, the highlights and shadow detail will be unaffected by the applied colour.

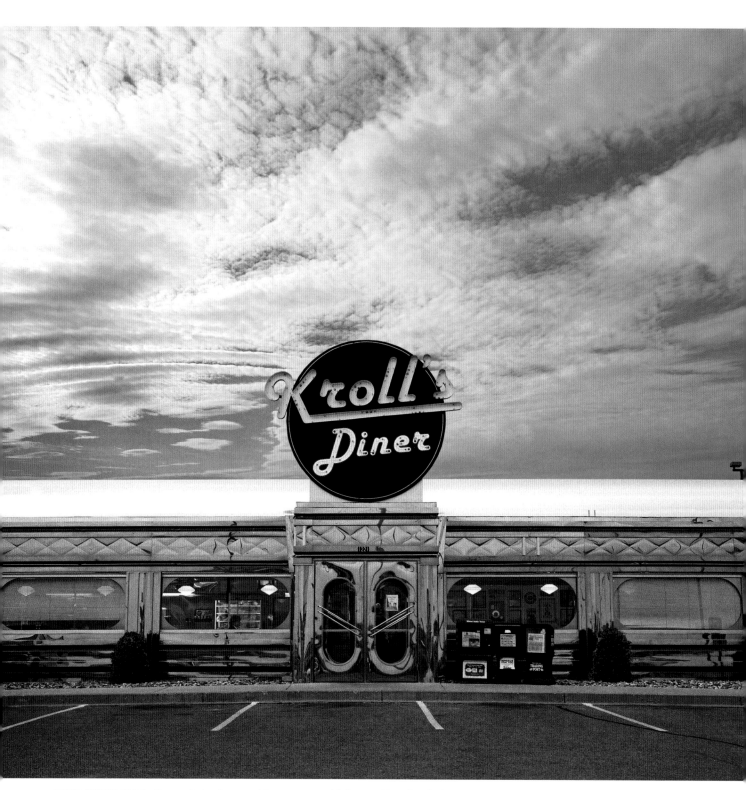

FINAL IMAGE / While the applied colours could never reasonably be considered realistic, they nevertheless capture the character of the hand-coloured postcards that were so popular in the middle of the last century.

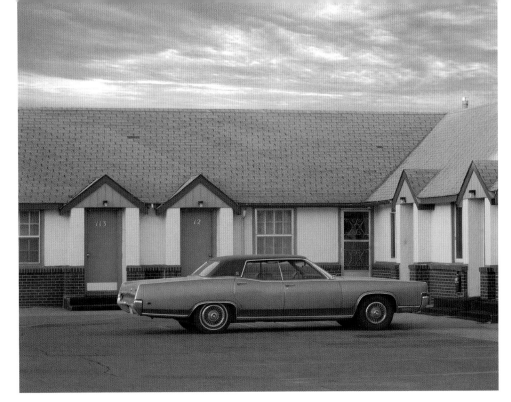

USING LAYERS / Building up your image using Layers allows you to revisit parts of the process and make the relevant adjustments as you go along.

ORIGINAL IMAGE / Because of the simple, clear-cut lines, this image screams out to be coloured.

MAKING SELECTIONS / Starting with a desaturated image is almost like starting with a blank canvas. It is possible to introduce as much colour as you wish and, once again, selection is the key. Always start with the larger areas and then proceed on to the smaller ones. In this example, there is a natural division between the sky and the other remaining areas, therefore the sky was selected using the Polygon Lasso tool feathered by 2 pixels. The selection was saved, an Adjustment layer was made and then the sky coloured using Hue/Saturation. The selection was then Inversed, another Adjustment layer made and the remaining part of the image was gently sepia toned using Color Balance. This is precisely how the traditional hand colourists would have started. From this point, it is simply a matter of making further accurate selections and adding colour using Color Balance, Hue/Saturation or the Airbrush option on the Brush tool.

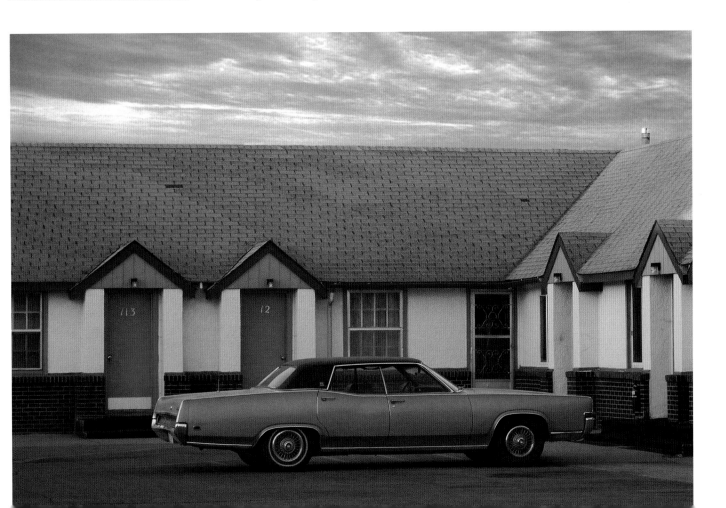

CHAPTER 5: COMPOSITES AND FURTHER SPECIAL EFFECTS
DROPPING IN A SKY

ORIGINAL IMAGE / This is a classic image of Death Valley that would benefit from a more dramatic sky. I have often visited this marvellous Californian location, but only once have I been able to catch it with passing clouds. In common with many monochrome landscapes, a more interesting sky is needed as a counterbalance to the lively foreground.

SKY SAMPLE / Over the years I have collected a number of suitable skies precisely for this kind of thing. When photographing them, it always helps to ensure that no prominent areas of the landscape protrude into the sky. In this example, although distant hills do appear on the far right of the horizon, these can easily be made to disappear behind the mountains of the landscape layer.

The tradition of dropping in a sky from another source dates back to the beginning of photography. It was easily achieved in the darkroom, as long as you were presented with an uncluttered horizon. However, this became quite a challenge if areas of the landscape, particularly if they were light in tone, protruded into the sky. It could be done by masking parts of the print with large lith negatives, but these were expensive to produce and difficult to use. Thankfully, Photoshop has changed all that.

CUT AND PASTE

Step 1. Call up the landscape image, and make an accurate selection of the sky. There are, of course, no golden rules when making selections and often it is a matter of using a method you feel most comfortable with. In this example, I opted to use the Magnetic Lasso tool, feathered by 1 pixel, largely because there was an obvious tonal separation between the lower part of the sky and the distant mountains. As with all selections, it is always useful to store it as an Alpha Channel (Select > Save Selection), just in case it is required again.

Step 2. Call up the sky image. It does not matter that it comes in horizontal format, as it can easily be resized later on. It is important to give some consideration to the image being used. If the landscape is obviously lit from the right,

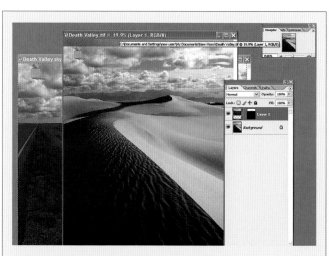

COPY AND PASTE / The new sky file is selected then Edit > Copy. The landscape file is activated (with the sky selected) and Edit > Paste Into is applied. The Move tool is used to make further adjustments.

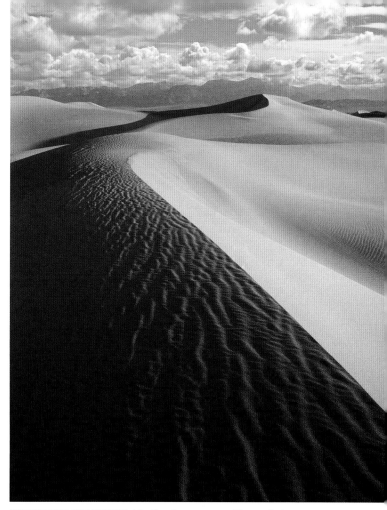

then ensure that the sky image is also lit from the right; if it is not, flip horizontally. While it is not necessary to accurately resize at this stage, it is important to ensure that the resolution of both files is the same.

Step 3. With the new sky file active, Select All, then Edit > Copy. Now activate the landscape file and Edit > Paste Into. The imported sky will appear within the selection. Use the Move tool to reposition the imported sky so that the two horizons roughly match.

Step 4. It is always sensible to approximately resize the imported sky before pasting it into the landscape file, but further adjustments can still be made using Edit > Transform > Scale. To retain the correct proportions, hold down the shift key while dragging the handles.

Step 5. Often when importing one file into another, a very fine but visible line can appear along the join; this can be eradicated by expanding the selection. Load the Layer Mask and the familiar 'marching ants' indicating a selection will appear. Go to Select > Modify > Expand (see Merge, below right) and increase the selection by 1 pixel. Hit OK, and the two layers should fuse together seamlessly.

Step 6. Crop the part of the sky no longer required. It is

COMPLETED COMPOSITE / As the changes are neither radical nor obvious, the image remains plausible. All that has happened is that the original insipid sky has been replaced by a more visually attractive alternative to give the image more impact.

only when the new sky has been successfully imported, that tonal changes should be made. While it might help to apply Unsharp Mask to the landscape layer, leave the sky unsharpened. Once you are satisfied that all the required adjustments are made, flatten the image to save file size.

OPACITY / Slightly reducing the Opacity of the Background layer subdues the tones of the sky, allowing the two layers to blend seamlessly.

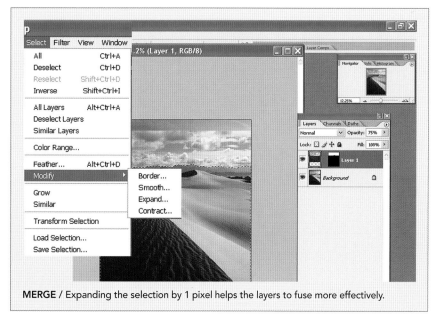

MERGE / Expanding the selection by 1 pixel helps the layers to fuse more effectively.

DROPPING IN A SKY

MULTIPLE PRINTING

Although cut and paste is always guaranteed to work, it is not necessarily the best method; if circumstances allow, blending two skies can often prove to be a more appropriate technique. Sometimes, the area of sky directly above the horizon shows good detail and it is only the upper parts of the sky that require changing. In those

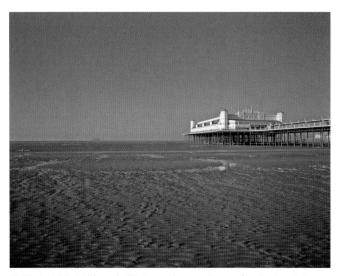

FIRST IMAGE / Although this image has an obvious focal point, it is let down by an uninteresting foreground and a lacklustre sky. But as both images share a similar lighting and angle of view, blending them should be easy.

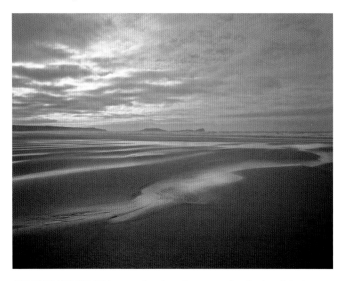

SECOND IMAGE / Taken during the winter months, the low light has picked out details in the sand but, from a visual standpoint, this image needs a focal point.

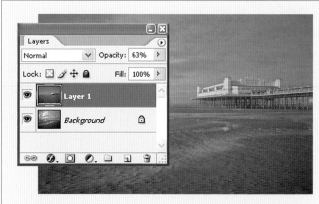

LAYERS / Make the beach and sky the Background layer and the pier Layer 1.

ERASER TOOL / This has numerous options that make the task of removing detail easier to do.

STRIPPING BACK / By removing the lower part of the beach and the upper part of the sky from Layer 1, detail from the Background layer shows through.

TONES / While they remain as independent layers, it is still possible to make separate tonal adjustments.

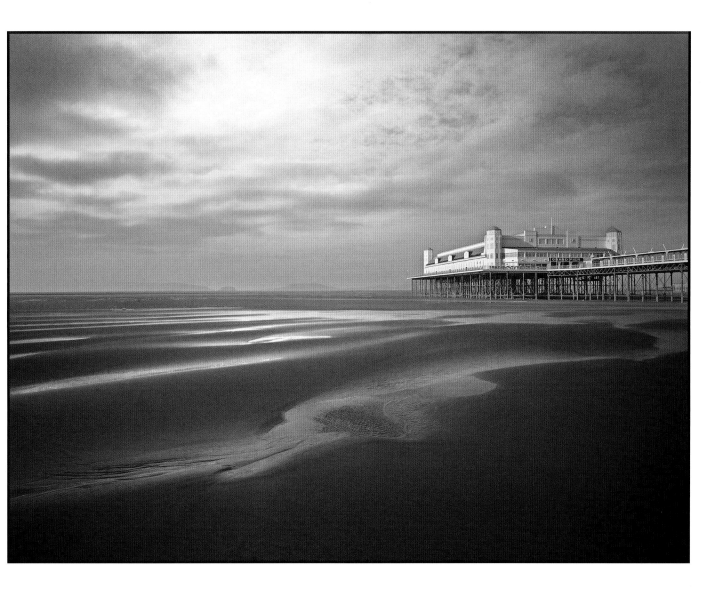

circumstances, multiple printing the two skies is certainly the best solution. It is, of course, important to ensure that both sky files are reasonably compatible and that they have some shared characteristics. Think about the direction and the intensity of the lighting, and be aware of the prevalent cloud patterns; for example, trying to blend cumulus with cirrus rarely works.

If it is possible to blend one sky file with another, then why not try blending together files that share other similar characteristics? For example, if you have two images showing a common area of backlit sand, then it should be possible to blend them. One may have the advantage of an interesting foreground, while the other may have an interesting feature on the horizon. In those circumstances, blending them together would be both plausible and achievable. This can be applied to any two landscapes that share a common feature such as pasture, dunes or backlit water.

SKY, SAND AND PIER

Both files were saved, desaturated and resized to ensure that they matched. The sky and foreground were established as the Background layer, and the pier was then dragged over it, to become Layer 1. It is important to ensure

COMPOSITE IMAGE / Providing you start with two relatively compatible images, it is possible to merge them together in a most plausible way. It is important that issues such as the relative vantage points and lighting are carefully considered.

that both horizons are on the same level; check this out by reducing the Opacity and if necessary making the required adjustments.

Select the Eraser tool, set to a large but very soft setting, and carefully remove the top part of the sky from Layer 1. As you do, the sky from the Background layer will emerge. Similarly, by removing the beach from Layer 1, the beach from the Background layer will begin to show through. As you work closer to the horizon, what is removed becomes more critical, therefore be prepared to reduce the size of the brush. If you do remove more than you intended, use the Step Backward facility (Edit > Step Backward) and have another go. Although Photoshop defaults to Paintbrush, other options can be selected including Block, Pencil and Airbrush. Each of these has unique characteristics and these can be applied to achieve a perfect blend. Finally, for the really critical areas close to the horizon use the Opacity setting, as this only partially erases pixels.

CREATING A MORE COMPLEX COMPOSITE

BACKGROUND COMPOSITE / Two shots of the same building were copied and pasted together to form an abstract design.

MODEL IN STUDIO / The model was photographed against a plain background to make selections easier.

Creating montages and composites goes back almost to the beginning of photography, but what could be achieved in the darkroom was always constrained by what could realistically be cut and pasted. With the advent of Photoshop, our ability to fuse together images has been transformed, allowing us to create wonderful and complex montages. However, while the methods may have changed, the necessity for good planning has not. A successful composite will not work merely by cobbling together various unrelated images. It is best to start with an idea, and take the photographs specifically for the task. In this way it is possible to ensure that issues relating to lighting, proportion and scale remain consistent.

THE BACKGROUND

This was inspired by an advertisement I had recently seen in a car magazine. The elements for the background were taken from photographs I took of the Sage Building in Gateshead; I found the interplay between the angular steel supports and the reflective glass surfaces particularly appealing. I called up the first image and did Edit > Copy, then called up the second and applied Edit > Paste. By using Soft Light from the Blending Mode, the two layers fused, creating an interesting, almost cubist, background. This then became the scenario for the figure.

THE MODEL

Accurate selections are the key to all successful composites. In this example, the uncomplicated background makes this task easier. It is often possible to use one of the automatic selection tools such as Color Range or Magic Wand, but with this shot, the similarity of the tones in the face and background required a more laborious approach.

I decided to use the Polygonal Lasso tool feathered by 1 pixel. This tool creates a freeform selection with straight line segments. If it is used in conjunction with the Zoom tool, very accurate selections can be made, particularly around the head and hair (see Zoom Tool, right). Once the selection is made, save it as an Alpha Channel, then drag it over the background. This now becomes Layer 2. The size of the figure was increased slightly using Scale (Edit > Transform > Scale). Once all the elements were in place, it was clear that the figure required more contrast. With Layer 2 active, an Adjustment layer was applied, Curves selected and subtle tonal changes made, without affecting the background.

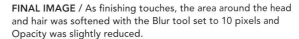
FINAL IMAGE / As finishing touches, the area around the head and hair was softened with the Blur tool set to 10 pixels and Opacity was slightly reduced.

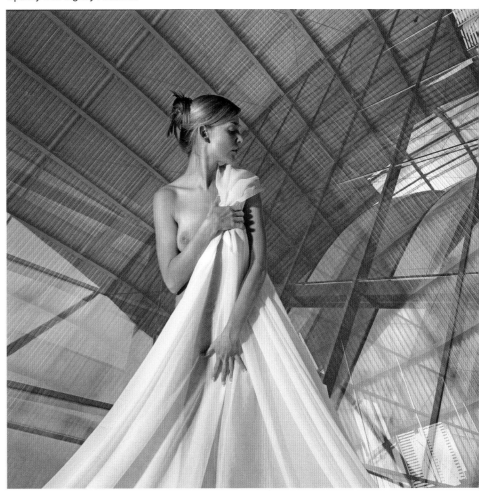

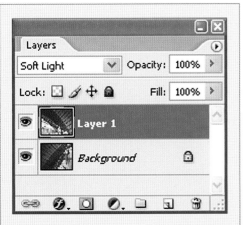
SOFT LIGHT / Experiment to find out which of the Blending Modes works best. In this case Soft Light proved to be most suitable.

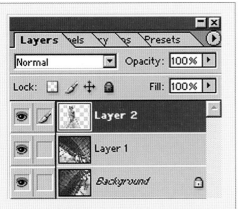
TONES / Apply Layer Masks when you wish to make selective tonal changes.

ZOOM TOOL / Accurate selections are the key to good montage work. Use the Zoom tool to deal with more difficult areas.

LAYERS / Use the Move tool to drag the selection into the destination window.

CHAPTER 5: COMPOSITES AND FURTHER SPECIAL EFFECTS

MAKING SELECTIONS USING CHANNELS AND MASKS

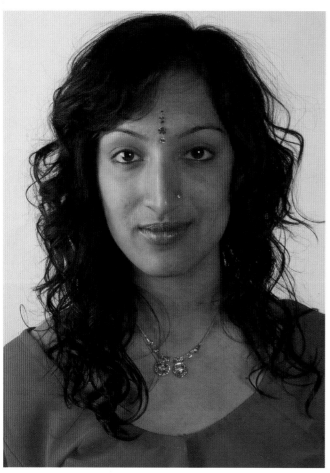

ORIGINAL IMAGE / Portrait of Sunny taken in a studio against a light background. It is helpful to start with a colour image.

When creating montages in Photoshop, the selection of areas of fine detail seems to give people the most problem. Making selections around complex shapes such as trees, foliage or hair often leads to either loss of detail or tell-tale fringing. With this portrait we are going to make use of Channels, Masks and Filters to create a cut out around the hair and place this on to a new background. It helps to photograph the model against a light background.

Even though this is going to become a monochrome image, starting with a colour original is advantageous. The selections will be made by the difference in tonality between the hair and the background. This will be different in each of the three separate colour channels and we can select the one that suits us best. By using the channels, a new Mask Channel can be created, which will follow every contour and wisp of hair.

CREATING A MASK

Step 1. Open the Channels palette and click on each colour channel in turn. Select the one that gives the best difference in contrast between the hair and the background. In this case I have selected the Blue channel.

Step 2. Now make a copy of this Channel by dragging the Blue channel down to the New Channel button at the bottom of the palette.

Step 3. To increase the contrast between the hair and the background still further, go to the Image menu and select Apply Image. Work through Blending Modes and observe the effect. Usually Multiply or Overlay work well.

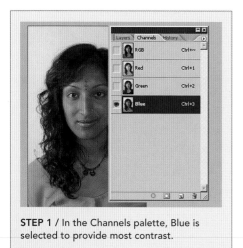

STEP 1 / In the Channels palette, Blue is selected to provide most contrast.

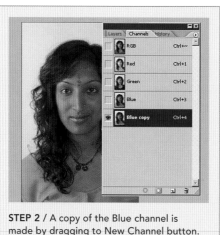

STEP 2 / A copy of the Blue channel is made by dragging to New Channel button.

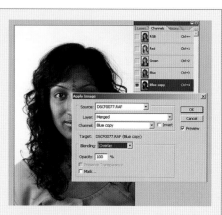

STEP 3 / To further increase contrast, select Apply Image in the Image menu.

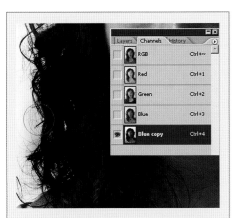

STEP 4 / Select a Brush and, in Overlay mode, paint with black to darken the hair.

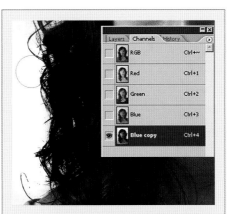

STEP 5 / Paint with white to lighten the background, increasing tonal separation.

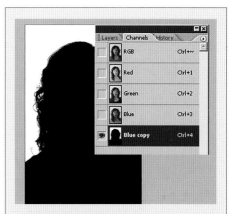

STEP 6 / Paint the inner selection black to complete the mask.

NEW BACKGROUND / The textured wall will convert well to monochrome.

STEP 7 / Import the background and drag over the original to form a new layer.

STEP 8 / In Channels palette, drag Mask Channel to the Make Selection button.

STEP 9 / The 'marching ants' show the selection over the background image.

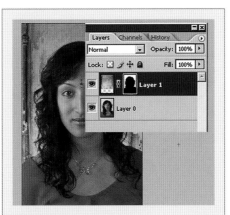

STEP 10 / In the Layers palette, click on the Add Layer Mask button to reveal image.

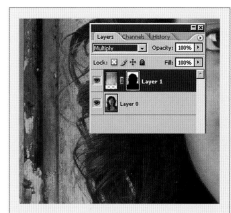

STEP 11 / Multiply Blending Mode smooths the join between subject and background.

MAKING SELECTIONS USING CHANNELS AND MASKS

Step 4. Now select a Brush of about 80 pixels and set the Blending Mode of it to Overlay. Set the Background and Foreground colours to black and white. Painting with black in Overlay mode will darken the darker pixels (hair).

Step 5. Painting with white will lighten the lighter pixels (background). The good thing is that painting with white has no effect on the darker pixels and painting with black has no effect on the lighter pixels. The hair will now be totally black and the background pure white.

Step 6. The inner parts of the selection, face and body, can now be painted in using a normal Brush loaded with black to complete the mask.

COMBINING IMAGES

Step 7. Now import the background image you are going to use, and drag it over the original to create a new layer. Resize if necessary using the Transform tool.

Step 8. Next, load the selection by returning to the Channels palette and dragging the Mask Channel down to the Make Selection button.

Step 9. You will see the 'marching ants' selection appear over the background image.

Step 10. Go back to the Layers palette and click on the Add Layer Mask button. This action creates a mask identical to the selection and so reveals the image below.

MODIFYING THE MASK

Though the montage might look pretty good at this stage, closer inspection might reveal that a little more work is necessary to make it truly convincing.

Step 11. Using the layer Blending Modes often makes a difference to the effectiveness of the join. In this case choosing Multiply has made a significant difference in creating a more natural combination between subject and background.

Step 12. With the mask selected, go to Filter > Other > Maximum. This shrinks the mask slightly. Select 2 pixels.

Step 13. A more natural cut out can be achieved by softening the mask slightly. To do this, use Filter > Blur > Gaussian Blur on the mask. Select 1–2 pixels. Not too much effect will be seen at this stage, but now open the Levels palette and adjust the highlight input slider to the left.

Step 14. The mid grey slider can also be moved to fine tune the effect. This should remove any remaining fringes of background colour and produce an invisible join between the subject and its new background.

FINAL IMAGE / OPPOSITE / The completed montage has been converted to monochrome and toned using Curves.

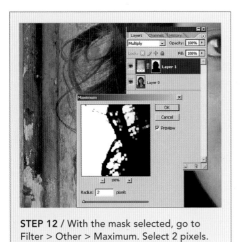

STEP 12 / With the mask selected, go to Filter > Other > Maximum. Select 2 pixels.

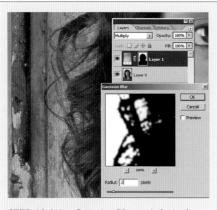

STEP 13 / Use Gaussian Blur at 1–2 pixels on the mask to soften it.

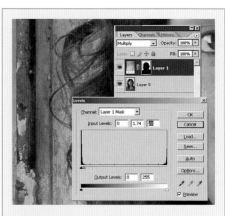

STEP 14 / Move the mid grey slider to join the subject with the background invisibly.

SPECIAL EFFECTS: THE ILLUSION OF LIGHTNING

Lightning flashes are relatively uncommon and, of course, the chances of witnessing a wonderful electrical storm while located in a fabulous landscape are even rarer. If you are lucky enough to see one, it requires lengthy exposures on a tripod as our normal reactions are simply too slow to capture the flashes. Now it may just be a personal thing, but using a metal tripod during an electrical storm is something I am reluctant to do; consequently my collection of images featuring lightning strikes is severely limited. Fortunately, this beautiful phenomenon can quite easily be created digitally using the Gradient tool and the Difference Clouds filter.

There is a certain randomness about this technique, although that is not to suggest that you cannot exercise some measure of control. Before starting, it does help to have various illustrations of lightning to hand in order to get a better understanding of what it should look like.

CREATiNG LIGHTNING
Choose an image that you would dearly like to have photographed during an electrical storm. It is also important to choose one featuring a threatening sky so that the lightning looks believable.

Start by opening a new file, but keep this small; try dimensions of 300 x 500 pixels at 72 dpi, ensuring the background remains white. Select the Gradient tool and drag the cursor across part of the width. This is important because it determines how 'wiggly' the lightning will appear: the broader the sweep, the more irregular it looks. Then go to Filter > Render > Difference Clouds and an image that looks rather like a flash of lightning in negative will appear. Invert this layer (Image > Adjustments > Invert). The lightning still appears too bright. Call up Levels and drag both the Shadow and the Gamma sliders positively to the right so that it is set against an uninterrupted black background. The position of the Gamma slider can be quite critical, because by placing it adjacent to the Highlight slider, an interesting fringing effect occurs.

COMPLETING THE IMAGE
To finish the task, use the Move tool to drag the lightning layer over the landscape. It depends on the size of the destination layer, but generally it is unlikely to fit. While the lightning layer is still active, go to Edit > Transform > Scale and adjust the handles on the bounding box so a more accurate fit is achieved. Use Screen from the Blending Mode, and a plausible flash will appear over the landscape layer.

FURTHER MODIFICATIONS
Lightning flashes often occur in quick sequences, therefore if your camera was fixed to a tripod, opened for numerous seconds, it is quite likely that various flashes would be

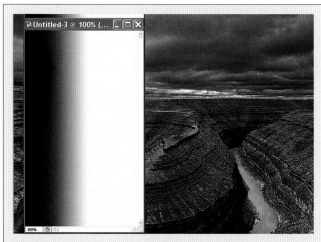

GRADIENT / When using the Gradient tool, only drag the cursor across part of the width. The wider the drag, the more irregular the flash will appear.

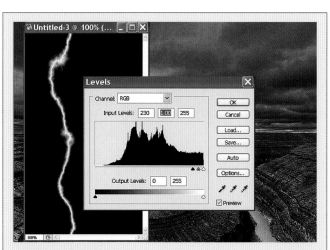

LEVELS ADJUSTMENT / In order to darken the background for a more dramatic effect, push both the Shadow and the Gamma slider to the right.

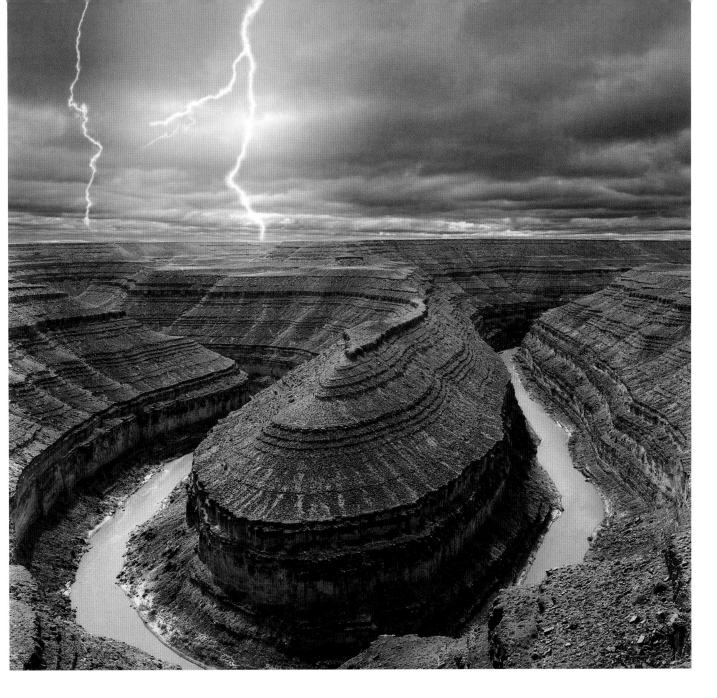

FINAL IMAGE / Lightning illuminates the sky, therefore I have selected an area, (feathered by 50 pixels) around the flashes, and lightened it using Levels. The selection was then inverted and Levels was used to darken the remaining part of the image.

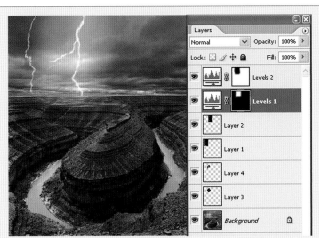

LAYERS PALETTE / Each flash of lightning represents a separate layer, therefore Opacity adjustments can be made on one without affecting the others.

captured. Working digitally, this is easy to simulate by simply creating further layers. Another characteristic of lightning is that it frequently forks; to create this effect, make a new flash layer, drag it adjacent to an existing lightning layer, rotate and position it so it appears to fork from a larger flash (Edit > Transform > Rotate). This is where it helps to have sample images to work from. It is also important to appreciate that each flash represents a separate layer, therefore subtle adjustments with the Opacity slider can be made so that some of the flashes appear more distant than others. Finally use the Eraser tool to remove parts and the Blur tool to soften the effect, particularly where it appears to hit the ground.

TEXT IN CLOUDS

The Text tool can be used in many ways but in the following example it is going to be combined with Layers, Layer Styles and Filters. We have all imagined cloud formations as constantly changing shapes that take on the appearance of animals or faces. Here we are going to create clouds composed of letters or words.

Step 1. Create a new document (File > New). Enter a size of roughly 450 x 300 pixels at 72 dpi and select Color mode Grayscale 8-bit.

Step 2. Choose a dark grey Foreground and light grey Background from the Color Picker. Use the Gradient tool to drag from the top to the bottom of the document to form a graduated sky. This is in fact only for reference so that we can see the white clouds we are going to create.

Step 3. Reset the Foreground colour to black and select the Text tool. In the Options bar select a large text such as Rockwell Extra Bold and a point size of at least 72 pt. Now type in your text, keeping it relatively short and simple. You can use the Transform tools at this stage to alter the size or perspective of the text.

Step 4. Open the Layers palette and control click on the Text layer to select the text.

Step 5. Open the Channels palette. Click on the Save Selection As Channel button. This creates a new Alpha Channel. Click on the channel and deselect.

CLOUD TEXT / Rockwell Extra Bold font was used as the starting point. The Ocean Ripple filter creates the cloud effect.

LAYER STYLE / The Layers palette showing Layer Style.

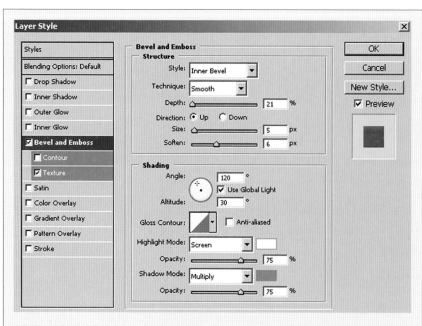

BEVEL AND EMBOSS / Found in Layer Style, this gives options for structure and shading.

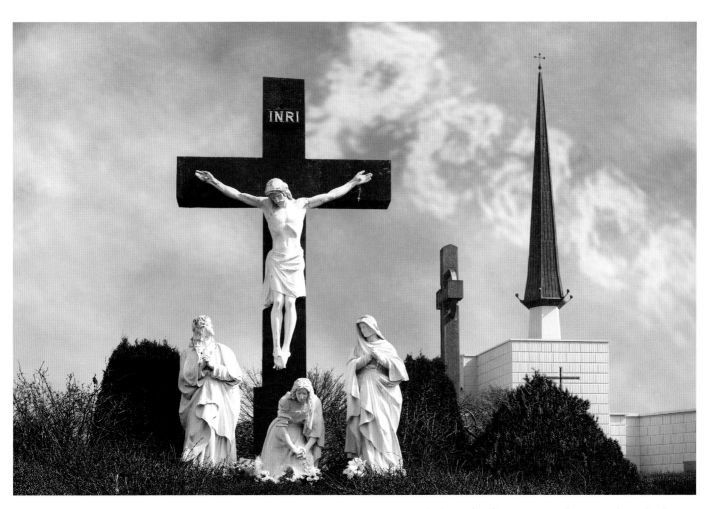

FINAL IMAGE / Text placed into an image taken at Knock in Ireland. Layers have been used so that the cloud text appears behind the church, and the other clouds in the sky have been painted in using a specially created 'cloud' brush to make the finished effect appear realistic.

Step 6. Blur this channel using Gaussian Blur set to about 6–8 pixels.

Step 7. Add some grain using Filter > Texture > Grain. Select Regular Grain with Intensity 50 and Contrast 40.

Step 8. Add a new filter: Filter > Distort > Ocean Ripple. This will break up the text and create a cloud-like effect. A setting of Ripple 8 and Magnitude 8 will be about right but you can experiment.

Step 9. Remove any grain from the background by calling up Levels (control L) and moving the black slider along to the right.

Step 10. Now you can add more Gaussian Blur – about 1 pixel should suffice.

Step 11. Control click on the Alpha Channel to make a selection.

Step 12. Go back to the Layers palette and create a new blank layer. Name it 'text clouds'.

Step 13. Switch off or delete the original text layer.

Step 14. With white selected as the foreground colour, hit alt backspace on the keyboard and you will see white text appear. Now deselect.

Step 15. Double click on this cloud text layer to open up the Layer Style window. First add Bevel and Emboss, which gives options for structure and shading. Select Inner Bevel Depth 20–100%, Size 5 pixels and Soften 6 pixels, choosing a grey as the Shadow Mode (see Bevel and Emboss, left). Next select Texture from the Layer Style options and add a Clouds texture (see Texture, above).

Step 16. The text layer is now finished and can either be saved for later or dragged on to an image and added to the sky using the Move tool.

FINISHING OFF

On a normal 300 dpi image, the text layer will look extremely small. This is to make use of the filter effects. Now the text can be enlarged using the Transform tool (Edit > Transform > Scale). Because the text layer has a transparent background it should merge easily with any sky. For the final image, the original sky was deleted to transparency (on a copy layer) and a new grey graduated sky introduced as a separate layer. The text layer was modified using the Distort function and the Liquify filter. To achieve a more realistic sky, part of the cloud text was selected, feathered and made into a Brush (Edit > Define Brush Preset). This was used on a separate layer to paint in the sky, varying the tones of grey.

CHAPTER 5:
COMPOSITES AND
FURTHER SPECIAL EFFECTS
ADDING SHADOWS

Whether an object is illuminated by a softly diffused or a strong directional light, it will always create a shadow, which needs to be considered when producing a composite. Every object has a 'weight' so, if it is presented without a shadow, it will appear to float. The nature of the shadow will be governed both by the angle of the light, and by its intensity, but this can also be made more complicated if there are several sources of light. But do not let this deter you because including shadows as part of your composite will undoubtedly add a further dimension to your work.

CREATING A SHADOW

I wanted to place the dancer in a more exciting setting but, to make it look believable, she would need to have a shadow. To create a shadow, first make a selection and then drag it into the destination window (see Before Shadow, above right). This becomes Layer 1. Save the selection as an Alpha Channel as further changes will be required later on. Select the dancer again and drag a Duplicate copy into the destination window. This becomes Layer 2. Invert it 180 degrees and then flip it horizontally using Transform (see Copy, right). This will now become the shadow.

With Layer 2 still active, reduce the Brightness/Contrast to zero. Then using Distort (Edit > Transform > Distort), carefully manipulate the shadow so that it appears

BEFORE SHADOW / Having made a careful selection, the dancer was dragged into the destination window. While the proportions work, the lack of shadow suggests that the figure is floating.

COPY / A duplicate of the dancer was made, which was rotated 180 degrees and flipped horizontally.

BACKGROUND / A shot taken inside the famous Mezquita Mosque in Cordoba. I opted to hand-hold the camera using a slow shutter speed in order to create an impressionistic blur.

SHAPE / The shadow layer is darkened by reducing Brightness/Contrast to zero, dragged into position and then manipulated into a plausible shape using Distort. The harshness of the shadow was reduced by applying Soften from the Blending Mode.

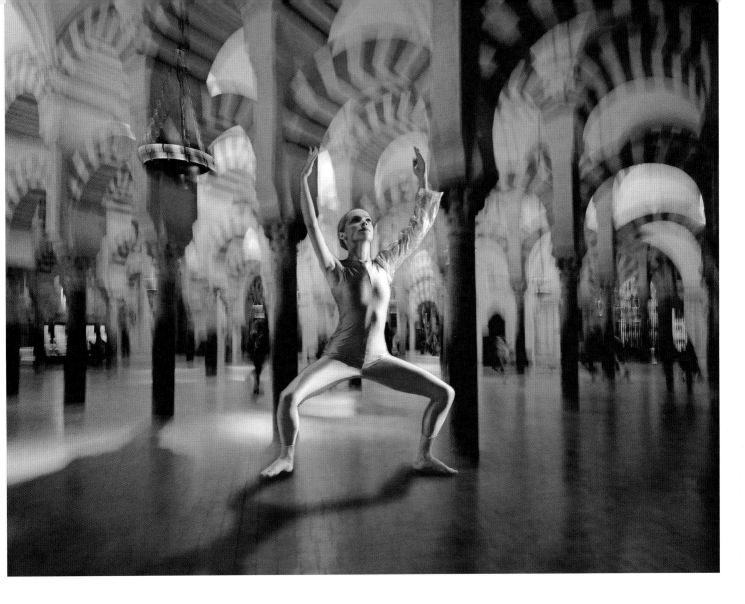

diagonally opposite the source of lighting. With interiors, this can be difficult to establish, but if there are other shadows present, these should offer a clue. It is important that the feet of the shadow are positioned directly below the feet of the dancer (see Shape, left).

The shadow still looks false, but various other techniques can now be used. Firstly, as the shadow appears too dark, apply Soften from the Blending Mode, which lightens the shadow and allows the detail in the Background layer to show through. To reduce the hard-edged nature of the shadow, apply Gaussian Blur. Finally use the Eraser tool, set to Soften, to incrementally blur the parts of the shadow furthest from the dancer.

REFINEMENTS

As both feet are in contact with the ground, the shadow needs to be most prominent directly below them, which requires making further adjustments. Activate Layer 1, load the selection and then Inverse it. With the foreground colour on black, use the Brush tool set on Soft Light, but with a reduced Opacity, and carefully add more tone (see Layer Mask, right). Finally, with Layer 2 active, make a heavily feathered selection of the shadow furthest from the feet and increase fuzziness using Gaussian Blur.

FINAL IMAGE / Careful thought needs to be given to the direction of the shadow. It should be diametrically opposite the source of light.

LAYER MASK / The shadow area below the parts of the object that are in contact with the ground often need to be darkened. This is achieved by applying a Layer Mask and then accentuating the shadow using the Brush tool set to Soften.

CHAPTER 6:
THE DIGITAL
DARKROOM
LITH PRINTING

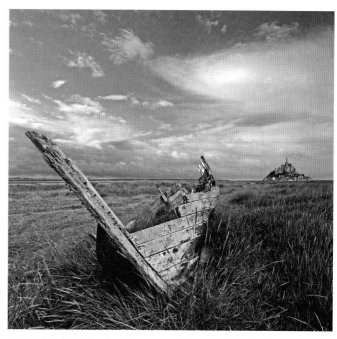

In the darkroom, the basic lith process works by grossly over-exposing the printing paper, then developing it in a very weak solution of lith developer. The hallmarks of lith printing are strong shadow detail countered by delicate highlights and, working digitally, this tonal profile must be replicated accurately. Even the most committed darkroom worker would concede that the lith process is particularly fickle and subject to so many possible pitfalls: staining, uncontrolled fogging and uneven toning are the most common. Using Photoshop, it is easy to bypass all these shortcomings.

ORIGINAL IMAGE / As with most techniques, it does help to carefully select the image that best suits the characteristics of a lith print.

CREATING A LITH EFFECT USING LAYER MASKS

Select the image to be 'lithed'. Make a Duplicate layer, which becomes Background copy, then create another layer, which becomes Background copy 2. Hide Background copy 2, and activate the Background copy. Apply an Adjustment layer, select Hue/Saturation and dial in a reddish hue. If you are happy with the result, click OK. Select Background copy 2, make another Adjustment layer, select Hue/Saturation once again, but this time choose a lighter beige colour. The selected hues are important and it helps to have some familiarity with the colours created by darkroom lith printing.

To restrict the grittiness to just the shadows, create a New layer and fill it with grey (Edit > Fill > 50% Gray). Click OK. Select Noise from the Filter options and start with 140.

This will appear too gritty in the final print and needs to be countered by applying Gaussian Blur; try a radius of 0.4.

With Layer 1 still active, apply Soft Light, then activate Background 2 and use Overlay. At this stage it will start to look like a lith print, except that the grittiness is distributed throughout the image. To restrict it to the shadows, make a Layer Mask. Activate Layer 1, go to Color Range and, using the Color Sampler, select the shadows. This will determine how much of the final image will appear gritty. You can also feather your selection at this stage. Once you are happy with the selection, click OK. Then make a Layer Mask, which will prevent the grain influencing the highlights. Now create another Adjustment layer, and select Levels. It might to help to lighten the image slightly by adjusting the Gamma slider. Select Color Range but this time select the highlights. Click OK, then delete the current channel.

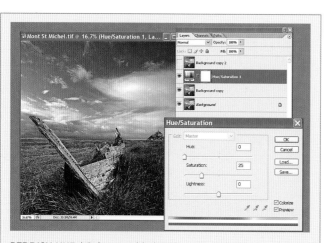

REDDISH HUE / Colour is added to the Adjustment layer using Hue/Saturation. It is an advantage if you are familiar with the hues you can achieve when processing lith prints in the darkroom.

CARAMEL HUE / Background copy 2 was selected and another Adjustment layer created, but this time a caramel hue was selected using Hue/Saturation.

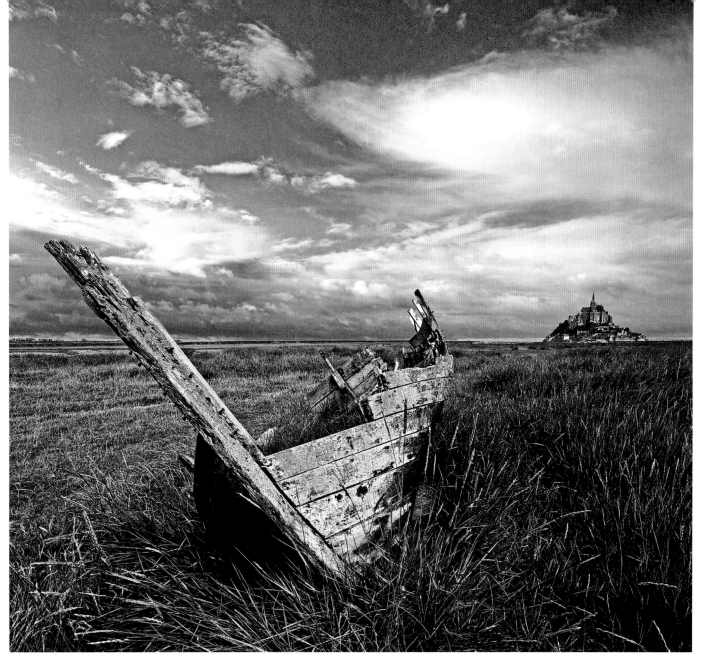

FINAL IMAGE / The dark, gritty foreground is countered by delicate highlights that are particularly evident in the clouds. This is typical of a traditional lith print.

OVERLAY / By activating Background 2 and then applying Overlay, the image appears through the grain screen. The only problem at this stage is that the grain affects the entire image; it needs to be restricted to just the shadows.

LAYERS / An overview of the actions. Do remember that you are still able to revisit any of them and make further adjustments if required.

SOLARIZATION

Solarization is a process in which a strong source of light causes a reversal of tones. Probably the first record of the use of this technique was Armand Sabbatier who, in 1862, used fogging of partially developed photographic materials to produce a tonal reversal in certain areas of an image. The so-called 'Sabbatier effect' is characterized by not only tone reversal but also the formation of a distinct line at edges between areas of tonal difference. The effect is usually performed by a brief exposure to light midway through film development. Of course, there is always the risk of ruining an original negative by this process and many people use a copy negative. With digital techniques, however, the original file is always safe. Probably one of the most famous artists to make use of this process was Man Ray who, in the 1930s, produced a series of portraits and figure studies using the 'Rayogram' technique.

There are many ways to emulate the appearance of a solarized image digitally. In most cases the result is much more predictable and more manageable than by traditional darkroom techniques. The success or otherwise of this process lies in matching the image with the technique chosen. Generally speaking, simple images with a strong

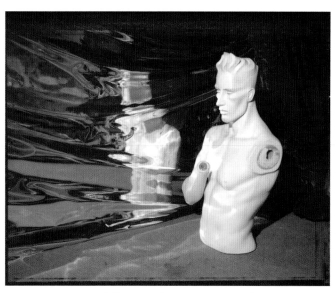

MANNEQUIN SCAN / The original image was a scan of 5 x 4in Polaroid negative.

shape and outline seem to work best when using this technique. One feature of solarized images is that they combine elements of both the positive and negative within the same image. The balance of these can easily be fine tuned in Photoshop.

LAYERS AND BLENDING MODES

The first method is to combine both positive and negative images together. This is easily accomplished using multiple layers. Here, the original image of a mannequin has been copied twice in Layers. The top layer has been converted to a negative simply by using Image > Adjustments > Invert (control I on the keyboard). To combine elements of this negative image with the original positive layer below, we can use a number of techniques. The most interesting is to call upon various Blending Modes. With the inverted top layer selected, click on the Blending Mode at the top of

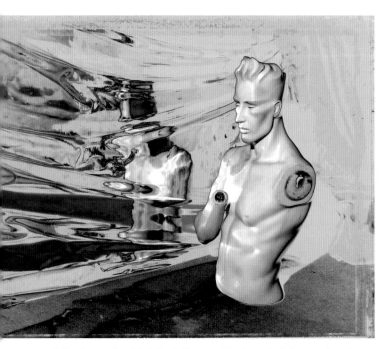

SOLARIZED IMAGE / The Difference Blending Mode has produced a convincing solarization and the mannequin appears to have a black line running around it, which is typical of solarized images.

LAYER BLEND / A negative copy layer has been blended with the underlying positive layer using Difference mode.

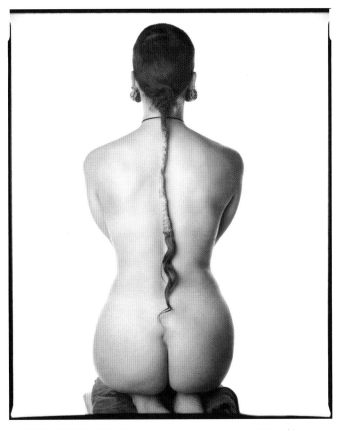

ORIGINAL IMAGE / This image was chosen for its simplicity of lines and shapes.

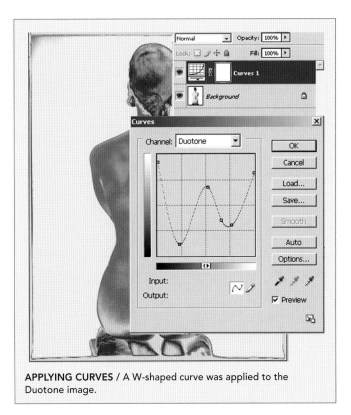

APPLYING CURVES / A W-shaped curve was applied to the Duotone image.

the Layer palette. By scrolling through these options using the up and down arrows on the keyboard, you can immediately see their effect. In this case, Difference produced the desired effect but others such as Pin Light, Lighten and Darken all gave interesting, though totally different, solarized images.

USING CURVES

Probably the most powerful and controllable way to achieve a solarized effect is to make use of Curves. With Curves, the output value of any tone in the image can be accurately changed, allowing tone reversal to be achieved in any area of the image. Normally, the appearance of the graph in Curves is a straight line between Input and Output. By altering the shape of the curve you can impose your own tonal values. Start by pegging the midpoint of the curve and moving it into a V shape. This will reverse tones of the shadow areas and produce a high-key solarization. By pulling the midpoint down, you will introduce more blacks into what were originally midtones. Next, try changing the shape of the curve to an inverted V. Now the highlight areas have been inverted in tonality. Numerous shapes of curves can be used and saved to apply to further images, but W or inverted W-shaped curves work particularly well. In the shot of the model's back shown here, the monochrome image was first coloured using Duotone and then a W-shaped curve applied, resulting in an effective solarized image.

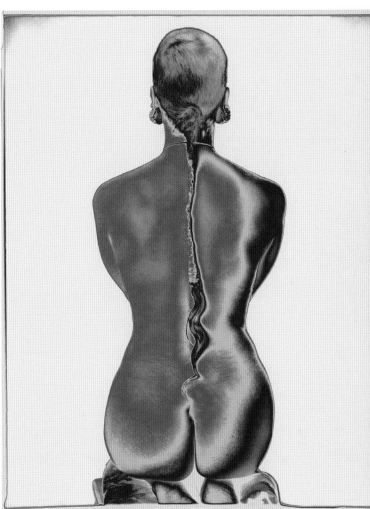

RESULT / The final solarized image.

BAS RELIEF

Bas Relief, (taken from the French 'low relief'), is a time-honoured technique that has fallen out of fashion in recent years; but, as with most techniques, it can be improved and updated. It is a process that makes the image look as if it is heavily embossed, often resembling a piece of sculpture.

To create this effect in the darkroom, it is necessary to combine a positive and negative of the same image, copied on continuous tone film, which is then sandwiched slightly out of register in the negative carrier. The way the film is sandwiched determines on which side the 'shadows' appear. Often the results are quite abstract and clearly some thought needs to be given to subject matter. Usually an image showing strong textural or graphic qualities works best.

In Photoshop, the simplest way of recreating this effect is to use one of the filters designed specifically for the purpose. Start by making a Duplicate layer then go to Filters > Sketch > Bas Relief. This filter offers three settings, Detail, Smoothness and Light. The Detail slider operates on a scale of zero to 15 and determines how much of the fine detail is selected. It does not make a great deal of sense to dial in a larger setting as this cancels out the effect; try starting with 4 or 5. Smoothness governs the graininess of the image: if you opt for a low setting, the image will appear gritty, however a higher setting smoothes out the tones. The third slider allows you to decide which side you want the off-set to appear and often it is simply a matter of seeing which one works best.

The results from applying the Bas Relief filter can appear a little over the top for some people's tastes, but its effects can be pleasingly modified. Try experimenting with the various Blending Modes in order to achieve a more visually satisfying outcome.

OFF-SET FILTER
As we have seen, the bonus of working digitally is that it allows you to modify darkroom techniques in a way that was

ORIGINAL IMAGE / The rich textures of this deteriorating façade make it an ideal subject for Bas Relief.

BAS RELIEF FILTER / It often helps to experiment with the Blending Modes to see if the image can be improved. Inverting the copy layer can also offer an interesting alternative.

LAYERS / By blending the Positive and Negative layers using Overlay, an exaggerated sense of texture is created, but without radically changing the character of the image.

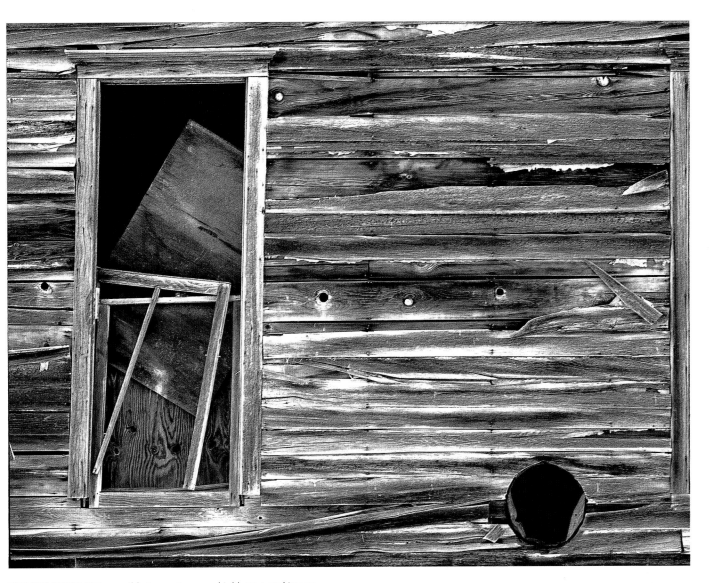

OFF-SET FILTER / It is possible to create a very highly textured image by using the Off-Set filter. This example has been toned using Color Fill.

previously impossible. By using a filter that is similar to Bas Relief, equally interesting avenues can be explored.

Firstly, make two Duplicate layers, renaming Layer 1 'Positive', and Layer 2 'Negative'. Go to Filter > Other > Off-Set; this filter allows you to misalign a layer relative to the Background layer. Activate the Positive layer and, using Levels, increase the contrast. Select the Off-Set filter, and then misalign the horizontal and vertical axis by +1 pixel. Now, activate the Negative layer, increase the contrast again using Levels, Invert (Edit > Adjustments > Invert), and then misalign the horizontal and vertical axis by -1 pixel. Finally, using Overlay, blend the Positive and Negative layers.

In the example shown here (see Off-Set Filter, above), I decided to sepia tone the final image to add warmth and richness to the textures inherent in the image. To do this, make an Adjustment layer, apply Solid Color and then select a suitable hue. Use Overlay and Opacity to blend the Adjustment layer.

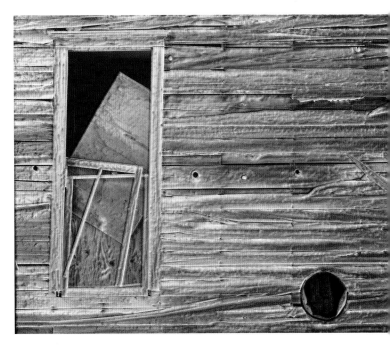

TONING DOWN / Some of the excesses of the Bas Relief filter can be subdued by applying Overlay.

CHAPTER 6:
THE DIGITAL DARKROOM
INFRARED EFFECTS

For true infrared effects we really need to photograph purely with infrared light. With film photography, this means using film such as Kodak High Speed Infrared together with appropriate filters. The hidden world of infrared is then converted to a black and white image that was previously invisible to the naked eye. However, most modern digital cameras incorporate a filter that blocks out infrared, allowing only the visible light spectrum to be recorded on the sensor. In this case we have to look at the characteristics of an infrared image and try to recreate them digitally using Photoshop.

Before we do, it is worth mentioning that some early digital cameras, especially the compact types, had sensors that were sensitive to infrared light. Cameras such as the Nikon 950 and Olympus C-2000/C-2020 do not have infrared filters. Therefore, if combined with a filter such as Hoya R72, they can create true infrared images. Some experimentation with exposure may be necessary, but this

is easily accomplished using the playback screen to check as you shoot. It is also possible to remove the internal infrared filter on some cameras and create your own digital infrared camera, although you will nullify the manufacturer's warranty by doing so.

Assuming that you are using a modern digital camera, however, there are several ways of producing infrared effects from an RGB file. It is essential to start with a full-colour image because the Channel Mixer will be used to fine tune the effects.

TONAL CHANGES

The first characteristic of an infrared image is the way colour is translated into monochrome tones. Typically, green foliage and skin tones become very light, and blue skies become very dark. To achieve this, open up the Channel Mixer as an Adjustment layer (Create New Fill or Adjustment Layer icon at the bottom of the Layers palette) and check the Monochrome box. There is no magic formula for what comes next. The settings that you use will depend upon the range of colours within your image. Remember that a positive value of red, green or blue will lighten that colour. Therefore, if the original contains green foliage, the Green channel is increased to lighten it.

In the landscape image shown here, there is a large amount of green in the foliage and moss. The Green slider has been pushed to its maximum +200. This now causes the whole image to lose highlight detail, so to compensate the Red and Blue sliders are moved to a negative value. In this case Red -70 and Blue -30 seems to work well (see Channel Mixer, above right). You will notice that the three colour settings add up to 100. As a rough guide, this should always be the case to ensure a full range of tones. By using the Channel Mixer as an Adjustment layer, the effect can be fine tuned at any stage. In this case, for example, a Curves Adjustment layer has been used to boost contrast.

Sometimes, a single global change using the Channel Mixer needs to be selectively modified. In this example, the foreground rocks became a little too light and needed toning down. Fortunately, the Adjustment layer automatically produces its own mask. By painting on to the mask with black, using a low Opacity setting, the foreground can be partially returned. As the underlying layer is still colour, however, some colour will now appear in the image. To retain the monochrome effect, a further Hue/Saturation Adjustment layer has been used and the saturation reduced to zero.

ORIGINAL IMAGE / It is essential to start with a full-colour image. This landscape has plenty of fresh, spring greens.

FINAL IMAGE / Now in monochrome, the landscape has a distinctive infrared look to it.

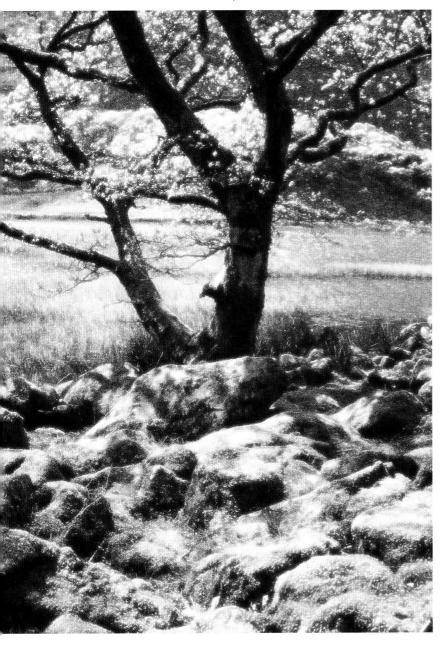

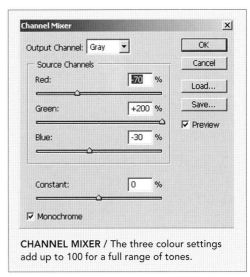

CHANNEL MIXER / The three colour settings add up to 100 for a full range of tones.

LAYERS / The palette from the completed image. Masks can be used to make local changes if required.

ADDING A GLOW

Film such as Kodak Infrared lack an anti-halation layer. This means that highlight areas tend to 'bleed' producing an ethereal effect. To achieve this, duplicate the original layer and use Gaussian Blur set anywhere between 5 and 80, depending upon the file size. Now set the Blending Mode to Lighten and you will see the image start to glow. The effect can be adjusted by using the Opacity slider at the top of the Layers palette (see Layers, right).

ADDING GRAIN

Infrared shots are usually fairly grainy. To mimic this characteristic digitally, grain can be added quite simply by using another layer. Create a new layer and fill with 50% grey (Edit > Fill > 50% Gray). Change the Blending Mode of this layer to Overlay. Now go to the Filter menu and choose Filter > Noise > Add Noise. Select Gaussian and check the Monochrome box. The slider can now be used to adjust the size of the grain desired.

DIFFUSER AND
TEXTURE SCREENS

Not all images need to be sharp. Occasionally, for purely aesthetic reasons, some need to be softened and the fine detail obscured. Monochrome portraits, for example, can occasionally appear overly harsh, but by applying a soft filter a gentler mood is introduced.

Traditionally, this is achieved in several ways. The most obvious method is to attach a soft-focus filter over the lens, but the problem is that the degree of diffusion is determined by the filter, not the photographer. As the filter remains over the lens for the duration of the exposure, the effect often proves excessive. An alternative is to soften the image at the printing stage by placing the filter under the enlarging lens for only part of the exposure, which allows you to take precise control over the extent of the diffusion in the print.

ORIGINAL IMAGE / While this was photographed during the winter months in fairly misty conditions, the degree of tonal recession that I was seeking was not sufficiently apparent.

Darkroom workers employed other, equally creative, methods including printing through a nylon stocking, or smearing Vaseline on glass and then using this as an improvised filter. Another method was to place light-translucent materials directly over the printing paper during part of the exposure; the results were highly idiosyncratic,

GAUSSIAN BLUR / I made a Duplicate layer and then applied the Gaussian Blur filter, set to 25 pixels. Using the Opacity slider, a balance was achieved between the blurred and the sharp layer. An Adjustment layer was made and blue was added using Hue/Saturation. Decreasing the Saturation reduced the intensity of the colour.

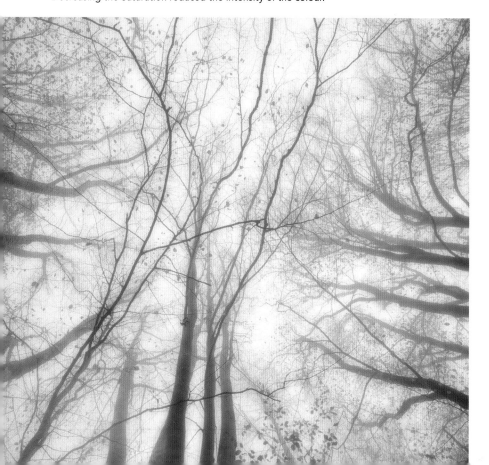

ADJUSTMENT LAYERS / Blending Mode options offer another way of balancing a sharp and unsharp layer; in this example, I chose to use Lighten. Further Adjustment layers were applied to both lighten the highlights and to colour the image blue.

yet strangely appealing. Whichever technique was used, the effect was to create the illusion of light scattering from the lighter parts of the image, while the shadows appeared to smudge and spread. Often a charming, evocative and nostalgic atmosphere could be created.

Achieving this digitally is best done using Layers. Open up the image you wish to use, and then create a Duplicate layer. Use one of the softening filters from the Filter Options (Gaussian Blur set at 25 pixels works well) and using Opacity or the Blending Modes, balance the blurred and the sharp copy. If the highlights lose their brightness, make an Adjustment layer and use Curves to remedy this.

This principle can be taken further. Many lightly textured materials such as tissue paper, lace or rice paper can be scanned to create a background layer and then blended with another image using either the Opacity slider or the Blending Modes. Doing this digitally, it is possible to precisely determine the Opacity of each of the layers.

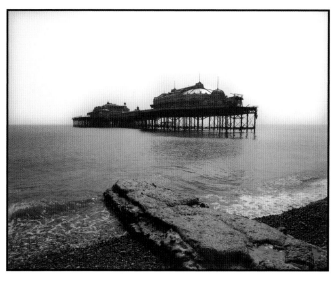

ORIGINAL IMAGE / Brighton's West Pier has all but disappeared, but it had an illustrious past. It is one of those classic subjects that evokes a strong sense of nostalgia.

COLOR BALANCE / Having used Screen as the Blending Mode to merge together the background and Layer 1, I made an Adjustment layer and selected Color Balance. Restricting the changes to the highlights only, I dialled in a small amount of red and yellow to create a sepia effect. The diffusion allowed the colour to separate in parts, with the yellow affecting the highlights and the midtones appearing pink.

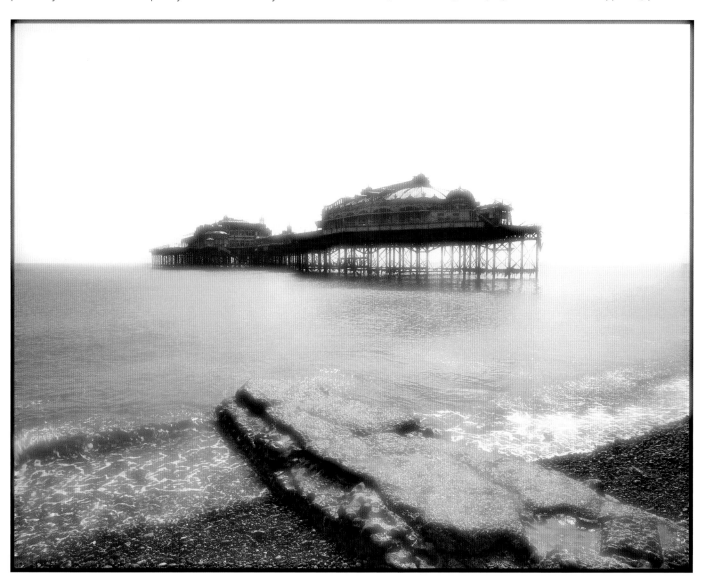

MIMICKING ALTERNATIVE PROCESSES: LIQUID EMULSION

Of all the alternative processes, liquid emulsion is probably the one that most darkroom workers have tried, if only because it requires very little additional equipment. It is a relatively modern technique that gained surprising popularity, possibly as a reaction to the rigid way most darkroom papers are manufactured to the same size, format and type. But with the demise of the darkroom, we need to look at other ways of producing such beautiful, one-off images, while retaining their hand-crafted look.

Firstly, it is important to identify those qualities that distinguish a liquid emulsion print from any other, then examine how this can be recreated using Photoshop. The process involves coating the emulsion, under darkroom conditions, on to good quality watercolour paper and then exposing the sensitized surface to light through an enlarger. The emulsion is applied using a wide brush and often requires several coatings. As all this is done under safe lighting, it is difficult to see how the coatings build up, and inevitably there will be missed areas, particularly on the margins. Coupled with the predictable fringing, liquid emulsion prints certainly do look handmade. But it is these idiosyncrasies that make this such an interesting technique.

BRUSH BACKGROUND / This background has been created by applying black gouache paint directly on to a sheet of white paper, which was then scanned on a flatbed. The brush marks need to be broad and spontaneous.

ORIGINAL IMAGE / Most subjects can be used successfully to create a digital liquid emulsion.

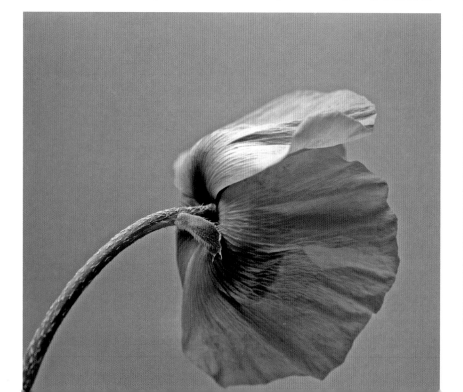

LAYERS / The tones in the final image were fine tuned using Curves. A subtle sepia layer has also been applied.

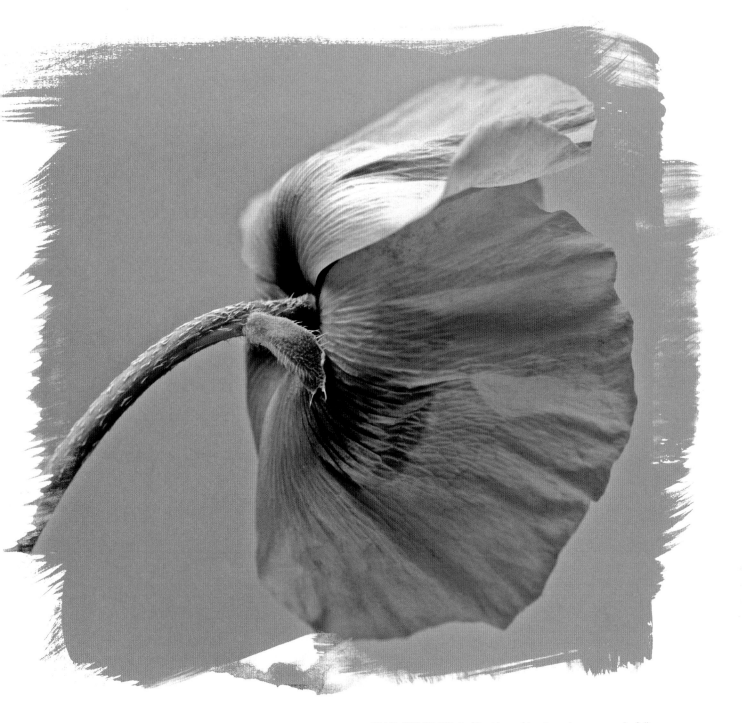

CREATING THE BACKGROUND

This part of the process is the key to producing plausible liquid emulsion images and yet it does not involve using Photoshop, or even a computer. Take a brush loaded with dark paint and cover a sheet of white paper. Often this is best achieved with a larger brush as it makes you paint spontaneously. Do not use watercolour paper at this stage as the texture will show through. I have heard of some photographers trying to recreate these effects using various Photoshop tools. Unless you are prepared to commit a huge amount of time, the results are often disappointing.

Having prepared a background, the best way of digitizing it is to use a flatbed scanner. Once scanned, it may be necessary to brighten up the whites on the edges using Levels, but avoid the temptation of cloning out imperfections within the painted area. This becomes the Background layer.

FINAL IMAGE / Digital liquid emulsion introduces a wonderfully informal quality to this image.

COMBINING LAYERS

Call up the image you wish to use, making sure that the size and resolution of both layers is consistent. Using the Move tool, drag the image over the Background layer; this becomes Layer 1. Ideally this layer should just about cover the Background layer. If either of the layers requires resizing, use Scale. Activate the layer which needs to be changed, then go to Edit > Transform > Scale and, while holding down shift, drag the corners until Layer 1 fully covers the Background layer. Once this is done, apply Lighten from the Blending Mode.

Remember, liquid emulsion is coated on to a high-quality watercolour paper, so aim to print the finished image on to one of the many wonderful art papers currently available.

CHAPTER 6:
THE DIGITAL DARKROOM
CYANOTYPE

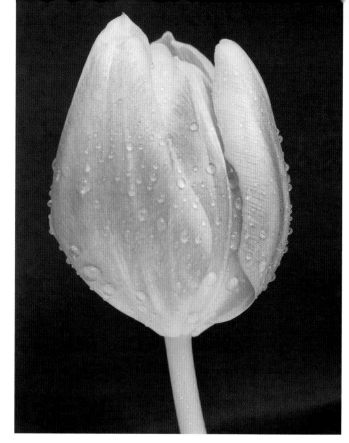

ORIGINAL IMAGE / When creating a cyanotype, start with a simple, clear-cut image.

Cyanotype (also known as the blue-print process) is without question one of the most easily recognized of all the alternative processes. The striking blue is an immediate giveaway. Dating back to the beginnings of photography, it was pioneered initially by Sir John Herschel and Anna Atkins in the 1840s. It works on the principle that ferric salts of citric and other organic compounds change to ferrous salt when exposed to ultraviolet light. The ferrous salts combine with potassium ferricyanide to form the characteristic cyanotype blue.

Like the liquid emulsion technique, it involves coating a surface (usually paper, but other porous surfaces can also be used) prior to exposure. When dry, it then involves contact printing the negative directly with the sensitized surface and exposing it to UV light; this used to require exposing it to the sun, which reduced the ferric salts to ferrous salts. Once the exposure was complete, the unwanted ferric salts were washed away. Contemporary practitioners use UV lamps instead, but it is still a long and tricky process.

The traditional method is time-consuming and does not guarantee success. After coating the surface, the exposure can take many minutes. It requires washing, and it needs to dry before an accurate assessment of the final colour

can be made. This needs to be repeated for each print. As this process requires contact printing, the size of each image is governed by the size of the negative. In order to get a reasonably sized print, you will be required to work from negatives as large as 5 x 4in or 10 x 8in. This, of course, can prove to be hugely expensive. Realistically, most photographers these days use digital cameras, but, as we shall see in Chapter 7, it is possible to make a large negative from a digital source if this is a route you wish to go down. But at a time when we are concerned with the environment, it seems inappropriate to use hazardous chemicals such as potassium ferricyanide. Add to this the difficulty of acquiring some of these materials and the argument for trying a digital alternative is persuasive.

THE DIGITAL PROCESS

Produce and scan a brushed background as described for the liquid emulsion technique (see pages 102–103). Any dark colour can be used, as the final scan will need to be desaturated. If it appears too dark, lighten it using Levels, aiming to achieve a dark grey. Try to resist perfecting this layer, as the imperfections add to the idiosyncratic qualities of this beautiful process. It is a matter of judgment, but I tend to find that digitally created cyanotypes work best when the proportions match well-recognized film sizes such as 5 x 4in or 10 x 8in. Printing this on to a sheet of A4 (29.7 x 21cm/11½ x 8¼in) or A3 (42 x 29.7cm/16½ x 11½in) ink-jet art paper can create a very authentic result.

Bring up the image you wish to use and desaturate it, ensuring that it remains in RGB mode. Make sure that it matches the resolution of the painted background but

TONE / Apply the colour using Color Balance. If it proves a little overwhelming, reduce it using Hue/Saturation.

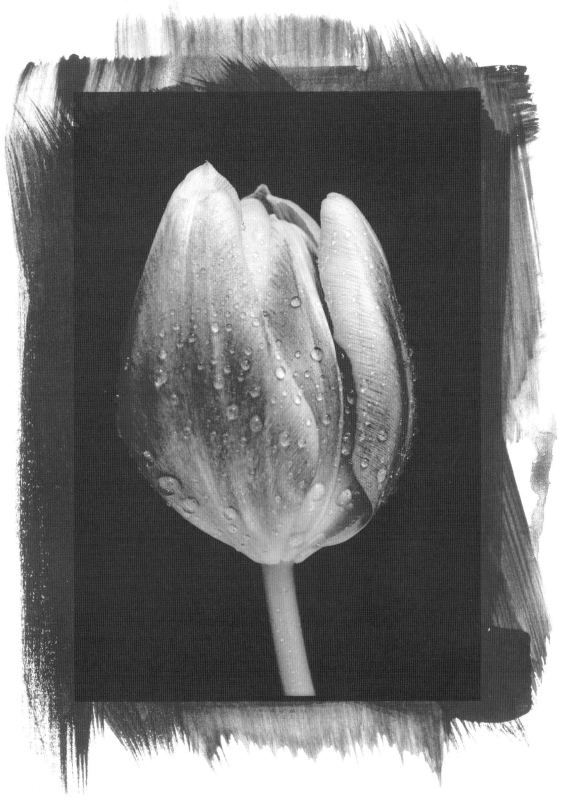

is slightly smaller in size, so that this layer can fit easily over the paintbrush layer. Using the Move tool, drag the image over the paintbrush layer. The paintbrush becomes the Background layer and the image becomes Layer 1 (remember, you always have the option of using Scale to ensure that both layers match). Leave these two layers in Normal mode, although applying either Screen or Lighten does offer an interesting alternative. Open an Adjustment layer and select Color Balance. Selecting the Midtones, dial in -62 Cyan, +95 Blue. Open a second Adjustment layer and use Hue/Saturation to reduce the intensity of the colour.

FINAL IMAGE / Images like this are designed to be printed on to a high-quality fine art paper. Also, cyanotypes often conform to a large-format image size, such as 5 x 4in or 10 x 8in. Always aim to leave a large white margin around your image, which is a defining characteristic of most cyanotypes.

Once you are satisfied with your digital cyanotype, flatten the layers to reduce the file size, but do keep a layered version if you want to revisit it at any future point. Finally, if you wish to make a print, make sure you use one of the heavyweight fine art ink-jet papers such as PermaJet Classic Fine Art Papyrus (see pages 134–135).

GUM BICHROMATE

LAYER 1 / It is possible to create a painterly effect using the Dry Brush filter in Photoshop, but scanning a home-made one offers a more authentic alternative.

From a historical perspective, the gum bichromate process is fascinating because it first enabled photographers to work in colour, albeit not true colour. It was developed at the end of the 19th century and, like most alternative processes, it requires contact printing the negative with a sensitized sheet of watercolour paper. To produce a gum bichromate, a mixture of gum arabic and pigment is applied to the paper, which is sensitized with potassium bichromate. This hardens the gum if it is exposed to ultraviolet light. The coated paper is then contact printed with either a film or paper negative and the image created by washing away the unhardened gum, particularly in the lighter areas of the image. A gum bichromate can be produced using a single colour, or several. Either way, the results are delicate, ephemeral and almost painterly.

CREATING THE IMAGE

Call up the image, make an Adjustment layer and apply Color Balance. Remember, the colours achieved using the gum bichromate technique are governed by personal choice and are not dependent on a chemical reaction. In this sense, you have a great deal of choice. In this example, I opted to use two colours that provide a strong contrast,

although a more subtle combination could just as easily have been applied. Make note of which two colours were used as they will be needed later in the process.

To produce an authentic gum bichromate effect, it is important to recreate the characteristic brush marks that appear throughout the image. This is done by making a second layer. Apply a dry brush with a small amount of gouache paint on to a sheet of white paper (see Layer 1, above), let it dry, then scan it on a flatbed. Resize, and then drag it over the original image, so that the original image becomes the Background layer and the brush marks become Layer 1. Blend the two layers using Multiply (see Multiply, right). This has the effect of slightly darkening the image, but this can easily be countered using Curves. If you

DETAIL / This close-up illustrates how the scanned dry brush layer gives the impression that the image has been created by applying layers of watercolour pigment over a sheet of paper sensitized with potassium bichromate.

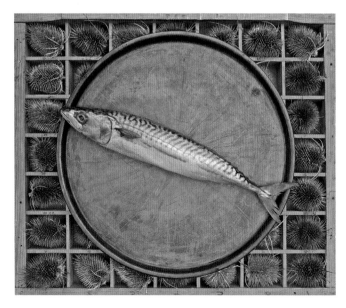

ORIGINAL IMAGE / The gum bichromate process creates an almost painterly effect, and images with a strong graphic element work particularly well.

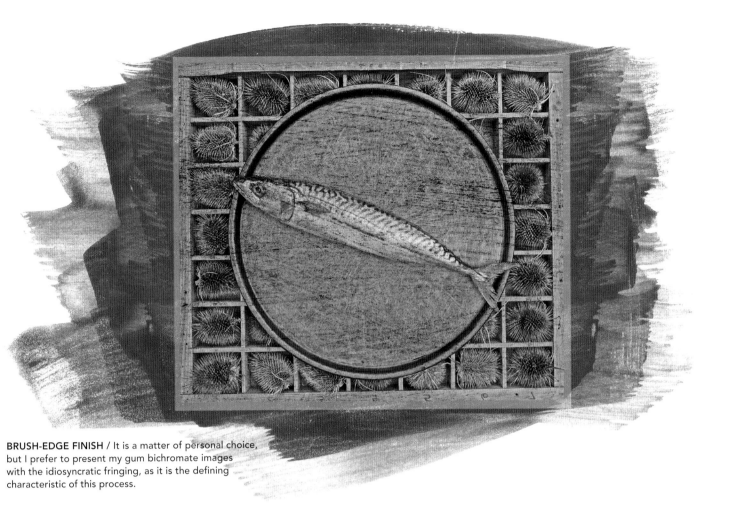

BRUSH-EDGE FINISH / It is a matter of personal choice, but I prefer to present my gum bichromate images with the idiosyncratic fringing, as it is the defining characteristic of this process.

find creating your own brush-effect layer too problematic, use Photoshop's Dry Brush filter (Filter > Artistic > Dry Brush), setting the Brush Size to 2, but leaving the Texture at 1. This is not my preferred method, largely because these filters do not accurately reflect the informal characteristics of applying pigment to paper.

CONSTRUCTING THE BACKGROUND

Firstly, two separate painted backgrounds were produced; the colour of the paint is irrelevant at this stage. These

sheets were then scanned, desaturated and resized. The aim is to create the effect of one layer of colour being painted over another. This is achieved by digitally colouring each of the layers using the same two colours that were applied to the original image, and then dragging one layer over the other and blending them using Multiply. If the result appears too dark, lighten it using Curves. Once this has been achieved, flatten the two layers to create the background. Finally, call up the original image and, using the Move tool, drag it over the background. Resize if needed.

MULTIPLY / Use this to merge the Background layer with Layer 1.

SHARP-EDGE FINISH / Many exponents of the gum bichromate technique opt to present their work without the brushed edging.

CHAPTER 6:
THE DIGITAL DARKROOM
FURTHER ALTERNATIVE PROCESSES

In addition to gum bichromates and cyanotypes, there are other equally interesting alternative processes, including salt printing, kallitypes and argyrotypes. The latter shares many of the visual characteristics of the others, though it has been developed in recent years using modern chemistry.

In the darkroom, these prints are all created in the same way: sensitized emulsion is applied on to watercolour paper, which is then exposed to UV light. As a result, they all reveal the distinct fringing that characterizes most alternative

ORIGINAL SCAN / Many exponents of the alternative processes work from large-format negatives; in this example, I have scanned a discarded 5 x 4in negative.

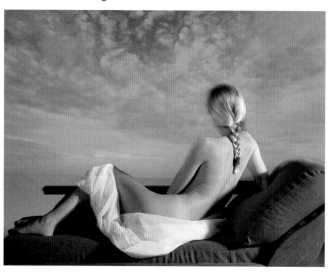

ORIGINAL IMAGE / I often find simple themes make ideal subjects for use in alternative processes.

processes. To mimic the effect digitally, the starting point is a background, made simply by applying paint on to paper (see pages 102–103). This is then scanned using a flatbed, or copied digitally using the camera's macro facility.

Once opened in Photoshop, the brushwork image becomes Layer 1, which is then dragged over the Background layer (the subject image). An Adjustment layer is made and the new combined image is toned according to the process being simulated. Despite the obvious similarities in each of these processes, they are subtly different and their unique characteristics need to be understood if they are to be successfully mimicked. Salt prints, for example, were created by immersing the watercolour paper into a salt solution, which was then sensitized with silver nitrate. After exposure to UV light, the image appeared showing a reduced tonal range and a characteristic colour, ranging from a cool brown to a rusty red.

Kallitypes (also known as Van Dyke Brown prints) used the effect of UV light on a mixture of silver nitrate and iron salts. After exposure, the image was developed in a solution that determined its final colour. For example, if it was developed in potassium dichromate, the result would show a sepia effect. If you wanted to achieve a cold blue, then developing it in a solution of borax, Rochelle salts and potassium dichromate was required. One characteristic of a kallitype is the reduced tonal range and the appearance that the developer has dyed or stained the paper. Printing digital 'kallitypes' on a high-quality watercolour paper such as Somerset Enhanced works particularly well, as the ink appears in, rather than on the paper.

It is also worth noting that most alternative prints were presented quite small. It is a personal thing, but I think these images are best printed in the proportions of the originals they mimic, with plenty of white paper surrounding them.

DIGITAL SALT PRINT / OPPOSITE ABOVE / Once scanned, I imported the image of the model into a 5 x 4in negative using Paste > Into (see the section on Borders and Edges, Chapter 7). This was then flattened and dragged over the brushstroke background. An Adjustment layer was made, Color Balance selected, and 15 Red/20 Yellow used to create brown. The contrast of the entire image was reduced using the Brightness/Contrast command.

DIGITAL KALLITYPE / OPPOSITE BELOW / When producing a kallitype, the colour is determined by the developer used. In this example, I have tried to mimic a cold blue using Hue/Saturation. The tonal range has been reduced, as is consistent with this beautiful process.

As a photographer, I love to experiment with different techniques to create interesting and, hopefully, unique images. I have printed through textured papers and grain screens, photographed through black stockings and glass smeared with petroleum jelly; I have an enormous collection of Cokin filters – largely unused. After the initial experimentation, most of the effects, particularly those of the filters, fall by the wayside as they can become clichéd or gimmicky. For black and white film photography, however, some remain essential, such as the use of red filters for producing dramatic skies, or green filters for lightening foliage in landscapes.

With film, the use of a filter at the capture stage is irreversible, but the advent of digital imaging has changed all that. We now have the great advantage that such effects can be added after an image is taken, with the original retained in unadulterated form. The range of filter effects in Photoshop and third-party plug-ins is enormous and can be applied in any combination if required.

Some of these filters are particularly useful for the black and white digital photographer. We have already discussed how the Channel Mixer can be used to affect tonality in the same way a colour filter would with black and white film

GRAIN TYPE / A number of different grain effects are available from the Filter > Texture > Grain menu.

SETTING / The Speckle Grain filter set at Intensity 35 and Contrast 55.

(see page 17). The use of filters to soften an image has also been covered (see pages 100–101). Delving into the Filter menu can be like opening Pandora's Box so some thought and care has to be taken. It is very easy to apply a filter effect, but often this results in images that are recognizable purely for the effect and little else. Always consider why you are using a filter and whether it is appropriate to an image. Situations where fast film would have been necessary usually work well with grain effects for example.

GRAIN FILTERS

The appearance of grain was once thought of as a technical fault, but the images by people such as Lord Snowdon and Sarah Moon led to acceptance of grain as an integral

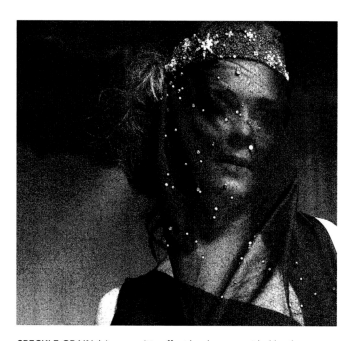

SPECKLE GRAIN / A very gritty effect has been provided by the Speckle Grain filter and is particularly apparent in the midtone areas. It has also increased the contrast of the original image.

and sometimes important part of an image. The size of the grain and its sharpness was characterized by the film and developer combination chosen, and most photographers had their favourites. Digital images, by their very nature, lack grain, though if higher ISO values are set a type of digital grain called 'noise' is apparent. However, it is easy to create grain effects using the appropriate filter. In Photoshop there are a number of alternatives.

TEXTURE: Select Filter > Texture > Grain (see Grain Type, left). This filter provides a greater range of grain effects, some of which (Vertical and Horizontal) do not resemble traditional film grain at all, but are worth trying. Apart from the type of grain, both intensity and contrast can be altered. For the portrait shown here, I have used the Speckle Grain effect.

NOISE: Select Filter > Noise > Add Noise. This brings up a dialog box, which adds a grain-like effect (see Add Noise, right). Check the Monochromatic box to prevent unwanted colour appearing and select Gaussian Distribution to make the grain seem more irregular. By using the Amount slider, the size of the grain can be increased or decreased. Rather than apply the grain irreversibly to the image, it is useful to create a new layer above the Background image layer, fill with 50% Gray (see Gray Fill Layer, below) and set the Blending Mode to Overlay (see Overlay, below right). The filter effect can now be applied to the Fill layer and the

ADD NOISE / This is the digital equivalent of grain. Gaussian Distribution makes it more irregular.

GRAY FILL LAYER / Create this layer rather than applying the grain irreversibly to the image.

OVERLAY / The grain effect will appear on the image but the grain layer can be changed at any time.

grain will appear on the image. However at any time, the grain layer can be changed if required.

CREATING SNOW

Unfortunately there is no snow filter, but we can use filter effects to create snow. Obviously it is best to start with an appropriate image. In this case I have selected an image of sheep in a field of snow and added the snowstorm with the use of three filters. The settings apply to a 12MB grayscale image but they may need to be adapted if your image is smaller or larger.

Step 1: Create a 50% Gray Fill layer and set the Blending Mode to Overlay.

Step 2: Filter > Noise > Add Noise. Set the Amount to about 90%, Distribution to Gaussian and check the Monochromatic box (if using an RGB image).

Step 3: Filter > Sketch > Graphic Pen (see Second Filter, below). Set the Stroke Length to 11, the Light/Dark Balance to 36, and the Stroke Direction to Left Diagonal.

Step 4: Filter > Blur > Motion Blur (see Third Filter, below right). Set an Angle of -61° and Distance of 45 pixels. The effect can be manipulated by changing the Opacity of the snow layer, selective erasing or dodging and burning.

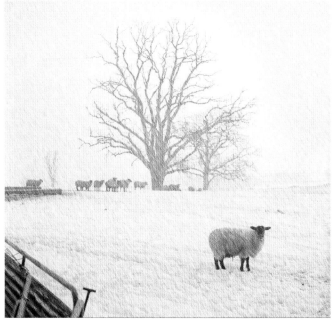

SNOW EFFECT / Three filters combine to create a wintry scene.

SECOND FILTER / Filter > Sketch > Graphic Pen.

THIRD FILTER / Filter > Blur > Motion Blur.

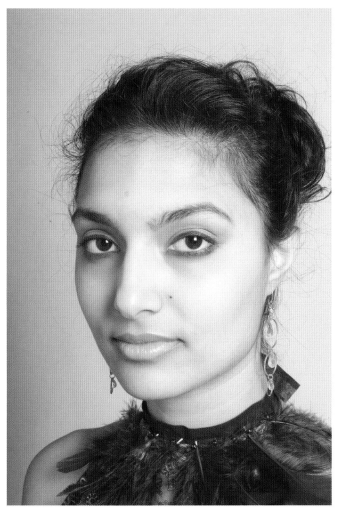

MODEL BEFORE / Kinjal before any manipulation.

LIQUIFY / The dialog box has tools and Tool Options.

MODEL AFTER / Kinjal after using Liquify to make very subtle alterations.

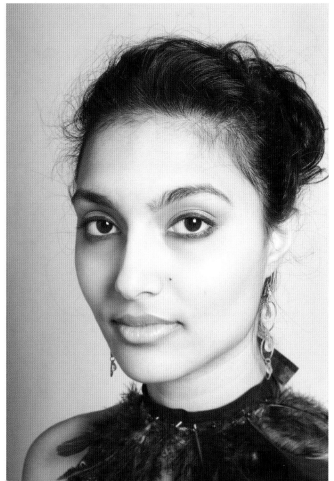

PLASTIC SURGERY USING THE LIQUIFY FILTER

Liquify is a powerful filter that is more like a separate image manipulation package within Photoshop. It can produce very strange effects, but is also capable of very subtle alterations to an image. Basically, It works by shifting pixels using a variety of paint tools. When you open up Liquify, your image will appear in a dialog box complete with a new tool box and Tool Options (see Liquify, above right). You can work on a whole image, or, before opening the filter, you can make a selection and just work on that. I use this filter to make subtle changes in portrait and figure work.

The first tool in the box is the Forward Warp tool. By selecting a large Brush, this can be used to subtly move pixels, almost like pushing a finger through wet oil paint. In this example, I have used it to narrow the model's face, raise the arch of her eyebrow, remove a bump from her shoulder, and slightly change her nose shape (compare before and after images). In most cases this is the only tool I would use. If a mistake is made or you go too far, the next Brush down in the tool box is a Reconstruct tool, which can selectively return any changes back to their original state. The other tools, such as the Bloat and Pucker tools, can be useful to enlarge or shrink areas of the face or body, but need to be used with caution.

CHAPTER 7: EXTENDING THE BOUNDARIES
EDGES AND FRAMES

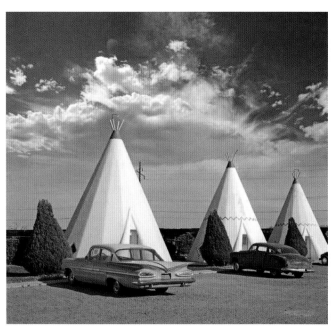

ORIGINAL IMAGE / A desaturated image in RGB mode.

All aspects of the visual arts show certain characteristics that mark them out from the others. Etchings and lithographs are embossed into the paper, the layers of colour in silk-screen prints inevitably misregister, while paintings often show marks and dribbles that reveal how the artist has chosen to apply the pigment. These illustrate the processes that are needed to produce unique images, which are why works of art are often so highly valued: they are seen as 'one-offs'.

Identifying similar idiosyncratic features in photographs is a little more difficult, if only because of the mechanical way we produce them. But they do exist. For example, more and more photographers want to add interesting borders to their images, many of which reflect traditional photographic techniques. Various software manufactures now offer plug-ins, notably Extensis Frames and Auto FX.com, that allow the user to import a variety of frame options. While some of these are good, others are less impressive. They can also take up quite a lot of the computer's memory. Rather than rely on a packaged set of borders or frames, why not create your own?

FILM SCAN / A piece of discarded film. It does not matter too much whether it is a colour or black and white film, as it will be necessary to desaturate it anyway. Try to use a piece that does have an image in it or, as in this example, use one which has been underexposed. This makes the task of separating the film rebate from the emulsion much easier.

WITH REBATE FRAME / Adding the frame has highlighted the photographic nature of the image, adding a stylish and contemporary dimension to it.

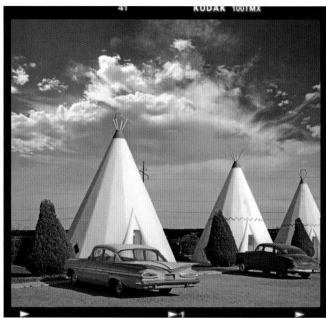

FILM REBATE

A simple yet effective way of achieving this is to add the film rebate to an image. As printers, we were often reluctant to reveal our film stock, but oddly enough including the words Agfa, Ilford or Kodak within the image makes a positive statement about the medium we have chosen to use. To achieve this digitally, find a discarded strip of film and make an accurate scan on a flatbed. You can use 35mm, 6 x 6cm, 5 x 4in, or any piece of film you have to hand. What appears in the film is irrelevant, although in this example I have purposefully used one that was underexposed as it allowed me to clearly distinguish where the image ended and the border began. All scanned objects retain some colour, so it was necessary to desaturate it. I then resized it to match the intended final image. With the shift key held down, I used the Magic Wand tool to select the light emulsion area, so that the entire area selected. Often the selection does not quite extend to the black border, so expand it by 10 pixels (Select > Modify > Expand). This ensures the selection covers the thin grey area between the white and the border.

Call up the image you wish to see inside the frame. Resize it to its intended final dimensions, then Select > All > Edit > Copy. Activate the frame image file and apply Edit > Paste Into. The selected image will appear inside the frame, although it is unlikely that it will prove to be a perfect fit. To overcome this, go to Edit > Transform > Scale. The Transform bounding box will appear, which will allow you to fine tune the selection. Remember, it is the image not the border that is being resized, therefore it is important to try to keep the resizing down to a minimum. You still have two layers at this stage, so further tonal adjustments can be made. Once you are satisfied with the result, flatten the image to reduce the file size.

THE FILED-OUT FRAME

There is a rather interesting darkroom tradition of filing back the negative carrier so that part of the film rebate shows through at the printing stage. As this process is unique to each individual photographer, it can easily be viewed as a distinctive, yet stylish signature. You may well have an example that dates back to your darkroom printing days, or you could persuade a friend who has one of these carriers to allow you to use it. If neither of these are an option, then try creating one for yourself.

Set the Background and Foreground colours to black and white, then open a new file with the dimensions

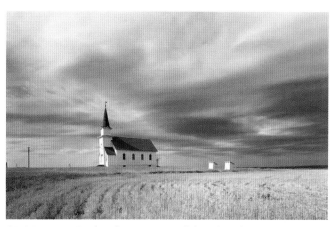

ORIGINAL IMAGE / As the tones around the edge of this image are rather pale, it would clearly benefit from having a dark border.

CONSTRUCTED FRAME / Although this looks like it was produced in the darkroom, it has been constructed digitally using the Rectangular Marquee tool, the Paint Bucket tool and the Airbrush. Once you have made a frame, it can be used again and again.

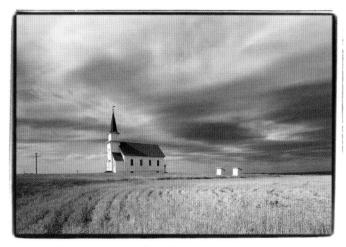

WITH FILED-OUT FRAME / This informal black frame has added weight to an otherwise rather pale image.

slightly larger than the intended size of the border. Select a rectangle using the Rectangular Marquee tool and feather it (try 10 pixels in the first instance). Using the Paint Bucket tool, fill the selection with black. Select the Rectangular Marquee tool once more and make another selection inside the black (don't worry if the selection appears a little uneven). Feather this selection to soften the effect. Using the Paint Bucket tool, select white and do another fill. Using the Airbrush option from the Brush tool, set to a small size, apply white and begin to fringe the edges. The ragged effects on the outside of the frame are created in precisely the same way. This is a time-consuming exercise but once you have perfected a frame you are happy with, it can be used again and again as an individual signature.

The process for adding the image is exactly the same as the film rebate method on the previous page: select the inside of the frame, then activate the image file and Edit > Copy. Make the frame file active and Edit > Paste Into.

BLURRED FRAME

An alternative frame involves creating a black border that appears to bleed into the image. Start with a new file the same size as the intended image. Set the Background colour to black. Using the Rectangular Marquee tool, create another selection inside the black rectangle, feather and then change this to white. This gives you the empty frame.

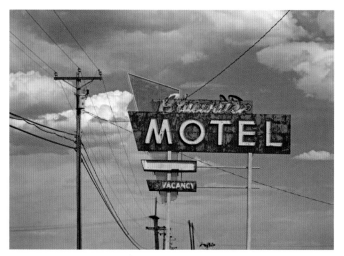

ORIGINAL IMAGE / The image presented without a border.

In order to drop the image into the frame, use the Magic Wand to select the white area inside the frame and expand the selection (Select > Modify > Expand) to ensure that it completely covers the blurred part of the edge as well. Use Edit > Copy, then Edit > Paste Into and the image will appear over the frame, but will not yet be part of it. To overcome this, select Darken from the Blending Mode, which will create a seamless join.

WITH BLURRED FRAME / This informal black border helps to prevent the lighter areas on the edge of this image bleeding out on to the white of the paper.

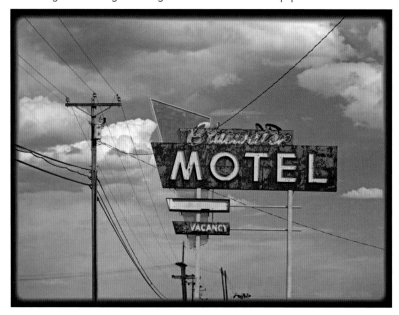

DARKEN / Using Darken as the Blending Mode helps to create a seamless join between the border and the image.

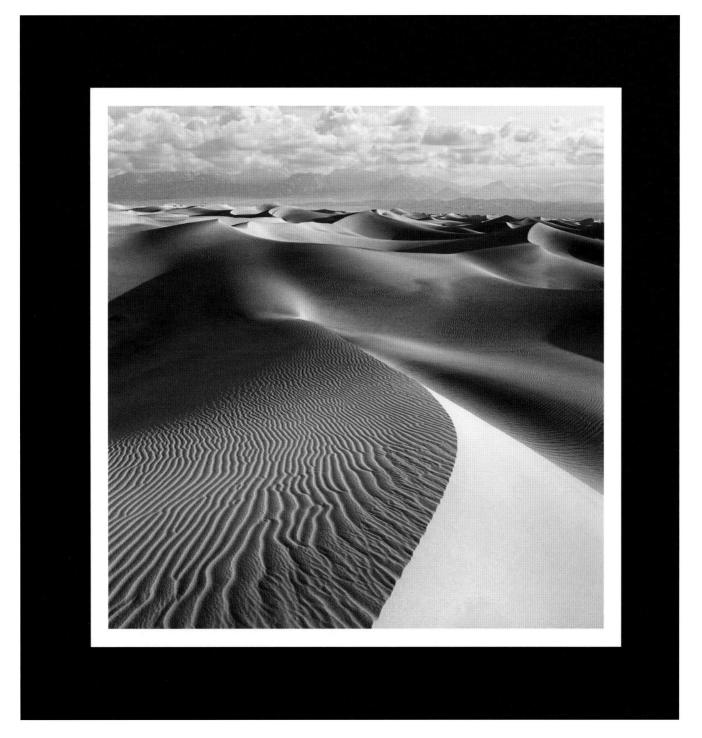

CANVAS SIZE / Sometimes we overlook the obvious. Using Canvas Size (Image > Canvas Size), very dramatic and effective borders can easily be introduced. It is important to select the background colour before using the Canvas Size dialog box. In this example, two borders have been added, firstly a white one and then a black one.

CREATING A POLAROID BORDER

When, in the 1940s, Edwin Land pioneered instant photography with his invention of Polaroid film, it was aimed largely at the amateur market. But its many virtues were recognized by professionals, who quickly appreciated that potentially expensive mistakes could be avoided by using Polaroids as a means of proofing. As a result, the material was manufactured to accommodate both medium- and large-format cameras.

There is also an aesthetic dimension to Polaroid. Exposing the film triggers an immediate chemical reaction. When, after a minute or two, the film is peeled back, traces of the dye often bleed out on to the edges, creating the qualities that are the hallmark of Polaroid. The problem is this is a very expensive material, particularly if you intend making large

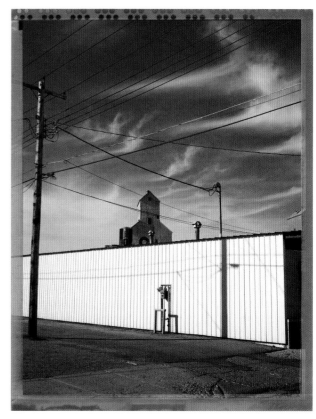

NEGATIVE BORDER / Polaroid negative has a translucent quality, which allows part of the image to show through the border.

ORIGINAL IMAGE / A desaturated image in RGB Mode.

LAYERS / The Polaroid image becomes the Background and the image of the elevator becomes Layer 1. They are merged using Screen from the Blending Mode.

POLAROID SCAN / This was copied using a flatbed scanner, but it could easily have been captured with a macro lens.

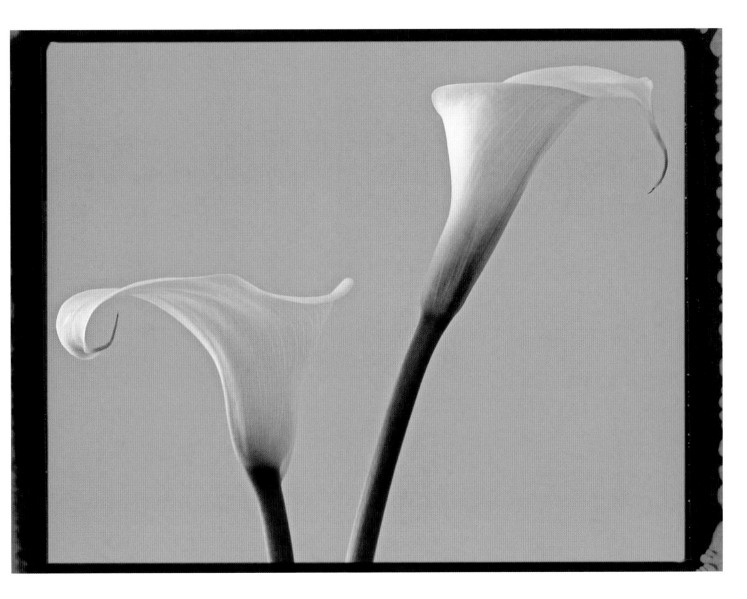

images. However, it is a simple task to mimic these distinctive border effects digitally, using your own images.

DIGITAL PROCESS

Start by scanning a Polaroid on a flatbed scanner. If you do not own a scanner, a copy can just as easily be made using the macro facility on your camera. If the edging appears damaged or frayed, this can easily be remedied by cloning the area using the Patch tool. If some of the parts are too damaged even to use the Patch tool, then cloning might prove to be the best solution. Select an undamaged area using the Rectangular Marquee tool (feathered by 3 pxl) and apply Edit> Copy, Edit>Paste. By using the Move tool, the cloned area can then be carefully manoeuvred into place. For the image of the building and wall, I opted to use a discarded sheet of Polaroid, which had been poorly exposed.

The first task is to remove the image from the Polaroid. Make a selection of the emulsion surface (feathered by 5 pixels) using the Magic Wand tool, then save as an Alpha Channel. Fill the selection with black using the Paint Bucket tool. There are alternatives to this, which we will deal with later. Call up the image you wish to import into the Polaroid frame. Resize both images so that they are

POSITIVE BORDER / Polaroid is made as a negative or positive material, each displaying its own unique characteristic. With the positive film, traces of dye bleed out on to the edge, creating an unusual yet stylish border. This example was achieved by selecting the original emulsion surface of the Polaroid material and then importing the new file using Paste > Into.

compatible, although further smaller adjustments may still be required later on. Using Edit > Copy, then Edit > Paste, make the Polaroid layer the Background layer and the image Layer 1. (Layer 1 will now have disappeared behind the Background layer). Using Screen from the Blending Mode, the image will reappear showing a Polaroid border. If the image layer and the Background layer do not fit, use Scale to make further adjustments. The aim is to achieve a translucent border so that some of the image appears through the Polaroid material.

If you wish to import an image with a lighter background, an alternative is to fill the Polaroid emulsion with white but to blend the two layers using Darken. This ensures that the darker edges of the Polaroid show through. Having previously saved the selection, this is an option that can easily be explored. Once you are satisfied with the result, flatten and save.

CREATING IMAGES WITH
A FLATBED SCANNER

Most people are familiar with using flatbed scanners as a means of copying flat artwork and photographs. We have also discussed how they can be used to scan film negatives. What many people do not realize, however, is that flatbed scanners can be used as very high-quality copy cameras and images can be created without ever using a film or digital camera. Many artists such as Maggie Taylor and Bill Jackson produce remarkable layered images from scanning and combining found objects.

Any flatbed scanner can be used for this type of work, but having a TPU (transparency unit) extends the possibilities. Resolution is not too much of an issue as even the cheapest scanners usually have a minimum of 1,200 dpi, which is perfectly adequate. Obviously, care has to be taken with placing objects on the glass platen of the scanner.

FLOWER SCAN UNIT / Homemade counterbalance unit.

SCANNING BOX / A collection of objects for scanning. Included here is the box that I use to create backgrounds.

FIRST SCAN / A nautilus shell scanned in 8-bit grayscale against a black background at 600 dpi.

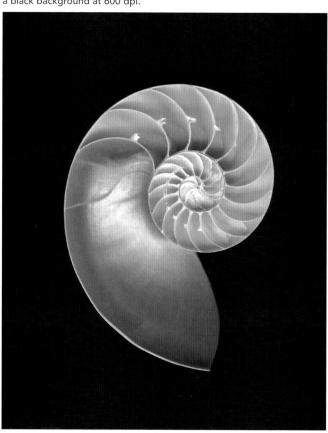

POLAROIDS / I keep discarded Polaroid prints and other film failures purely for scanning and combining with other images.

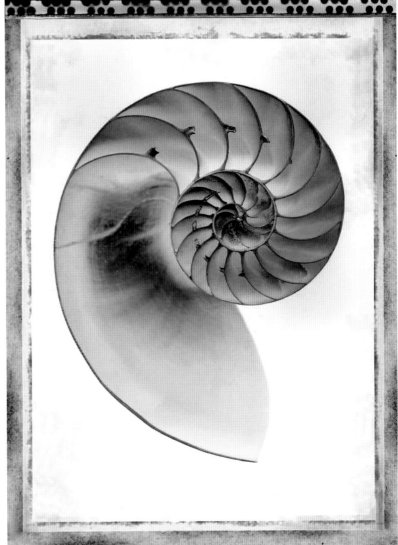

FINAL IMAGE / The completed image combining the nautilus shell with a Polaroid border.

LAYERS / The two scans have been combined in Layers using the Difference Blending Mode. A Color Balance Adjustment layer has then been used to add a blue tone.

PRECAUTIONS

Do not place really heavy objects on the scanner, which are likely to break the glass platen. Some portable scanners are available that can be linked directly to a laptop with no external power source. These can be used at a variety of angles and so, with heavy objects like rocks and so on, the scanner can be placed on the object rather than the other way round. Beware of sharp objects that can scratch the surface of the platen. A clear acetate sheet can be used to protect the surface, but watch for dust. Never place water or liquids directly on the scanner. Liquids can be used in containers or sandwiched between acetates. Make sure there is no chance of leakage, however, as a combination of water and electricity is not a pleasant prospect.

BACKGROUNDS

Using a scanner in Reflective mode, any object can be scanned with the lid up or removed. As the object is scanned, the surrounding area of the platen, the background, is also scanned. How this appears in your final image will depend on many things. Unless there is a bright

CREATING IMAGES WITH A FLATBED SCANNER

NEGATIVE SLEEVE / An old plastic negative sleeve, complete with accumulated dust, was scanned at 1,200 dpi as it is far smaller than the corn on the cob. It was also scanned in RGB for the Blending Mode to be used next.

LAYERS / The two scans were combined in Layers having converted the corn image to RGB. Difference Blending Mode combined the two images and produced a split-toned effect. A Curves Adjustment layer was added for fine tuning of contrast.

light above the scanner, very little light travels back from these background areas, so to all intents and purposes, the background will appear black. To ensure a perfect black background, it is easy to improvise a very versatile background unit. I use an old box file (see Scanning Box, previous page) but any type of box will do. Inside the lid of the box you can tack black paper or, even better, black velvet. Now, when you scan an object, the background is perfectly black. The great thing about this unit is that you can change the black background for any colour you want just by tacking in a new sheet of paper. You can even

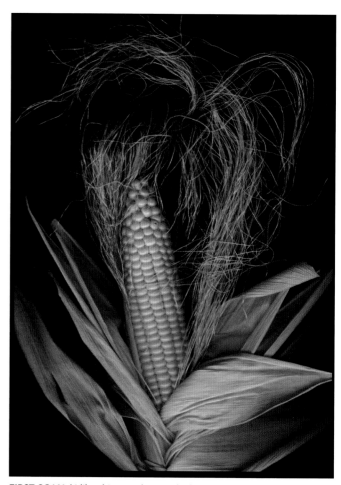

FIRST SCAN / I like things to have a dual purpose. This corn on the cob was scanned at 300 dpi grayscale and then eaten!

FINAL IMAGE / OPPOSITE / The finished split-toned image of corn on the cob has an antique quality to it.

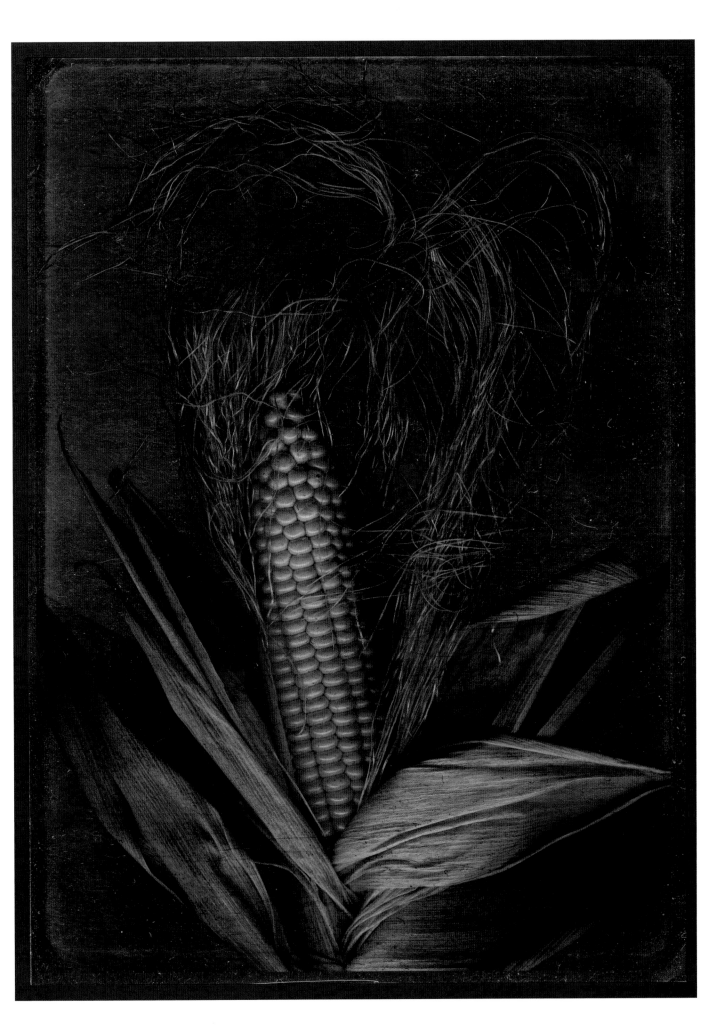

CREATING IMAGES WITH
A FLATBED SCANNER

use textured cloths, leaves or feathers to create individual backgrounds, the possibilities are endless. One word of caution: if the background is too far away from the subject, it will be very dark, so it is best to create a box that is only slightly deeper than the object to be scanned. Choosing the right colour background at the scanning stage can save a great deal of time and effort later, especially if you are combining images using Layers and Blending Modes.

DEPTH OF FIELD
Unfortunately it is not possible to adjust the depth of field with a scanner. Anyone who has attempted close-up work knows that depth of field can be severely limited even when using a camera. However, it is remarkable how much will be in focus and the acceptable level of sharpness can extend to several centimetres. This is not usually too much of a problem if the right subject matter is chosen.

MOVEMENT
The scanner records the object in stages as it works from top to bottom. If the object moves it will become distorted. Again this is not a problem with most things that are going to be scanned and, on the positive side, this can lead to some very weird and creative effects; just try scanning your hand and moving it during the scan to see what I mean.

DELICATE OBJECTS
Under this category I would include flowers. They make great subjects for scanning, but often distort and squash under their own weight when placed on the scanner. To prevent this I devised a very simple system (see Flower Scan Unit, page 120). A heavy weight is placed to the side of the scanner and a wooden skewer is attached to it with sticky tack. The flower is then attached to the end of the skewer and a blob of sticky tack used as a counterweight at the other end. Using this homemade contraption I can balance the flower just above the platen and prevent any delicate petals being squashed. If the skewer appears in the scan, it can easily be cloned out at a later stage.

SCANNER SETTINGS
Normally the scanner will be accessed through Photoshop via File > Import. This will reveal any scanners installed. Selecting the scanner will then open a dialog box, which will obviously vary depending upon the scanner. If there is an alternative between auto scanning and manual (sometimes

called 'professional') scanning, always select the manual setting. Before you set anything, do a Prescan and view the thumbnail that appears. Remember that the scanner will scan the whole of the platen to produce a large file. Always select the scanned object by clicking and dragging before committing to the real scan. I've had students forgetting to do this and the computer crashes trying to produce a 100GB file!

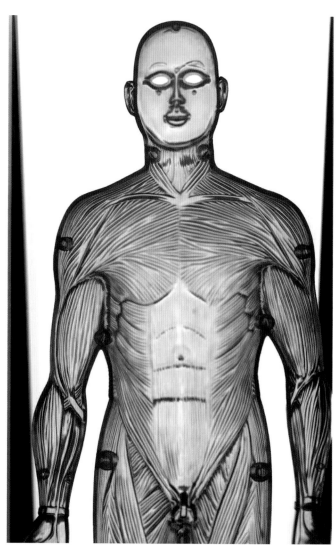

FIRST SCAN / A transparent plastic figure was scanned in 8-bit grayscale using transmitted light from the TPU.

LAYERS / The scanned figure was selected, distorted and layered with a plastic negative sleeve background using Soft Light Blending Mode.

TONE / The flattened image was then toned using the Duotone facility (see pages 64–65).

BIT DEPTH AND RESOLUTION

This has been discussed in more depth earlier (see pages 10–12) and is particularly important when scanning film. For highest quality select 16-bit and RGB. However, this will produce very large files and in most cases 8-bit will suffice when scanning objects (see the plastic figure scan). Scanning resolution will depend on the size you wish to print your final image. If it will appear the same size as the original object, then 300 dpi is sufficient. If it is to be enlarged, then a higher resolution is necessary. I usually look at the file size that is being created. To print a scanned object at A4 (29.7 x 21cm/11½ x 8¼in) I need an 8-bit RGB file of about 25MB and for A3 (42 x 29.7cm/16½ x 11½in), 50MB.

ADJUSTMENTS

All scanning software contains a basic means of manipulating colour, contrast, sharpness and so on. These features can be useful, but in most cases Photoshop can do a better job and therefore it is recommended that these adjustments are left until later. However, I do regularly use the histogram at the scanning stage to ensure that both highlight and shadow detail are recorded without any clipping. Use the black and white sliders to ensure an even spread of tones.

FINAL IMAGE / Finished image of the plastic figure.

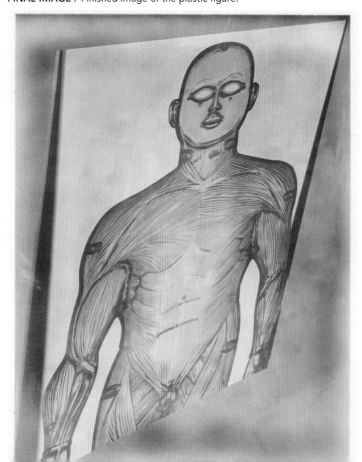

PRODUCING DIGITAL NEGATIVES

Having worked in the darkroom for over 25 years, I must confess I found it quite a wrench abandoning the skills I had acquired in order to 'go digital'. While I welcome its sheer flexibility, and enjoy the opportunity to produce fabulous composites using Photoshop, I do occasionally miss printing traditionally on high-quality darkroom paper. But as that fine old saying goes, 'you can't have your penny and your bun.' Well actually you can. It is possible to produce a copy negative digitally, print this on to OHP Transfer Film, which is then contact printed in the darkroom. This way you are then able to enjoy all the advantages of Photoshop, but still produce your final image in the darkroom.

There is a point to doing this as well as satisfying a darkroom urge and that is as a means of producing negatives large enough for alternative processes. Often photographers are put off exploring wonderful old processes such as cyanotypes, gum bichromates and salt printing because they do not have access to a large-format camera. By making a copy negative, they can produce images up to A3 (42 x 29.7cm/16½ x 11½in) or even larger. Also, lith printing in the darkroom can be such a hit-and-miss process that few printers are prepared to risk producing a complex, multiple-imaged lith print, only to see it ruined at the printing stage. Using a digital negative simplifies the task.

STAGE 1: IN THE LIGHTROOM

The primary task is to produce the image on screen. In the first instance it is important to get the image just as you would wish it to appear in the final print, although be prepared to make changes. This, of course, is the real joy of working digitally: as you can see the image on screen, it is possible to apply sophisticated controls to ensure that the final image appears as you want it to be. Working from a RAW image or a negative, it is important to desaturate early in the process so that you have a good appreciation of the tonal values. What works well in colour does not always translate well into monochrome. Use Levels or Curves to produce a tonally perfect image that will then form the basis for the copy negative.

Unfortunately the image on screen does not always translate well on to the transfer film and further adjustments still need to be made. When printed, the image often appears too thin and contrasty. Do not be tempted to use the Brightness/Contrast command as you risk losing

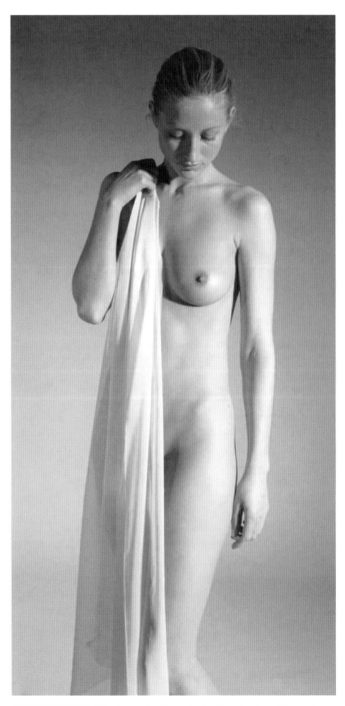

ORIGINAL SCAN / Photographed in a studio, the simple outlines of the figure make this a particularly easy subject to select and drag.

BACKGROUND SHOTS / Both these shots were taken in London's Canary Wharf. After completing an Edit > Copy, Edit > Paste, the two images were then superimposed using Opacity.

of view certainly does not bring clarity to this issue, and clearly the process you wish to use the digital negatives for will have a bearing. Having used the PermaJet OHP Transfer Film (www.permajet.com), I am confident that most readers will achieve a usable negative for producing silver images by printing the negative in black and white, but this will require using contrast filters at the printing stage. If, however, you wish to produce negatives for one of the alternative processes (where you have less flexibility when printing), you would do well to consult Dan Burkholder's book, *Making Digital Negatives for Contact Printing* (which comes with a useful CD), or alternatively visit The PDN system website at www.precisiondigitalnegatives.com.

Whether your intention is to make a silver print, or a copy negative, you will need to invert the image (Image > Adjustments > Invert). As the image will then need to be contact printed, it is important that it is flipped horizontally (Image > Adjustments > Flip Canvas Horizontal). Resize as normal, A4 if you want a 10 x 8in print or A3 if you want your final image to fit on to a 12 x 16in sheet of printing paper.

important highlight detail; far better to use Curves and peg the lightest quarter.

It should be noted that digital negatives can be made not only for producing silver prints but also as a way of producing larger negatives for the various alternative processes. Each process requires a different approach. The main problem is getting a perfect white. The most popular method for overcoming this has been pioneered by Dan Burkholder who suggests converting the digital negative to red as a means of increasing the whites in the final image. The PDN system proposed by Mark Nelson argues that for any single process, one establishes a standard time with a step wedge that gives a maximum black. Using that time, a colour mix is created that just gives paper white. This then allows you to produce a 100-tone scale, which can be plotted to make a Process Adjustment Curve.

The best UV blocking colour varies with each process, although Nelson suggests this is usually in the green spectrum. The precise hue is also determined by whether dye or pigment inks are used. Having two conflicting points

COMPOSITE / The combined image is Inverted and Flip Canvas Horizontal applied. Various tonal changes were made to reduce contrast.

PRODUCING DIGITAL NEGATIVES

STAGE 2: PRINTING ON TO THE TRANSFER FILM

The PermaJet OHP Transfer Film is coated with a transparent layer of ultra-fine ceramic particles that form a number of regular-shaped pores enabling the ink to be absorbed more evenly, thus giving an even density and a good tonal range. Each box of film contains 10 sheets, but there are no interleaving sheets of paper between each sheet, which makes handling a little difficult. Alternatives to PermaJet include Kentmere Translucent 11, which is marketed in both A4 (29.7 x 21cm/11½ x 8¼in) and A3 (42 x 29.7cm/16½ x 11½in), and Pictorico OHP Transparency Film (www.pictorico.com), which offers a choice of sizes ranging from 8½ x 11in to 24 x 66in.

As with most printing materials, the printing side faces you in the box. If you get confused, when you hold up the film, the cut corner should appear in the top right. It is important to handle this material with care to avoid leaving finger marks, so hold it by the edges. It is very easy for two sheets to stick together. The best way to avoid this is to hold the sheet to the light and, if there is an appearance of Newton rings, then it is likely two are stuck together. Finally, while the material is quick drying, if you intend producing numerous copy negatives in one session and need to stack them, allow three hours to dry completely.

PRINTED NEGATIVE / Once printed, the digital negative can look worryingly thin, but if you lay it over a sheet of white card you should be able to see discernible detail in both the shadows and the highlights.

It is difficult to be specific about which dpi to use with individual printers as these are being constantly updated. My advice is to follow the film manufacturers' instructions and not to be tempted to lay on more ink than the material can cope with. Perfectly adequate negatives can be achieved with a dpi as low as 1,440.

You may still be alarmed when you see your printed copy negative because, when it is held up to the light, it will appear remarkably thin. You will get a much better appreciation of its tonal range if you place it on a sheet of white paper. If all the shadow and highlight detail is visible, then you should be able to take it into the darkroom with confidence.

STAGE 3: IN THE DARKROOM

The process is straightforward in that the copy negative is placed in direct contact with the printing paper, held in place with a sheet of glass. But there are still one or two pitfalls to avoid. The most obvious danger is getting finger marks on either the copy negative or the glass. To avoid this, wear latex gloves for all the darkroom work.

Place the paper on the printing easel, then carefully place the copy negative directly over it so that emulsion side faces emulsion side. Place the glass over the negative and paper to ensure that the surface is as flat as possible. It is worth having a sheet of glass cut specifically for the purpose; make sure that the edges have been polished to ensure that there is no accidental damage. The glass needs to be sufficiently heavy so that the paper and negative lie flat, but not so thick that it creates a distortion. Dust will pose a problem but, as there is no enlargement involved, this need not become a big issue.

Set the lamphouse on the enlarger as high up the column as possible to ensure an even distribution of light. The copy negative is much thinner than conventional film and, while the light might appear quite weak, you should opt initially for a small aperture. Produce a test strip as if you were printing from a conventional negative. This will enable you to make an informed judgment concerning the length of exposure and grade filtration. When that is established, start producing prints.

THE QUALITY OF THE RESULTS

Purely as a matter of interest, I tried producing the same images on an Epson printer and tried to identify any differences between the prints. If I am absolutely critical, the prints produced digitally do appear fractionally sharper

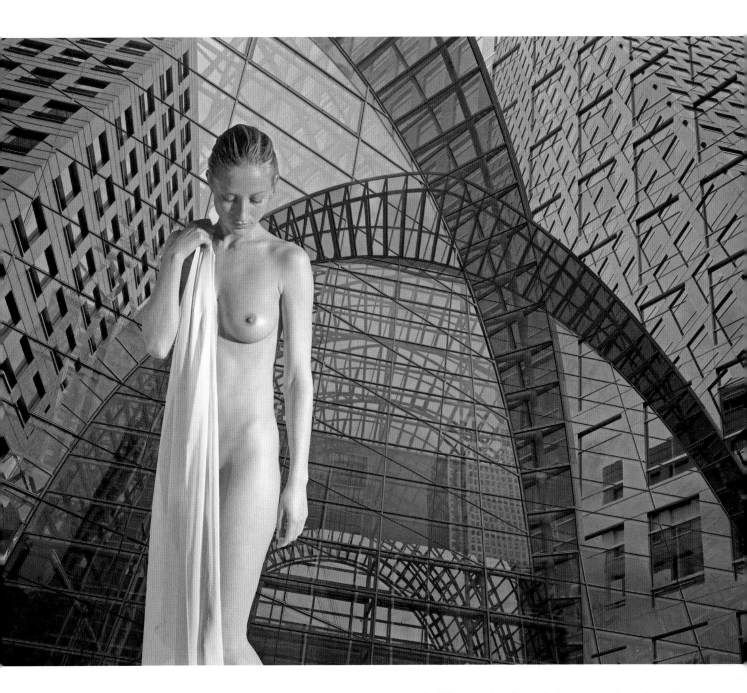

(although we have to remember that Unsharp Mask had been applied in Photoshop) than those produced using the copy negative, but the difference is so negligible that it is barely worth mentioning. On the plus side, it allowed me to produce a complex image that I could never have achieved in the darkroom, which was then printed on to a high-quality, silver-rich paper.

FINAL IMAGE / The procedure for producing a composite such as this is explained on pages 80–81. The huge advantage of using Photoshop is that it allows the user to create montages that were simply impossible to produce in the darkroom. But by producing a digital negative, you are then able to print the final image in the darkroom.

CHAPTER 8: PRINTING AND PRESENTATION
MAKING TEST PRINTS

One of the most common problems people encounter is that the image they see on their computer screens is different in colour and tonality to the one they print out. To understand the problems and therefore produce a solution requires a thorough knowledge of colour management systems. However, some simple common sense should enable anyone to produce satisfactory results. The colour and tonality of an image, even in monochrome, depends upon a number of factors.

COLOR SPACE: Most digital cameras work either in sRGB or Adobe RGB (1998). If there is a choice it is probably best to work in Adobe RGB (1998) as this records a wider spectrum of colour.

MONITOR: This can be adjusted for colour, brightness and contrast. The monitor settings and, to some extent, its age and the lighting conditions in the room will affect the way an image appears on screen. It is best to work under constant lighting conditions with neutral coloured surroundings. Work through Adobe Gamma using the wizard to set your monitor at regular intervals.

PRINTER: Each printer varies slightly and the best results will only be produced if the correct procedures are followed within the print dialog box. Pay particular attention to setting the correct media type for the paper being used.

INKS: Using the printer manufacturer's recommended inks is the safest way to achieve colour consistency. For third party inks, it may be necessary to use special profiles.

PAPER: Again, using the printer manufacturer's recommended papers is the easiest route to achieving consistent colour, but the range of papers by a variety of manufacturers is too tempting to ignore. Using these will inevitably lead to some changes in colour, though.

VIEWING CONDITIONS: The colour of light reflected from a print will depend upon the ambient light: daylight, tungsten or fluorescent. This will be evident even in monochrome prints, especially those printed with dye-based inks.

The best way around these problems is to establish a consistent workflow and have each stage professionally profiled. This means using colorimetric methods to establish profiles for your camera, scanner, monitor,

PRINT OPTIONS / Epson Stylus Photo dialog box.

ADVANCED MENU / Print with Preview dialog box showing Color Control sliders.

printer, paper and inks. This can be costly, especially if a large variety of media are being used. Many independent manufacturers produce generic profiles for their products, but some tweaking may be necessary. Having said all this, a simple way to produce a satisfactory result is to produce test prints before finally committing to a finished print. This is a familiar route to most darkroom workers and the basics can be transferred to the digital workflow.

PRODUCING TEST PRINTS

This applies specifically to Epson printers, which I use, working with Windows, but other printers will have similar functions. Working in Photoshop and having completed an image on screen:

Step 1. From the menu select File > Print with Preview. Select More Options then Color Management. In Options select Color Handling Let Printer Determine Colors or No Color Management, and, by Rendering Intent, select Relative Colorimetric. In the preview, deselect Center image and scale print size to about 20%. Now drag the image in the preview to the top left corner or use the position controls to place the image.

Step 2. Click on Print, select Properties and check the Advanced button.

Step 3. Print on to the test sheet, selecting the correct media setting and Best Photo (see Advanced Menu, left). Ensure that your test sheet is the same media as your final print and make a record on the sheet for future reference.

Step 4. Preferably allow the print to dry. Compare the print with the screen image. If changes to colour or brightness are necessary, open Print with Preview again.

Step 5. Use the cursor to move the thumbnail image across the preview page (see Test Print 2, right).

Step 6. Load the same piece of test paper and select Print.

Step 7. In the Advanced menu there is now an opportunity to adjust Brightness, Contrast, Saturation and Color using the sliders under Color Controls (see Advanced Menu, left). Don't make too many changes in one go. It is best to change one thing at a time. Now print out the second test image and write the new settings underneath it.

Step 8. If further changes are needed repeat steps 5–7.

Step 9. When you are satisfied with the output, the settings can be saved by using the Save Setting feature in the Print dialog box. Enter the name of the paper and this can then be recalled at any time from the Custom Settings box.

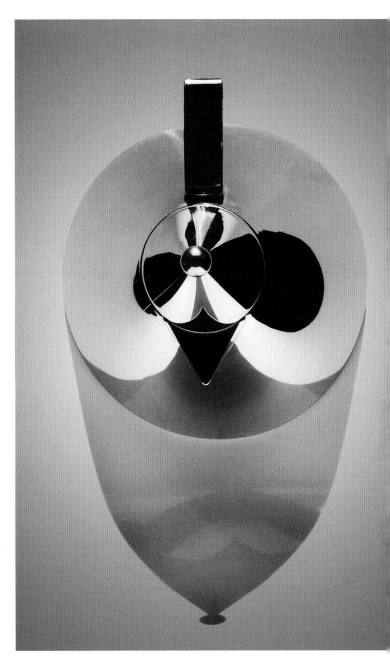

FINAL PRINT / Alessi Kettle. The final toned image has been printed on PermaJet Gloss paper to give a high-tech feel.

TEST PRINT 2 / The thumbnail has been moved to its new position for printing.

PRODUCING A CONTACT SHEET

Working digitally has a lot to offer, but there are still many darkroom traditions we would do well to observe. One of these is to produce a contact sheet. This is a practice that offers two advantages; firstly, when photographing images, we are inclined to take several shots in order to take into account the unpredictable movement of the subject or changing light. Photojournalists or sports photographers frequently fire off numerous shots per second, in the expectation that they will reveal the one critical image they are after. Making a contact sheet allows that important choice to be made. Secondly, it helps to organize files and group together related images to use for a personal project, exhibition or publication. Either way, producing contact sheets is a useful exercise.

THE DIGITAL PROCESS
To achieve this in Photoshop, it is important that all the relevant files are grouped together into a single folder. Then go to File > Automate > Contact Sheet II. The Contact Sheet dialog box will appear. Click Browse to specify the folder you wish to use.

In the Document area, specify the dimensions, resolution and colour mode you require. If, for example you wish to create an A4 hard copy, then make the dimensions 21 x 29.5cm at 300 pixels/in. If you anticipate making adjustments to the contact sheet then deselect Flatten All Layers. This allows you to create a contact sheet in which each of the images and captions will be presented on a separate layer. For a CD/DVD jewel case, use 12 x 12cm.

The Thumbnails box allows you to determine the required rows and columns; by selecting 'across first', the images will be presented from left to right then top to bottom. If you select 'down first', the images will be presented from top to bottom then left to right. By choosing Auto Spacing, Photoshop will automatically space the thumbnails for you. Alternatively, you can deselect this facility and specify the vertical and horizontal space you require around each of the thumbnails. The contact sheet preview will automatically be updated if you use this option.

If you select Rotate for Best Fit, Photoshop will organize the thumbnails so that best use is made of the space available, regardless of their orientation, meaning portrait-format images may be rotated to appear landscape-format and vice versa. If you require that all the thumbnails appear in their correct orientation, deselect this option.

Finally, you can decide whether you require captions with the thumbnails or not by selecting Use Filename As Caption. If you do choose to use this option, then you can also select (albeit from a very limited range) the font style and size. Once you are satisfied with the layout, hit OK.

While the conventional purpose of contact sheets is to provide you with a source of reference, they can also be used for other purposes. For example, you might wish to construct purpose–made covers for CD or DVD cases, allowing you to see at a glance which images are saved on any specific disc.

CONTACT SHEET / OPPOSITE / It often helps to have a hard copy of images you have saved in a folder, if only for quick reference. In this example, I have opted to use Auto Spacing; if a more uniform spacing is required, deselect Auto Spacing then the horizontal and vertical spacing can be specified.

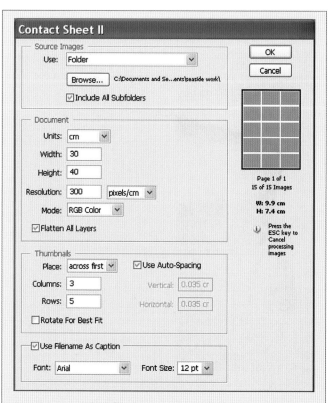

DIALOG BOX / This offers quite a degree of flexibility in the way the images are arranged.

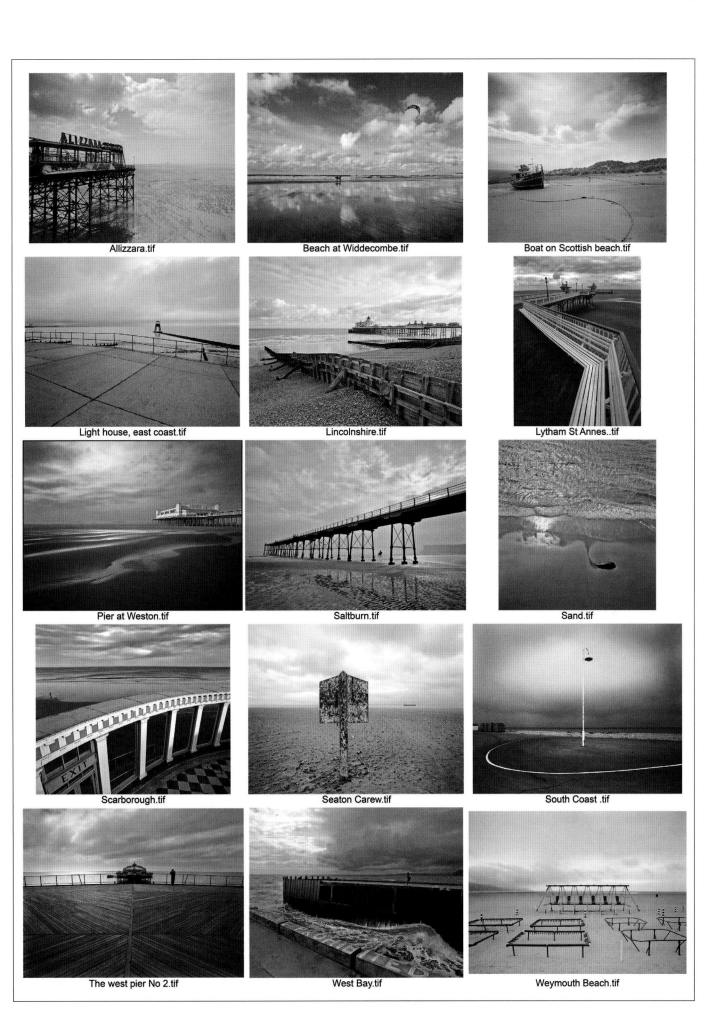

Allizzara.tif

Beach at Widdecombe.tif

Boat on Scottish beach.tif

Light house, east coast.tif

Lincolnshire.tif

Lytham St Annes..tif

Pier at Weston.tif

Saltburn.tif

Sand.tif

Scarborough.tif

Seaton Carew.tif

South Coast .tif

The west pier No 2.tif

West Bay.tif

Weymouth Beach.tif

INK-JET PAPERS FOR THE MONOCHROME WORKER

In terms of variety of papers, the digital worker is undeniably spoilt for choice. In addition to Kodak and Ilford (the main suppliers of traditional darkroom papers) new manufacturers have sprung up, all offering a fabulous range of surfaces. Theoretically, all papers are designed to accommodate both colour and mono, but in reality that is not the case. Most ink-jet papers look and feel like traditional colour papers.

The early problems experienced by monochrome workers are well known; if they tried printing black and white using full colour then they were likely to encounter colour cast, banding in the shadows and obvious metamerism. This was largely due to the inks, but printing on such insipid papers did not inspire confidence. Printing black only was never a viable option unless you were prepared to accept unsightly grain in the highlights. But with the development of a new breed of dedicated printers and pigmented inks, as well as a genuine recognition that committed monochrome workers require something different, various paper manufacturers have sought to produce a new generation of papers that, in terms of quality, vie with traditional bromide papers. Three that spring to mind are Chaudigital (www.chaudigital. com), PermaJet (www.permajet.com) and Fotospeed (www. fotospeed.com).

CHAUDIGITAL DA VINCI FIBRE GLOSS PAPER
After searching for many years for a paper that matched the quality, look and feel of traditional bromide paper, the Da Vinci Fibre Gloss was co-developed by Danny Chau and represents a new direction in the development of ink-jet papers. He had been a highly regarded exhibition darkroom printer but, in 1998, decided to transfer his business to a completely digital workflow. Dissatisfied with the inferior quality of ink-jet papers, he approached various manufacturers and, after two years of development, this new paper emerged. The Fibre Gloss paper retains all the wonderful qualities of a traditional bromide paper. It not only looks and feels like real fibre base darkroom paper but, more importantly, it rivals it in terms of quality and technical specification. It is acid-free and has a weight of 300gsm.

PERMAJET FIBRE BASE GLOSS
This is a microporous, acid-free, fibre base paper. One senses this paper has been designed specifically to lure the die-hard traditional monochrome worker away from the darkroom. It has the feel and weight of a traditional fibre base darkroom paper and boasts a D-Max that is virtually identical to the much loved Agfa Record Rapid. It copes well with contrast and delivers a smooth tonal range. Coupled with its slightly undulating gloss surface and a weight of 295gsm, it undoubtedly looks and feels like a traditional darkroom paper. Tests carried out suggest that the D-Max and base white of Fibre Base Gloss compare well with both Agfa Record Rapid and Ilford Multi Grade FB. As you might expect, metamerism is slightly higher than with the traditional papers, but it has been so well controlled that it is hardly noticeable.

Rather interestingly, and perhaps a measure of how seriously the needs of monochrome workers is now being considered, PermaJet now also produces a Fibre Base Gloss Warmtone, which aims to rival Ilford FB Warmtone papers. It is about 10 RGB points warmer than the standard Fibre Base Gloss, producing slightly creamy highlights as no optical brighteners have been added. This paper works particularly well with most portraits.

FOTOSPEED PLATINUM GLOSS
Very similar to Fibre Base Gloss, this is another paper to die for. Boasting a very high D-Max and a nanoporous layer, it delivers extremely fine detail and, if printed using K3 inks, it is virtually impossible to distinguish this from a high-quality fibre base image produced in the darkroom.

RESIN-COATED PAPERS
While this new generation of fibre base papers will satisfy the monochrome purist, it is also worth noting that many of the other papers can also be used very effectively. If printed using K3 inks, PermaJet Instant Dry Oyster paper looks and behaves remarkably like a traditional, resin-coated, semi-gloss darkroom paper. Weighing slightly less than the Fibre Base Gloss (271 gsm), the printed image still has the feel of a traditional print. The tones are wonderfully neutral. Another excellent alternative is Fotospeed's Pigment Friendly Gloss (or Lustre). At 270 gsm, it feels very similar to Instant Dry Oyster.

MATT PAPERS
The tradition for printing on matt papers has been well established and this is an area where digital monochrome

PAPER CHOICES / The needs of the committed monochrome worker have finally been served with the introduction of these three excellent papers which in terms of feel, weight and quality vie with the best traditional bromide papers.

printers have been well served for a number of years. Papers that work well include PermaJet Matt Plus. This delivers a very clean white and has the feel and weight of a traditional darkroom paper. Obviously the D-Max will not be as good as the fibre base glossy papers, but that is not always required. Fotospeed's DWFB Matt uses the same base as its Platinum Gloss and consequently possesses the same wonderful characteristics. If you are printing using an Epson 2400, you will need to change to the Matte Black cartridge.

ART PAPERS

This is an area where some manufacturers excel. Many of the historic alternative processes require coating high-quality watercolour papers with an emulsion that is then exposed to UV light. Having created similar effects digitally, printing the results on to a quality art paper does seem the appropriate route. Here you are spoilt for choice but one that stands out is Somerset Enhanced. This is a company that has specialized in manufacturing archival watercolour papers, consequently the feel and appearance

of this paper truly rivals authentic watercolour paper. It really is a natural choice for digital alternative processes.

Fotospeed produces Natural Soft Texture, which closely resembles watercolour paper. If you require a slightly whiter base, try its High White Smooth, which is 100 per cent cotton. Although on close inspection this does not reveal the textures that characterize some watercolour papers, it is made of 100 per cent cotton rag and is truly archival. Alternatively, in the excellent PermaJet Classic Fine Art series, try Textured Art Silk; if you require a slightly heavier paper, consider Museum, which weighs in at 310gsm, or Papyrus (300gsm). Do also remember, many of these art papers work particularly well with images that have been hand-tinted digitally.

Manufacturers are constantly updating their papers. Most produce sample packs that encourage you to experiment and find out which ones best suit your images. Compared to the range of papers available to traditional darkroom printers, this must be seen as a great step forward and is yet another reason for embracing the digital revolution.

INKS

There are many ways of outputting digital files to print and, for most photographers, this is a critical step in the whole process, especially if the prints are to be exhibited or sold. Traditional black and white images on resin-coated or fibre base papers can still be produced from digital files. Digital enlargers produced by Durst such as the DeVere 504 DS, or commercial Durst Lambda printers will convert the digital

file to light, enabling traditional photographic materials to be used. The use of a digital negative for contact printing in the darkroom has been described (see pages 126–129). Most photographers, however, are making use of the ubiquitous ink-jet printer. The research and development that has gone into these printers and the associated inks is phenomenal. Even so, the ability to produce good black and white prints using these inks has been a bit of an uphill struggle. Recent developments have, I think, solved many of the problems and now it is quite possible for high-quality black and white images to be produced at home with a desktop ink-jet printer.

DYE INKS

Most manufacturers have produced sets of inks that are dye-based. Usually, for a full-tone colour image, there are at least six inks: cyan, magenta, yellow, light magenta, light cyan and black. It is theoretically possible to print a black and white image using a combination of these colours. However, in many cases a true black is difficult to achieve and prints often have a slight cast, usually magenta or

EPSON INKS / Epson Photo R2400 A3+ printer uses three black inks, which makes it ideal for high-quality black and white printing.

PIGMENT INKS / PermaJet MonoChrome Pro inks come in cartridge form for a range of printers and are particularly suitable for printing on fine art papers.

green. This is exacerbated by the type of viewing light. A phenomenon known as metamerism occurs, which basically means that the colour of the prints changes with the type of ambient light. It is possible to print with just the black ink, but the tonal gradation will be severely limited. Dyes are also more likely to fade with time.

PIGMENT-BASED INKS

Naturally occurring pigments are far more stable and tend not to exhibit such a high degree of metamerism. For archival quality they are to be recommended. However, this usually means using third-party inks, which then negates the printer manufacturer's warranty. The other advantage of using pigments is that suppliers such as PermaJet and Lyson produce sets of monochrome pigments. This means that for a six-colour printer, six black inks of varying consistency can be used. This vastly increases the tonal range that can be achieved. If you do try these inks in a printer that has been used with dye-based inks, it is essential to flush out the old inks first using a cleaning cartridge.

Manufacturers are now producing hybrid inks such as Ultrachrome inks, which are a mixture of dye and pigment. They are said to have a high degree of stability, 40 to 80 years in most cases. With the new breed of printers, an increasing number of black inks are being used. For example, the Epson Stylus Photo R2400 has three black ink cartridges, which produce excellent full-tone black and white prints. As these are produced by the printer manufacturer, they are completely compatible and the warranty is assured.

Pigment-based inks contain carbon, which is pretty stable, and are usually mixed with small amounts of colour to vary the tone. By using them in combination, warm sepia, neutral black or cool blacks can all be produced. The method varies with the inkset, but with the Epson Ultrachrome system, the Print driver has an Advanced mode whereby presets can be selected and a Color Control mode where discrete colour changes can be made. By adjusting the sliders in the Color Control Mode, fine tuning in terms of toning and shadow and highlight density can be achieved. Once you are satisfied with the output, all of the settings can be named, saved and called back at a later date. I have found that using the Epson 2400 and Permajet Fibre Based Gloss paper I can produce monochrome images of the standard I would have expected from traditional fibre based darkroom prints.

ADVANCED MODE / The Advanced Black and White setting of the Epson R2400 printer allows Neutral, Cool, Warm or Sepia prints to be produced.

COLOR CONTROL MODE / Toning monochrome images with the Epson Photo R2400 can be further refined using the Color Management system.

ARCHIVAL STORAGE AND PRINT PRESENTATION

STORAGE / Secol CD/DVD storage system. Each box is made of acid-free archival materials and can hold 50 CDs in a very small space.

EXTERNAL HARD DISC / These are high capacity and can be transferred to use with any computer.

Digital imaging has once again thrown up the old chestnut of the longevity of the files and images produced. In contrast to most art forms, the question uppermost in most people's minds is 'how long is it going to last?' In the early days of digital photography this was valid as the dyes and papers available were rather unstable and prints could be seen to be fading within weeks in some cases. New technology is by definition an unknown quantity and, as we can't see into the future, predictions of the archival nature of products has to be taken on trust. It is inevitable that technology will change, as will the methods we use to store, or even print, our images. Fortunately, with digital information, it should be possible to transfer to the new technologies relatively easily.

EXTERNAL HARD DRIVES

A camera's memory card and the hard drive on your computer should really be seen as temporary storage. Both can be damaged and important information lost. I favour a two-tier system of saving files and try to get into a regular habit of saving images before any manipulation is attempted.

My first step is to transfer files from my memory card to an external hard drive – I have a series of three that can be stacked. The files can then be easily accessed by any of my computers and, if I upgrade the hard drive, could still be used. The cost of these drives falls daily, while the capacity seems to increase at a similar rate. All my day-to-day work is then carried out with the images stored on the hard drive. By incorporating metadata and keywords in Adobe Bridge, I can quickly access any image I want.

CDS AND DVDS

My next stage is to transfer each photographic session from the hard drive to a CD or DVD. These copies are then stored away from my external hard drives so that if a catastrophe befalls one then, hopefully, I have the back up of the other. The problem with CDs, however, is they can take up a lot of space, especially if kept in jewel cases. I favour a system of storage boxes produced by the UK company, Secol. Each box stores up to 50 CDs and takes up a space of only 135mm x 95mm x 180mm. This saves about 80 per cent of shelf space. The CDs are held in polyester clear pockets, complete with their own index pocket for catalogue data, which makes searching very easy.

PAPER SELECTION / This swatch shows a taste of the great variety of papers now available to the digital worker. Many of these are acid-free, archival art papers.

STORING AND PRESENTING PRINTS

I treat my digital prints in exactly the same way I do my traditional fibre base prints. I only print using acid-free papers and either pure pigment or Ultrachrome inks. It is important to allow any image to dry (I recommend at least 24 hours air drying) before storing. Acid-free boxes are then used to store the prints, either in polyester sleeves (see Storage, above left) or separated by acid-free tissue paper.

MOUNTING / T hinges made of paper tape are the recognized way of attaching a print to a backing board. They will not damage the print and can be removed easily with a damp cloth for remounting in the future if it becomes necessary.

It is not a good idea to use the paper manufacturers' boxes as they may contain glues and acid materials that can affect the prints over time. Also, the surface of prints, particularly those on art papers, may be damaged if they are not separated from each other.

To mount work for sale or exhibition, I use normal museum techniques. A simple matte is cut and hinged on to a backing board. Both are made from acid-free board and usually I prefer white, though that is a matter of taste. The print is then attached to the backing board using T hinges of paper tape (see Mounting, below left). This allows the print to expand or contract under the matte with changes in the atmospheric conditions and it can also be remounted easily in the future if necessary.

MATTE / Prints are usually mounted on to a backing board and overlaid with a bevelled matte, which is hinged to it. The print is then protected using an archival polyester sleeve.

CHAPTER 8: PRINTING AND PRESENTATION
SELF-PUBLISHING

For most serious photographers, seeing their work on the printed page is surely the ultimate goal. A book devoted to your images is not just a celebration of your endeavours, but it is a legacy that you can pass to your family and friends.

There are two ways of getting your work into print; the first is to approach a publisher. This has the advantage that the cost of publication and distribution is borne by somebody else. However, it needs to be appreciated that, if you embark on this route, you may well be required to make compromises. Book publication is a commercial enterprise and the bottom line is 'will it sell?' Publishers often make demands that some might find untenable. A second option is to self-publish. A growing number of photographers are producing limited-edition fine art books, which feature the photographs they most value. This is a great way of showing your work, allowing you to retain control of the final outcome. Self-publishing can be achieved in two ways.

VANITY PUBLISHING
Firstly, you can approach a specialist printer and negotiate a price for a limited print run. It should be noted that whether you opt for 500 or 1000 copies, the main costs are setting up the run. Doing your own design and presenting your work as printer-ready files can defer part of those costs. With the software currently available, much of this is achievable. It is important not to enter into this task too lightly, however, as book design requires some expertise. Critically examine your favourite photography books and establish why, in

BINDING EXAMPLES / Self-publishing is a great way of showing your work while retaining control over the final outcome.

your opinion, they are successful. Look carefully at the size of the image relative to the page and how the text is used. A common mistake is to present all the images the same uniform size. While this works well in an exhibition, it looks less impressive in a publication.

APPROACHING DESIGN
Adding the text might prove the most challenging part of the exercise, but this should not discourage you. Photoshop has a limited capacity for introducing text, but it may well prove sufficient for your needs. Apart from captions, you may wish to print all the text on independent pages, in which case standard software such as Microsoft Word can be used. Try to avoid using very showy styles. There may be a dazzling array of fonts on offer but often the more traditional prove to be the best. It is important that the text plays only a supporting role and does not detract the eye from the images.

If you wish the text to be an integral part of the presentation, then try using specialist software such as QuarkXPress or Adobe InDesign. The latter is designed to work in conjunction with Photoshop and is possibly the more flexible of the two alternatives. Working from a grid or template, boxes are created into which the text can be imported. As you are also able to access Photoshop at the same time, it is a fairly easy task to design pages containing both the images and text.

It may well be that even a limited run of 500 is still too many. Not only will you have the logistical problems of storage, but, more critically, they need to be sold if you are to get a return on your outlay. Without the distribution network of an established publisher, this may not be as easy as it seems. Fortunately there are various specialist companies who deal specifically with vanity publishing. They are used to producing very small runs and can tailor the printing specifically for your purposes. One of the most prominent is Lulu (www.lulu.com); visit its website and see what it offers. Another is 100 Books Publishing Company (www.my100books.com), which will produce 100 very high-quality books from your printer-ready files, but on a purely pro rata basis, which can prove rather expensive. Using companies like these does not absolve you from all the hard work, however. 100 Books, for example, requires all the layouts in Photoshop CS2, with files saved on DVD and sent in a form ready for press. They do offer online tutorials showing you how this can be done. The printing

and binding of the books is carried out by 100 Books, which ships copies directly to the customer.

PRINT YOUR OWN
An alternative to employing a professional printer is to print your own books and have them bound. This is a less expensive option and can be extremely successful, particularly if you wish to restrict your run to just 10 to 20 copies. By printing all the pages on your own printer, you are in complete control of the quality of the outcome.

The binding is a task I most certainly would not recommend that you try yourself. Seek out your local bookbinder (particularly one used to doing thesis binding) and you will be surprised by how well these books can be made at quite a reasonable cost. At the time of going to press, for a 120-page A4 (29.7 x 21cm/11½ x 8¼in) book with a fly-leaf, I was quoted £20 ($37.50) for each copy, stab-stitched with archival thread and hardback covered with cloth. Add to this the cost of the paper and inks (archival of course) and you should be able to work out the total cost of each book.

Seek expert advice from the bookbinder before you start printing the pages; he will help with production details, particularly regarding margins and spacing. If you restrict your run to a manageable number and are prepared to sign and number each edition, this should increase its value. If someone is prepared to spend money buying one of your prints, then they will be just as keen to buy a limited edition of your book. A final point, should you wish to take this route, is that when considering the paper to use, make sure the grain runs vertically.

SPIRAL BINDING
If stitching is too expensive, another interesting and stylish alternative is to spiral bind. If you are worried that this sounds a bit down-market, don't be; many professionally produced books are done this way. In essence, once the pages have been collated, they are punch-holed and are bound using either plastic combs or wire coils. It is possible to buy kits for this, but generally they are poor quality and it is better to have it done professionally.

All books should be durable, so an interesting alternative is to add a clear PVC cover that allows the front of the book to show through. At the time of going to press, if you had 10 books produced in this way, the binding would cost you less than £2.50 ($4.50) per book.

SELF-PUBLISHING

TIPS FOR SELF-PUBLISHERS

- This is a great way to show your work, even to a publisher who may have rejected a proposal in the past. Once they see what it is you have in your mind, you are in a better position to change theirs.
- Don't produce too many copies; far better that you start a new run rather than be stuck with boxes of unwanted books. Work on the idea of a limited edition and be prepared to sign and number each one.
- Most good books have a theme, no matter how loosely you care to interpret that. It is hard to imagine monochrome landscape working well with colour portraiture, unless some other issue binds them together.
- Be imaginative about the way you present your book. You may wish to print on A4 (29.7 x 21cm/11½ x 8¼in) or even A3 paper (42 x 29.7cm/16½ x 11½in), but that should not necessarily govern its shape. With some portfolios, images look better presented in a square format, while others suit a narrow landscape format.
- If you are printing your own books, print on one side only. It is possible to see a printed image through even a heavy printing paper. But printing just one side also opens up the range of papers you can use.
- If text is to be included, think carefully about how this should be presented. Mixing text and images on the same page may well suit a documentary-style book, but if your aim is to produce a fine art publication instead, then consider printing the text on a separate page.
- Think very carefully about the cover; while it should be simply designed and eye catching, it should also epitomize what the book is all about. The proportion of the image relative to the size of the cover is another important consideration, particularly if a title is to be included. If the portfolio is exclusively in black and white, ensure that the background colour is subdued.
- If you intend to produce a limited edition, give it the best possible start. Only consider the best materials; if you are printing your own work, use pigmented inks on archival papers. If you choose to have your books professionally bound, don't cut corners. Anyone buying your book needs to feel that they are acquiring something special.

Vanishing Icons in small town America

Vanishing Icons in small town America

The Grand Canyon Cafe, Flagstaff Arizona.

The burning neon signs one commonly associates with "American Graffitti" are rapidly disappearing.

PAGE DESIGN / Most books appear far more interesting if the images vary in size. One way of achieving this is to group smaller images together on a single page.